ARKANA

Zen in the
Art of Painting

Professor Helmut Brinker studied History of Art, Sinology and Japanology at the Universities of Heidelberg, Harvard and Princeton. He was curator of the East Asian Department of the Rietberg Museum in Zürich and is presently Professor of the History of East Asian Art at Zürich University. He has published numerous books, essays and art catalogues and is an internationally renowned authority on the art of Zen in the West.

HELMUT BRINKER

ZEN IN THE

ART OF PAINTING

Translated by George Campbell

ARKANA

ARKANA

Published by the Penguin Group
27 Wrights Lane, London W8 5TZ, England
Viking Penguin Inc., 40 West 23rd Street, New York, New York 10010, USA
Penguin Books Australia Ltd, Ringwood, Victoria, Australia
Penguin Books Canada Ltd, 2801 John Street, Markham, Ontario, Canada L3R 1B4
Penguin Books (NZ) Ltd, 182–190 Wairau Road, Auckland 10, New Zealand

Penguin Books Ltd, Registered Offices: Harmondsworth, Middlesex, England

First published as *Zen in der Kunst des Malens* by Otto Wilhelm Barth Verlag 1985
This translation first published by Arkana 1987
3 5 7 9 10 8 6 4 2

Printed and bound in Great Britain by
Cox & Wyman Ltd, Reading
Filmset in 10/11 pt Sabon
by Columns of Reading

CONTENTS

Understanding Zen

Characteristic of Zen – and, in a sense, characteristic indeed of the oriental mind in general – is the attempt to understand and experience the things of this world, whether animate or inanimate, from *within*: to let oneself be seized and taken *by* them instead of trying to comprehend them, as we in the West do, from a point of view external to them. Thus, to a degree unparalleled in any other form of art, Zen art requires of the beholder tranquil and patient absorption, a pure and composed hearkening to that inaudible utterance, which yet subsumes in itself all things, and which points to the absolute *Nothingness* lying beyond all form and colour (Chinese: *wu*, Japanese: *mu*). And this is true whether the work of art in question be an abstract garden of stones, a piece of calligraphy thrown off in spontaneous mastery, an abbreviated ink painting, or a simple and unaffected tea-bowl.

If we can apprehend and accept this Zen paradox of the silent utterance (there can be no question of understanding it) we may hope that the specific essence of Zen art, cryptic and sublime, and concealed though it may often be in everyday and inconspicuous guise, will make its wordless and inaudible appeal to us. The problem lies in finding the right receptive wave-length. The philosopher Eugen Herrigel (1884-1955), a profound authority on mysticism who reached in Japan an unusually deep understanding of Zen, and whose book *Zen in the Art of Archery* (1953)[1] has become a classic of Zen literature, drew on his own personal experience to describe the irradiating effect of Zen Buddhist painting as follows:

These quite simple pictures, showing so infinitely little, are so full of Zen that the beholder feels overwhelmed by them. Anyone who has seen, at a long-drawn-out tea ceremony, how the whole atmosphere changes when the

1

hanging scrolls are put up, how the guests, sunk in
contemplation before the picture, experience an unveiling
of mysteries which none of them can put into words, and
depart from the tea room feeling unutterably enriched,
will know what power emanates from these paintings.[2]

But before we face up to the challenge presented by this art,
we must ask ourselves – what is Zen? Plenitude of emptiness,
the zero of Being? Is it meditative contemplation of the Self, or
a mystical vision of absolute truth? There is no ready-made
answer, as any definition will necessarily distort the nature of
Zen and diminish its irradiating clarity.

Once upon a time, three Buddhist monks of orthodox
persuasion were wandering about when they met a Zen disciple
who was just then returning home from a session with Lin-chi
I-hsüan (Linji Yixuan, Japanese: Rinzai Gigen, died 867), a Zen
master renowned for his drastic methods as a teacher. The
encounter took place on a bridge, and one of the monks
thought it therefore apt to put his question thus: 'How deep is
the river of Zen?' Whereupon the disciple of Lin-chi answered:
'That is something you must find out for yourself', and the
other two monks were just in time to stop him from throwing
their colleague into the river. As this anecdote shows, the
question posed can, in the long run, be answered by personal
experience alone. Nevertheless, whatever our misgivings, we
must try at least to clarify the matter.

Etymologically, zen is the Sino-Japanese pronunciation of
the Chinese character ch'an (chan), which entered the Chinese
lexicon as a somewhat abbreviated version of the Sanskrit word
dhyāna. In what follows, we shall not attempt to make a rigid
distinction between ch'an and zen; and on occasion we shall
use the established Japanese term zen even in cases where we
are mainly concerned with Chinese connotations. 'Zen' is
usually translated as 'meditation' or 'contemplation', perhaps
most aptly as 'inward communion'. Originally, the word
denoted the Buddhist practice of laying oneself perceptually
open to the essential being of things, intuitive immediacy of
perception, awareness of the elemental dynamics of vital
relationships generated in peace and silence. In China, the first
steps in this meditative practice were already being taken in the

second century AD; and from the sixth century onwards, the practice of *ch'an* became more and more widespread, probably as a reaction to the over-rigid dogmatism, the metaphysical abstraction and the speculative fancies of orthodox Buddhism. In Japan, the main upsurge in Zen was from the end of the twelfth century onwards.

It is true that, as a religious system, Zen has remained a living force in Japan, whence it has spread abroad, especially to America and Europe; but at the same time it must be said that the word has unfortunately become a fashionable, much misused cliché, and is even pressed into service in the most tasteless forms of advertising. One of the most distressing examples of this is to be found in the case of a celebrated Japanese cosmetic firm which has actually called one of its products 'ZEN': a perfume which is lauded as 'totally feminine, a great new classic fragrance'! There could be no more crass misrepresentation of the nature of Zen than this; though it is true to say that Zen has penetrated into hitherto unsuspected realms, both in the rapidly changing context of Japan and in the hectic world of the West, and has been – true to its nature and in spite of occasional abuse – fruitful in giving an impetus to new and promising initiatives. Popular abuse should not blind us to the fact that Zen is neither an oriental occult teaching offering redemption, nor an irrational way of mystic communion; it is not a way of escaping from the bonds of conventional social structure, nor is it an effective tool in the hands of the psychoanalyst:

> What differentiates Zen most characteristically from all other teachings, religious, philosophical, or mystical, is that while it never goes out of our daily life, yet with all its practicalness and concreteness Zen has something in it which makes it stand aloof from the scene of worldly sordidness and restlessness.[3]

Zen is one of the many doctrinal forms or schools – not sects – forming part of Mahāyāna Buddhism, whose adherents put intuitive grasp of religious truth before orthodoxy, dogmatic scripture and traditional ritual, in their search for enlightenment – that insight into the nature of things, the nought which is called *satori* in Japanese. *Satori* may come gradually to

fruition, but then again it may happen suddenly from the ground of one's own Self: often it is generated or precipitated by apparently disjunctive or irrelevant happenings. It cannot be brought about by theoretical method or by analytical ratiocination, both of which depend on language and on encoding in script. *Satori* takes place in everyday consciousness; it lays hold on and imbues body and soul in their togetherness as 'individuality'. The intellect, the source of logic and of methodology, is here totally excluded; for the intellect directs attention to the outer form, the surface, to what is ultimately non-essential, instead of to that insight into the inner truth concerning the things of this world, which can be achieved only via personal experience.

Psychologically, therefore, *Satori* is what is beyond the frontiers of the Ego. Logically, it is an insight into the synthesis of the positive and the negative, of affirmation and negation; and metaphysically it is the intuitive comprehension that Being is Becoming and Becoming Being.[4]

A striking verse, summing up the new teaching, is attributed to the Indian founding father of *ch'an* in China – Bodhidharma (died before 534) – but is considered by critics to be the work of the T'ang master Nan-ch'üan P'u-yüan (Nanquan Puyuan, Japanese: Nansen Fugan, 748-834). The four-line verse sets out the basic traits of Zen about as well as one can hope:

A special transmission outside scriptures (*kyōge betsuden*);
No dependence upon words and letters (*furyū monji*);
Directly pointing at the mind of man (*jikishi ninshin*);
Seeing into his own nature, man attains Buddhahood
 (*kenshō jōbutsu*).

The first two lines are directed against scholastic pedantry, systematic instruction, theological orthodoxy and blind faith in scripture. They demand a radical turn away from religion as encoded in sacred writings (an unheard-of revolution!) and its replacement by personal 'transmission' of the basic teaching of Buddhism from master to pupil: the 'transmission from mind to mind' (Japanese: *ishin denshin*).

The formula, which sums up a central concept of Zen, comes

from the *Fa-pao-t'an ching* (*Fabaotan jing*), the 'Platform-sūtra', which tradition ascribes to the sixth *ch'an* patriarch, Hui-neng (Huineng, Japanese: Enō, 638-713). The enlightened spirit of the Zen master works as a sort of catalyst which induces a comparable experience in the spirit of the pupil. Nothing is 'added' to the transmission: the pupil must reach the experience from his own inner resources, the master cannot 'give' it to him. It is for this reason that the Zen masters never tire of reiterating that, in the last resort, Zen is neither teachable nor transmittable; and in this light, concepts such as 'teaching, transference, transplantation' are to be seen as less than satisfactory attempts at designating a process which cannot really be grasped conceptually or intellectually. In the invisible and inaudible 'transference' of the deepest religious experience, Zen communication reduces ultimately to 'thunderous silence', if we may use the formula which Zen masters are fond of quoting, from the 'Vimalakīrti-sūtra'. 'In itself, the word is less than the thought, the thought is less than the experience. The word is a filtrate, a residue stripped of its best components.'[5]

Personal contact between master and pupil, without any disturbing or propagating middle factor, is here stressed. What Zen aims at is individual experience of absolute transcendence: and the disciple can attain this only by following the direct way prescribed by an experienced spiritual teacher – a required, often, indeed, provoked process of self-knowledge via the teacher's 'direct pointing at the mind of man'. Clarification of the inner being enables the pupil finally to experience identity of his own being with the Absolute, to be aware of his own primeval perfection, of Buddhahood. The celebrated Chinese *ch'an* master Huang-po Hsi-yün (Huangbo Xiyun, Japanese: Ōbaku Kiun, died *c.* 850) is supposed to have said once:

As the spirit is Buddha, the ideal way of perfection is the unfolding of this Buddha-spirit. Avoid thinking only in formal concepts which lead to cyclic ebb and flow, to misery in the world of the senses, and to much else. Then you will no longer stand in need of ways to enlightenment, and such like. Thus it is said:

What Buddha teaches has but one aim:

To transcend the bounds of thought.
Once the play of thoughts is stilled,
Of what further use is Buddha's teaching?[6]

One of the ways in which we may try to reach this liberating
experience, this unintentional emptying-out of the Self, is the
art of 'meditation' which gave the school its name. What is
called in Japanese *zazen* is a way of 'sitting in profound
contemplation' with crossed legs while one breathes naturally;
a posture which allows spirit and body to settle in relaxed and
unintentional rest while the mind stays wide awake. Pupils
deficient in concentration are encouraged and spurred on by
means of heavy blows on the shoulders and back with the
kyōsaku, the flattened admonition staff which Zen masters are
often shown holding in their hands in portraits. Between
periods of static *zazen*, 'Zen in motion', *kinhin*, is practised, as
a means of developing the capacity to 'translate' Zen practice
into everyday life. In the Lin-chi or Rinzai school it is
customary to shout out the untranslatable interjection '*katsu!*';
this, like the *kyōsaku*, serves to spur pupils on, and – again like
the *kyōsaku* – when used at the right moment can help the
pupil to achieve a *satori* experience.

A very important auxiliary means in Zen practice is provided
by the *kōan*: paradoxical 'cases' which are not amenable to
logical discursive reasoning called *kung-an* (*gongan*) in Chinese.
Over the years, various collections of these, large and small,
were formed in Chinese *ch'an* circles. The best known of these
are the *Pi-yen-lu* (*Biyanlu*, Japanese: *Hekiganroku*), the 'Green
Cliff Record'[7], compiled by Yüan-wu K'o-ch'in (Yuanwu
Keqin, 1063-1135) and first printed in 1125, and the *Wu-men-
kuan* (*Wumenguan*), the 'Pass without a Gate' of Hui-k'ai
(Huikai, 1184-1260) published in 1228.[8] The *kōan* consist very
largely of anecdotes, legendary and biographical details,
conversations with, and sayings of the great patriarchs. They
were designed to serve the pupil as a tool in his own religious
practices, and lead him in the long run to the enlightenment
which is his aim. For example, a monk asked his master: 'When
one asks a question, one always feels confused in one's mind.
How does that come about?' The master answered: 'Kill, kill!'
This apparently brutal injunction is no doubt designed to kill

desire, to switch off thought, to empty the spirit, thereby setting the scene for the experience of enlightenment. Again, another monk asked: 'What is the deepest significance of the law of Buddha?' The master's answer: 'To fill all streams and all valleys.' It was almost inevitable that such provocative exercises in meditation should appeal to the imagination of painters as material demanding translation into visual art.

The legend has it that the 'wordless transmission' of Zen began on the Vulture Peak at Benares, when the historical Buddha, Śākyamuni, seated in the congregation, answered a question concerning an important article of faith by silently holding a flower in front of his breast and turning it between his fingers. Alone among the disciples Kāśyapa understood this gesture as symbolical of the deepest truth, and he indicated this by smiling. In China, *ch'an* began with the Indian Bodhidharma (Chinese: P'u-t'i Ta-mo, Puti Damo; in Japanese: Bodaidaruma, died before 534), the last in a series of twenty-eight Indian patriarchs. He was followed by the Chinese founding fathers: Hui-k'o (Huike, 487-593), Seng-ts'an (Sengcan, died 606), Tao-hsin (Daoxin, 580-651), Hung-jen (Hongren, 601-674) and Hui-neng (Huineng, 638-713). At this point, after the fifth patriarch, serious rivalries over the true succession broke out which, coupled with irreconcilable differences in basic points of theology, led to a split into two schools – the northern and the southern. The northern school was led by Shen-hsiu (Shenxiu, 606-706), the southern by Hui-neng; and, if we may venture to express the difference between them in a nutshell, Shen-hsiu and his school saw the way to enlightenment as a gradual process, whereas Hui-neng saw it as a sudden revelation.

Hui-neng was officially appointed to the succession; and over the centuries that followed, his disciples created the canonical and historically important codification of Chinese *ch'an*, which reached its apogee in the T'ang (Tang) dynasty (618-906) and which was further disseminated, systematised and, in part, doctrinally recast in the Sung (Song) dynasty (960-1278). The Emperor Ning-tsung (Ningzong, reigned 1194-1224) organised the amalgamation and the hierarchical ordering of the five most important *ch'an* monasteries in Hangchow (Hangzhou) and Mingchow (Mingzhou, in modern Chekiang/

Zhejiang province) as the 'Five Mountains' (*wu-shan*). This
provided a model for the establishment of the *gozan* of
Kamakura and Kyōto, and exercised immense influence far and
wide as a centre of Zen art and culture. It was at this stage that
meditative Buddhism found its way into Japan.

Japanese Buddhism's first contacts with the, as yet, incipient
ch'an movement on the Chinese mainland go back to the
seventh century, when in 653 the Hossō monk Dōshō (629-
700) journeyed to China and made contact there with a disciple
of the second patriarch Hui-k'o (Huike), named Hui-man
(Huiman). Furthermore, during his eight-year stay in China, he
let himself be initiated into the ideology and the practice of the
new school by the experienced and much-travelled Hsüan-tsang
(Xuanzang, 603-664). Sporadic contacts of this sort continued
in the centuries that followed; Zen writings reached Japan, and
the practice of meditation, already customary in the Tendai and
Shingon schools, grew in prestige and significance.

For its main inauguration and establishment in Japan, Zen
had to wait until the late twelfth and early thirteenth centuries;
and it was left to three priests who had been trained in China,
to introduce three main currents of mainland *ch'an* to the
monastic communities of Japan. These were: the reformer
Myōan Eisai (1141-1215) who had been particularly drawn to
the ideas of the Huang-lung (Huanglong, Japanese Ōryū)
branch of the Rinzai school; the learned Risshū master, Shunjō
(1166-1227) who had made an intensive study of the Yang-ch'i
(Yangqi, Japanese: Yōgi) branch of the same school; and,
thirdly, the unconventional thinker Kigen Dōgen (1200-1253)
whose goal it was to bring about a realisation of the ideal belief
and the ideal life-style envisaged by the Ts'ao-tung (Caodong,
Japanese: Sōtō) school. Their own disciples and subsequent
masters carried on the work thus begun, with the support of
renowned *ch'an* masters from mainland China: Wu-an P'u-ning
(Wuan Puning, 1179-1276), Lan-ch'i Tao-lung (Lanqi Daolong,
1213-1278), Wu-hsüeh Tsu-yüan (Wuxue Zuyuan, 1226-1286)
and I-shan I-ning (Yishan Yining, 1247-1317). It was they who
set the course for the rise of the 'Five Mountains', the *gozan* of
Kamakura and Kyōto. In Kamakura, from 1386 on, the
following belonged to these elite Zen monasteries: Kenchōji,
Engakuji, Jufukuji, Jōchiji and Jōmyōji. In Kyōto, there were –

apart from the monastery of Nanzenji which was partly allotted to the *gozan* by virtue of the Shōgun's decree – Tenryūji, Shōkokuji, Kenninji, Tōfukuji and Manjuji.[9]

The Spiritual Sources of Zen

Painting in Zen: Zen in painting. This apparently trivial juxtaposition is not meant to be a capricious play on words, nor yet an attempt at formulating a typical Zen 'case', a *kōan*. Rather, it is a way of suggesting the multi-dimensional nexus, the many layers of meaning, the reciprocal stimuli, the various religious, cultural and intellectual factors, whose fusion over the centuries has cancelled out oppositions and dualisms, and which have found visual expression in this form of painting. Eugen Herrigel regards Zen painting as the end-product of *satori*, 'the way in which it expresses itself pictorially For there is a distinct school of Zen painting: works in which the illuminated vision of existence is the theme of the picture.'[10]

But, as one may well imagine, Zen painting was not produced, necessarily and exclusively, by Zen monks for Zen monasteries or for members of the Zen communities. In China, it was above all the *literati*, scholars, poets and statesmen who painted pictures in the Zen spirit – perhaps at the suggestion of *ch'an* masters in their circle of acquaintances. Sometimes it was even traditionally trained members of the court academy, who were commissioned by a monastery, a prelate, or perhaps a lay ruler, an Emperor or a Shōgun, attracted by meditative Buddhism, to take a Zen Buddhist theme as their subject-matter. Through contact – often close contact – with court officials who had been as a rule educated on Confucian principles, Zen monks were able to widen their intellectual horizon and see far beyond the limits of their monastic ambience. Here, Buddhism and Neo-Confucianism met in mutually fertilising and creative cultural exchange; and the reciprocal stimuli in philosophy, art and literature are too numerous to be listed.

Thus it came about that artists, who were by no means members of the Buddhist clergy, painted typical Zen pictures;

while, on the other hand, painter-monks appropriated for their own use the artistic concepts, themes and styles of the literati and produced typical literati pictures, elegant representations of orchids, bamboos and rocks. Questions arise in our minds as we contemplate these pictures. Is this Zen painting? Are these works in the spirit of Zen? Is this a form of Buddhist art, or are these pictures the spontaneous productions of artistically committed clerics? In what follows, we may be able to find answers to these questions.

At this point we must mention a further spiritual source of Zen and its art: Taoism. The Buddhist ideology emanating from India, and based, in the Zen reading, on the universal presence of the essential Buddha, was, in fact, very close to the concept of the *Tao* (*Dao*) in Chinese thought: the concept of a transcendental principle informing all things and manifesting itself in nature as a whole. The contemplative practices whereby Zen Buddhists and Taoists sought to gain insight into the elemental forces of the universe, the very roots of being, were closely similar; both Zen Buddhists and Taoists stressed the original and natural act of insight into the nature of being, expressed their distrust of any intellectualisation of their teachings, and laid value on the transmission, from master to disciple, of 'the wordless teaching' – a Taoist expression, which was to become a key-word in the conceptual world of Zen Buddhism.

Against the background of such a *Weltanschauung*, it was almost inevitable that representation of nature, especially of landscape, should prove an apt vehicle for Zen Buddhist painters wishing to express their cosmosophic insight. These artists, working as they were from the basis of religious enlightenment, saw the world around them with changed eyes. A metamorphosis had taken place within them, a change which enabled them to see the earnest of salvation in the world of empirical phenomena: the annulment of duality, and the religious-metaphysical *at-one-ment* of man and mountain, river, animal and plant:

A master said: 'Before a man studies Zen, to him mountains are mountains and waters are waters; after he gets an insight into the truth of Zen through the

instruction of a good master, mountains to him are not mountains and waters are not waters; but after this when he really attains to the abode of rest, mountains are once more mountains and waters are waters.'[11]

To throw further light on the Zen artist's insight into the nature of things, an insight which absorbs and cancels out all opposites, let us again quote D.T. Suzuki, who writes:

To become a bamboo and to forget that you are one with it while drawing it – this is the Zen of the bamboo, this is the moving with the 'rhythmic movement of the spirit' which resides in the bamboo as well as in the artist himself. What is now required of him is to have a firm hold on the spirit and yet not to be conscious of the fact. This is a very difficult task achieved only after long spiritual training. The Eastern people have been taught since the earliest times to subject themselves to this kind of discipline if they want to achieve something in the world of art and religion. Zen, in fact, has given expression to it in the following phrase: 'One in All and All in One'. When this is thoroughly understood, there is creative genius.[12]

What this fundamental saying offers us is not so much a glimpse of Zen pantheism as further evidence of the strong influence of Taoism, according to whose tenets the *Tao* (*Dao*), the 'way of nature' is everywhere revealed in reality-as-given, cancelling out in mutual interpenetration in the 'fundament of Being' all superficial contradictions and oppositions, such as those between fullness and emptiness, between multiplicity and unity, between 'One and All'.

The syncretic fusion of Buddhist, Confucian and Taoist thought and forms of expression found its most succinct expression in the theory of the 'Three Creeds and the Single Source' (Chinese: *san-chiao i-chih/sanjiao yizhi*; Japanese: *sankyō itchi*). Under Imperial patronage, symposia were often

Śākyamuni, Confucius and Lao-tzu (or: The Three Creeds) (detail); attributed to Josetsu (early fifteenth century). Ryōsoku-in, Kenninji, Kyōto

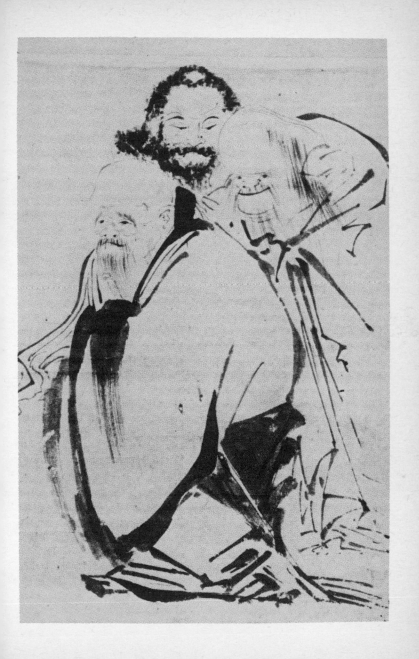

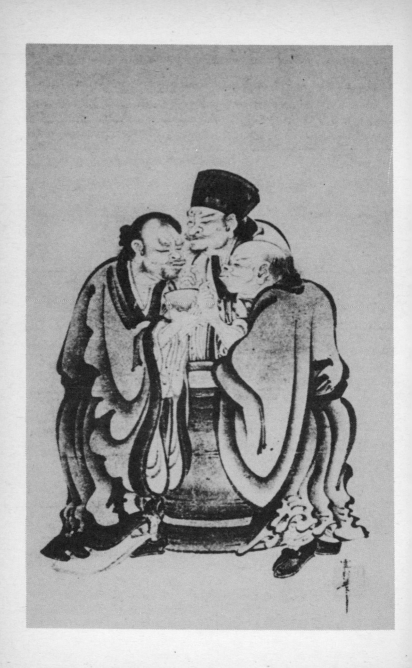

held in China at which leading representatives discussed the relationships between the doctrines they taught, their advantages and their drawbacks. In addition, painters like Sun Wei and Shih K'o (Shi-Ke) in the ninth and tenth centuries drew the three founders of these doctrines – the historical Buddha, Śākyamuni, Confucius and Lao-tzu (Laozi) – together into a group portrait, a theme which was enthusiastically received in the tolerant atmosphere of Zen, especially in the fifteenth century in Japan. Existent incompatibilities in doctrine were not exploited, as they were simply seen as different aspects of one and the same thing. 'Zen Buddhists are sometimes Confucianists, sometimes Taoists, or sometimes even Shintoists': this is D.T. Suzuki's terse and somewhat surprising verdict.[13]

The most prominent remaining version of the theme showing Śākyamuni, Confucius and Lao-tzu (Laozi) as a triad, is a rough rapidly brushed ink-painting in the Ryōsoku-in of the Kenninji in Kyōto. The hanging scroll was rediscovered in 1916 and is convincingly attributed, in one of the two inscriptions on the picture, to the Zen monk and painter Josetsu. It seems reasonably certain that Josetsu was active, early in the fifteenth century, in the Shōkokuji at Kyōto. He is said to have been given his monk's name of Josetsu – which literally translated means 'clumsy-like' – by the learned Zen master and poet Zekkai Chūshin (1336-1405): a reference to a passage in the 45th chapter of the Taoist classic, the *Tao-te-ching (Daodejing)*, the 'Holy Book of the Way and the Virtue', where we read: 'Great straightness seems bent; the greatest skill is like clumsiness; great eloquence seems tongue-tied.'[14] The inscription directly above the painting was written in 1493 by the well-known Zen monk Seishū Ryūtō (1434-1498), presumably about a century after the original painting was done. It may be translated in part:

> Gautama, Confucius, and Lao. The three are like one. One is like three. Together the three produce all virtues. They may be compared to three boatmen in the same

The Three Vinegar-tasters (detail) by Reisai (mid-fifteenth century); inscription by Yaun Eitsu. Umezawa Kinenkan, Tōkyō

great vessel containing heaven and earth and laden with the sacred and profane.

Earlier the concept of the unity of the Three Creeds was succinctly expressed by the influential Chinese *ch'an* abbot Wu-chun Shih-fan (Wuzhun Shifan, 1177-1249) in a prose-poem for a lost painting of our theme:

> The one is three.
> The three are one.
> The three are one.
> The one is three.
> Apart, they cannot be separated.
> Together, they cannot form a group.
> Now, as in the past,
> They join together
> In silence,
> For the simple reason
> That within the creeds
> Are many vessels.[15]

As ecumenical ideals, the inner identity of Buddhism, Confucianism and Taoism and the casting aside of narrow, artificial constraints in the shape of doctrinal and confessional prescriptions, were reinforced from the artistic point of view by the adhesion of two further themes: first, the representation of the 'Three Vinegar-tasters' (Chinese: *san-suan/sansuan;* Japanese: *sansan*), and second, pictures of the 'Three Laughers of the Tiger Ravine' (Chinese: *Hu-ch'i san-hsiao/Huqi sanxiao;* Japanese: *Kokei sanshō*). These two themes were favourites of the Zen painters, and were handled by them with sensitive humour. Whether the three vinegar-tasters are really Śākyamuni, Confucius and Lao-tzu (Laozi) or, as others maintain, the celebrated Sung (Song) dynasty literati, Su Tung-p'o (Su Dongpo, 1036-1101), Huang T'ing-chien (Huang Tingjian, 1045-1105) and their priestly friend, the *ch'an* monk Fo-yin (Foyin) from the Chin-shan (Jinshan) monastery, what is certain is that the picture expresses in allegorical form the essential identity of the three creeds, in that the three sages are sampling liquid from one and the same vessel: each is aware subjectively of a different taste – and yet it is the same liquid, wine that has turned to vinegar.

We have to thank an artist who is presumed to have been active in the middle of the fifteenth century in the Tōfukuji at Kyōto, for the most delightful version known of the 'Three Vinegar-tasters'. This was the painter-monk Reisai who seems to have taken part in an embassy to Korea in 1463. The picture is painted in ink on paper: a powerful and original statement in bold lines. The three old men are standing round a large jar. Eyes closed and lips thrust forward, they are concentrating on tasting their samples. The picture is signed by the artist in the bottom right-hand corner, and provided with the motto-seal *Kyaku tō jitchi*: that is to say, 'To plant one's feet on solid ground'.

The scroll, owned today by the Umezawa Kinenkan in Tōkyō, has a prose inscription by a monk named Yaun Eitsu in which we find the statement: 'The Three Creeds become a Single Doctrine The men endure the sour taste and knit their brows, standing face to face in silence. A dominant religion is an affliction to man.' Several poems preserved in the 'Collected Sayings' of *gozan* monks bear witness to the popularity of the 'Three Vinegar-tasters' in Muromachi poetry and painting. The Tōfukuji priest Genun Gesshû seems to have provided a number of inscriptions for paintings that have been lost; one reads:

Wearing Confucian shoes, a Taoist cap, and a Buddhist robe,
Three men taste vinegar standing in the setting sun.
Later it will be changed into a cup of wine.
They are T'ao [Yüan-ming], Lu [Hsiu-ching], and [Hui-] yüan;
T'ao will support the drunken one when they return home.[16]

In the Moyoma period, the painter Kaihō Yūshō (1533-1615) who was raised in the Tōfukuji and who was subsequently well-known in Zen circles in Kyōto, treated the same theme in a six-fold screen, which is now preserved in the Myōshinji in Kyōto, along with a representation of the scurrilous Zen saints, Kanzan and Jittoku. Later Zen artists, as for example Hakuin in the eighteenth century, have also treated this 'classical' theme.

Chronologically, the 'Three Laughers of the Tiger Ravine' may well be the oldest of these three allegorical themes. It is in the writings of the renowned *ch'an* painter-monk and poet Kuan-hsiu (Guanxiu, 832-912) that we first find the story of the poet T'ao Yüan-ming (Tao Yuanming, 372-427), who came from a Confucian milieu and who incorporates the ideal of the individual and solitary anchorite; the Taoist magus and philosophical formalist Lu Hsiu-ching (Lu Xiujing, *c*. 406-477); and the important Buddhist patriarch Hui-yüan (Huiyuan, 334-416). Round about the year 384, Hui-yüan had retreated to the Tung-lin (Donglin) monastery on Mount Lu on the south bank of the Yangtse; and here he swore never again to leave the holy confines of the monastery or to set foot in the profane world of desire and everyday human filth. But one day, T'ao Yüan-ming and Lu Hsiu-ching came to visit him. When they were leaving, he accompanied them a little way, engrossed in animated conversation – and, unwittingly, crossed the bridge over Tiger Gorge, which formed the boundary between the monastery grounds and the outer world. Suddenly the three men heard a tiger roar, and at once Hui-yüan realised that he had inadvertently broken his oath. Laughing heartily the three men shrugged off their little mistake, for they saw clearly that constraints and prescriptions, however rigorous, are of no avail against spiritual freedom and purity.

After Kuan-hsiu another eccentric painter took up the theme of the 'Three Laughers of the Tiger Ravine' in the second half of the tenth century. This was Shih K'o (Shi-Ke) who seems to have adorned the walls of a house with this motif, a house subsequently inhabited by no less a personality than Ou-yang Hsiu (Ouyang Xiu, 1007-1072), the great statesman, poet, historian and archaeologist. Tradition has it that Su Tung-p'o (Su Dongpo), a younger contemporary of the Neo-Confucian Ou-yang, wrote a poem on this wall painting. Alas, nothing remains of what must have been a most charming work of the tenth/eleventh century. However, we do have some good Japanese ink paintings, dating from the fifteenth century, of this allegory which is so popular in Zen circles: from the hand, for example, of the Zen priest Chūan Shinkō who lived in the Seirai-an of the Kenchōji at Kamakura round about 1450 (now in the Hosomi collection, Ōsaka); or from the hand of the

roughly contemporary Zen painter-monk Bunsei, who was evidently in close contact with the Daitokuji in Kyōto (now in the Powers collection, New York). Finally, we meet the three figures, squeezed and contorted into a most original caricature version, in an ink drawing by the eccentric abbot of the Shōfukuji, Gibon Sengai (1750-1837) who adds a 31-syllable poem:

> Why do they laugh?
> The clouds that make no pledges
> Pass over the mountain bridge,
> Morning or evening,
> With the utmost freedom![17]

In Japan, the form of religious figure-painting known as *dōshakuga*, which draws heavily on Taoist and Confucian sources, but most particularly on Zen Buddhist sources, is sharply distinguished, both from traditional and orthodox Buddhist painting (*butsuga*) and from the ideal portraits of the venerated Zen patriarchs of the past (*soshi-zō/zu*) and the actual portraits of Zen priests (known in general as *chinzō*). The word *dōshakuga* can be literally translated as 'pictures which explain the way (to enlightenment)'. It can, however, be analysed into three components: *dō* = Taoist, *shaku* = Buddhist (in compound with a second character, *shaka* = Śākyamuni) and *ga* = painting. Zen works of this type had a largely didactic character and were of high paradigmatic value; and figures from Confucian history and legend and from the rich Taoist pantheon, which had been integrated into Zen painting, were called into service as stimulating exemplars.

Zen Aesthetics and
Theory of Art

The cultural interpenetration which is so marked in this field and the exorbitant claims made in recent years for Zen and its art in a vast number of publications, have brought about a situation in which the very existence of a specific Zen art is being questioned, at least in China, while more weight is being laid on the Neo-Confucian component in this cultural amalgam. We may welcome this as a desirable expansion of what is often the over-narrow viewpoint adopted by many authors, but we must be on our guard not to empty the baby out along with the bath-water. It is certain that there is no such thing as a unified Zen style of painting: there are no generally valid formal guidelines, nor is there an established iconographic canon for artists to draw upon; and even the identification of the spontaneous, suggestive and abbreviated ink painting practised in China since the thirteenth century and in Japan since the fourteenth with 'Zen painting' is too simple and one-sided, not to say misleading. Zen painting has a much wider spectrum of artistic manifestations, methods, techniques, themes, forms and styles, and it is not easy to isolate the specific Zen features in a given picture. Zen painting is not a closed-off, isolated and clearly differentiated genre of East Asian art; on the contrary, it must be seen in its proper setting in the general history of art in China and Japan, on the one hand, and, on the other, in the overall development of Buddhist art in the Orient.

In the process of selecting their artistic means, their style, artists could draw upon an enormously rich reservoir dating back hundreds of years. True to the freedom and multilateral receptivity characteristic of Zen, they translated traditional formal principles into a new context, and selected a new and unconventional, even surprising mode of utterance; and the result was that, for example, an established academic style could be applied to an unmistakable Zen theme, an unorthodox

synthesis which could generate something new – a Zen work of art. On the other hand, when they chose themes which had reached Zen imagery from traditional Buddhist art, painters who were working from personal experience and belief, and who had discarded the constraints of conservative criteria, preferred to use unorthodox methods and means developed by eccentric outsiders for whom traditional Chinese critics had nothing but scorn. It was precisely in this context that such factors in the mind of the Zen adept as intentional incompleteness, the absence of the pretentious in favour of the spontaneous, were able to generate and embody high aesthetic and religious values. In Zen monasteries in Japan this form of art was accepted and preserved as something very precious; and it was promoted and fostered there by political personalities who were keenly interested in art. In Japan, from the thirteenth and fourteenth centuries onwards, men of influence, interested in Zen, were much more effective than were their counterparts in China in setting the spiritual and cultural tone of the people as a whole, and in making their aesthetic and artistic principles valid for lay circles as well.

What are these aesthetic principles? The first thing one notices about works of art imbued with the spirit of Zen, and about artistic skills which have blossomed into 'ways' (dō) – especially the 'tea-way' (chadō) – is an elemental sense of unadorned simplicity, artlessness, objectiveness and purity; a feeling for unforced naturalness, forceful directness and a deep respect for nature. In his book *Zen to bijutsu* the contemporary philosopher and authority on Zen, Shin'ichi Hisamatsu, has selected seven properties which are mutually valent or combinatorial on a given plane, and which give a Zen work of art its special quality. These are: asymmetry (*fukinsei*), simplicity (*kanso*), austere sublimity or lofty dryness (*kokō*), naturalness (*shizen*), subtle profundity or deep reserve (*yūgen*), freedom from attachment (*datsuzoku*), tranquillity (*seijaku*).[18] This list of properties gives us a good idea of what goes to make a Zen work of art. Some of these transcend purely aesthetic values and point to lofty moral and religious ideals, while at the same time adumbrating the basic concepts of that attitude to art which differentiates Zen in principle from the orthodox schools of Mahāyāna Buddhism. In what follows, we shall try to sketch

the main outlines of this specifically Zen Buddhist concept of art.

Cult pictures in the traditional sense play just as small a part in Zen as do classical Mahāyāna sūtras. After all, what one is seeking in Zen is 'independence from words and letters' and a 'special transmission outside scriptures'. Thus it comes about that Zen has developed its own extensive genealogical and hagiographical literature. In addition, the 'Collected Sayings' (Chinese: *yü-lu/yulu*; Japanese: *goroku*) of a great Zen master, usually assembled posthumously by his students, go to further the pristine 'transmission from mind to mind'. In these, the enlightened spirit of a Zen master is most clearly and purely revealed: as also in the portraits, often with dedications in the handwriting of the person portrayed, and in other 'ink-traces' (Chinese: *mo-chi/moji*; Japanese: *bokuseki*) by the master's hand. A hand-written token can transmit the being and the spirit of the teacher to the student more effectively than the invariably inadequate compromise of a reproduction: the deixis is 'directly pointing at the mind of man', and it transcends time and space to retain awake in one's consciousness the invisible presence of the spiritual exemplar.

We have mentioned the inscriptions on pictures (Chinese: *tsan/zan*, Japanese: *san*). In addition to these, the following documents – some of them on a very high level of literary and calligraphic merit – have, for the Zen disciple, the same evocatory power over and above the primary sense of their contents:

1 *Fa-yü/fayu*; Japanese: *hōgo*. 'Dharma-words' in the form of an essay or a poem, containing all sorts of personal hints for the Zen student engaged in his search for spiritual maturity or enlightenment.

2 *Fu-fa-chuang/fufazhuang*; Japanese: *fuhō-jō*. Instructions for Zen students ear-marked for the succession in a didactic or administrative capacity.

3 *I-chi/yiji*; Japanese: *yuige*. Precepts written down on the death-bed in verse form; the religious last will and testament of a Zen master, as it were.

4 *Yin-k'o-chuang/yinkezhuang*; Japanese: *inka-jō*. Documentation certifying that a Zen student has satisfied all the

conditions requisite for recognition as a master.

5 *Tzu-hao/zihao*; Japanese: *jigō*. Confirmation names, consisting usually of two large characters, which were conferred upon Zen students on the occasion of their graduation.

6 *Ch'ih-tu/chidu*; Japanese: *sekitoku*. Letters or epistles.

Nothing is further from the man of Zen than to seek his religious aim via the contemplation and veneration of a cult picture, or to let himself be guided by an esoteric ritual, a strictly ordered liturgy, into which petrified symbols are compressed to form a binding semiology. If one had to give a concise definition of the Zen Buddhist attitude to art, with particular regard to its understanding of unmistakably religious themes in painting, one might do worse than quote the words of the first *ch'an* patriarch, Bodhidharma, who was asked by the Liang Emperor Wu (464-549) what was the 'highest meaning of the Sacred Truth', to which Bodhidharma replied: 'Open distance – nothing sacred.' These striking words form the take-off point for the *Pi-yen-lu* (*Biyanlu*), the 'Green Cliff Record'. This well-known work contains a hundred 'cases' (*kōan*) collected by Hsüeh-tou Chung-hsien (Xuedou Zhongxian, 980-1052) which were used by the *ch'an* master Yüan-wu K'o-ch'in (Yuanwu Keqin, 1063-1135) when instructing his pupils, never intending, no doubt, that his exposition would one day be published along with the explanatory examples. One of Yüan-wu's pupils, Ta-hui Tsung-kao (Dahui Zonggao, 1089-1163), was probably convinced that he was acting in the spirit of his master when he burned the *Pi-yen-lu* (*Biyanlu*) in demonstrative protest against the proliferation of Zen writings. However, Ta-hui's copy was not the sole one extant; others survived so that we are still in possession of the hints, examples and panegyrics which go to make up the 'Green Cliff Record'.[19] A few more examples may help to show the radical nature of Zen rejection of traditional scripture and ceremonial veneration of iconography.

We are assured in various traditional sources that the sixth patriarch, Hui-neng, could not read or write. During the quarrel as to who should succeed the fifth patriarch, Hui-neng found that, in the hours of darkness, his rival had written a poem on the cloister wall which was to be painted next day. He

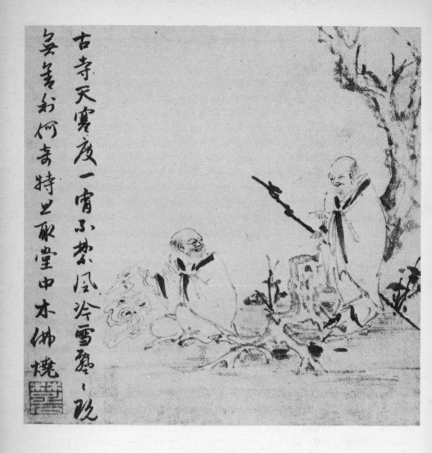

古寺天寒度一宵不禁風冷雪壓眠
無奈和何尋特上取堂中木佛燒

The monk of Tan-hsia burns a wooden Buddha statue, by Fan-yin T'o-lo (first half of the fourteenth century. Bridgestone Art Museum, Tōkyō

was moved to reply to it: but had to beg a monk with whom he was on friendly terms to write his poem down for him. There is a marvellous picture, traditionally attributed to the Sung academy painter Liang K'ai (Liang Kai) active in the first half of the thirteenth century, though some critics take it to be a Japanese copy, which gives a most impressive demonstration of Zen Buddhist rejection of scholastic dependence on texts. In it we see an old unkempt monk – probably the sixth patriarch, Hui-neng – tearing up a sūtra scroll with obvious and sarcastic pleasure. Another *ch'an* priest, Te-shan Hsüan-chien (Deshan Xuanjian), who died in 865, seems to have followed Hui-neng's example, when he consigned all his sūtra scrolls to the flames after he had achieved enlightenment.

Zen scepticism regarding the allegation that religious pictures and images were imbued with a holy substance which manifests itself in them, is well demonstrated by the unruly *ch'an* master T'ien-jan (Tianran, 738-824) from Tan-hsia (Danxia), of whom many very extraordinary tales are related in several collections of Zen writings. He shocked his fellows not only by pretending to be deaf and dumb, but by actually climbing up a Buddhist statue in sacrilegious disregard of all monastic rules. On another occasion, when he felt cold, he made no bones about lighting a fire with a wooden statue of the Buddha! When the abbot took him to task for this, T'ien-jan (Tianran) answered that he burned the image in order to get the *śarīra*, i.e. the ashes of the Buddha, which were venerated as relics. The abbot burst out angrily: 'How can you hope to gain *śarīra* from an ordinary piece of wood?' to which T'ien-jan (Tianran) replied: 'If that is so, why do you take me to task?' The picture by Yin T'o-lo (Yin Tuole), a *ch'an* monk and painter, who probably hailed from India and who seems to have been active during the first half of the fourteenth century mainly in the eastern coastal regions of China (his full priest name is Fan-yin T'o-lo/Fanyin Tuolo), very successfully captures the humour of this anecdote, which is so symptomatic of the true Zen attitude to things. The little ink painting in the Bridgestone Art Museum (Ishibashi collection) in Tōkyō mounted today as a hanging scroll, is probably a section cut out from a longer handscroll containing similar Zen anecdotes.

In burning a wooden statue of the Buddha in order to warm

himself, the monk from Tan-hsia (Danxia) was not simply indulging in an act of pure iconoclasm. Rather, he was helping to demolish what was for orthodox Buddhists an irrefutable belief in the hypostatization of the Absolute in a religious image; and equally, he was performing a *reductio ad absurdum* of the widespread practice of venerating relics. Zen is tolerant of pictures of Buddhas and Bodhisattvas, but does not consider them to be sacrosanct; so that, when T'ien-jan (Tianran) climbed up the Buddha statue he was simply making an unmistakable and provocative demonstration of his indifference to, and inner independence *vis-à-vis* the solemnity and sanctity ostensibly informing the statue: he was no longer abashed by it. For him, pictures and images – even of the Buddha – are transitory: forlorn attempts, doomed to failure from the outset, to make Buddha-being (*buddhatā*) visible and tangible, even anthropomorphic. Zen preferred to create images of great Zen masters, such as founders of temples, portrait statues of whom are still to be seen today in many Japanese Zen monasteries. Significantly, however, besides these portrait statues there is virtually no Zen Buddhist sculpture worth mentioning. By and large, we can say that mature Zen shows a tendency towards aniconism; it can do without representational images, though it would be going too far to say that it is hostile to representational art in general.

In type and character, however, a Zen picture is fundamentally different from a work produced by the traditional schools of Buddhist religious painting. To the ceremonial splendour, the radiance of colour and gold and ornamentation of these works, to their calculated and iconographically ordered plenitude of forms, Zen opposes an off-the-cuff spontaneity which jettisons deep-rooted conventions in favour of an almost ascetic and yet very effective economy of form, a down-to-earth objectivity, achieved with the simplest of artistic means, and eschewing virtuosity, saturation and prodigality. This matter-of-factness is allied to modesty and simplicity in the choice of motif and of material, and we must not fail to mention the preference for empty backgrounds. Frequently, this empty background is not simply a negative factor in the composition of the picture, an unpainted part of it. In keeping with the tenets of Zen, this empty space is of extreme significance as a

symbol of the absence of form, of colour and of attributes, the *śūnyatā* which the Japanese know as *kū*. The empty ground of the picture is identified as the empty ground of Being and as *satori* – absolute truth and the highest stage of knowledge.

The tenfold Zen parable known as the 'Ten Oxherding Songs' has been popular since the eleventh century in numerous versions both in verse and in picture form. It serves the Zen pupil as a spiritual and visual support and signpost on his way in search of enlightenment: the gradual process whereby maturity is achieved on the path of Zen is compared to ten stages in the search for an ox which a simple herdsman believes he has lost but ultimately finds. In the eighth stage, we find an empty circle – a symbol for the point of unintentional and unbidden forgetting of both ox and herdsman: or, to put it in other words, for the 'insight into one's own nature', which ultimately leads to 'Buddhahood'. We recall what Bodhidharma said when asked what was the supreme meaning of Holy Truth: 'Open distance – nothing sacred.'

The circle (Chinese: *yüan-hsiang/yuanxiang*; Japanese: *ensō*) has long been a central component in the ideology of Zen Buddhism. We find the third Chinese patriarch Chien-chih Seng-ts'an (Jianzhi Sengcan, died in 606), speaking in his *Hsin-hsin-ming* (*Xinxinming*, Japanese: *Shinjinmei*), the 'Engraving of Belief in Mind', of the 'Circle, which is equivalent to the "Great Emptiness"; nothing is missing, nothing is superfluous!' The circle as 'perfect manifestation', as a form without beginning and without end, represents the annulment of all contradictions to absolute unity and, accordingly, to 'true emptiness' (Chinese: *chen-k'ung/zhenkong*; Japanese: *shinkū*). It symbolises the formless and colourless Being-as-it-is of all things in creation, the 'original lineaments before birth', of which it is said in the *Wu-men-kuan* (*Wumenguan*; Japanese: *Mumonkan*): 'Even when we paint it, it is not painted.'

The most fitting symbol – perhaps we should say 'non-symbol' – for the 'insight into one's own nature' in Zen painting is thus the empty ground. 'The direct pointing at the mind of man' which precedes vision of 'the original lineaments before birth' (in the language of the fundamental article of the Zen credo, which we have already quoted more than once) is bodied forth for us in a humorous ink painting (now in the

MOA Museum of Art in Atami) by the Japanese Zen monk and painter Mokuan Reien, who was active in China from 1325 till his death in 1345. The painting, based perhaps on a Chinese representation of the historically attested beggar-monk Pu-tai (Budai, Japanese: Hotei, died in 916) shows the bald-pated old man happily roaming over the countryside, and laughing as he points with his raised hand into empty space. The other version, incidentally sometimes likewise attributed to Mokuan, helps us to understand this indicative gesture by placing at its crucial point a small circle (nimbus) with a tiny Buddha figure seated within it. This is the 'original lineaments' of Pu-tai or Hotei, a reference to his state of enlightenment and also to Maitreya, the future Buddha, as whose incarnation Pu-tai was seen by posterity.

Closely related to these ink paintings done by Mokuan in China are two Japanese representations of Hotei pointing upwards. One of these, at present in the Tōkyō National Museum, bears the seal of a little-known artist named Kōboku, who seems to have been active in Kamakura during the first half of the sixteenth century; the other, in the collection of Mrs Milton S. Fox, is the work of Yamada Dōan (died. c. 1573) bearing a quatrain written by a certain Tokei Dōjin. In translation, the lines run as follows:

> Big stomach, gaping garment,
> Treasures gathered deep in the bag's bottom,
> Passing through the sky is another road,
> Do not seek what his fingertip points out.[20]

This is probably meant to be taken as a warning not to seek the way to enlightenment in over-conscious and desperate fashion. But let us disobey the unidentified writer and try to guess what the secret and invisible something might be at which Hotei, in all such pictures, is pointing while he laughs in the knowledge of ascertainment. We may come to the conclusion that, over and above the other layers of meaning, the full moon could well be the answer here: it is moving across the firmament, it counts as a symbol of 'true emptiness without characteristics' (Chinese: *chen-k'ung wu-hsiang/zhenkong wuxiang*; Japanese: *shinkū-musō*), and it inevitably eludes representation in any form. Hotei's bulging sack in which

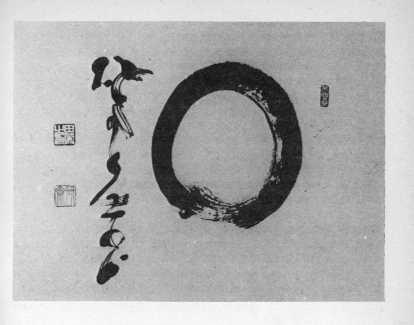

Circle (Japanese: enso*), by Yamada Kensai (1911-1974), Chūō Tōkenkai, Tōkyō*

'treasures' are deposited, according to the quatrain, can be taken as a tangible and visible counterpart to perfect emptiness and to the invisible and featureless moon, as the receptacle for the treasury-consciousness (*ālaya-vijñāna*); so that Kōboku in his version, and later Zenga artists, can underline the point by showing Hotei standing on the beggar's sack, that is to say, on the solid basis of this 'treasury-consciousness'. We may also recall that the Zen monk and painter Reisai used the following motto in his seal: 'To plant one's feet on solid ground.'

It is the great Indian patriarch Nāgārjuna himself (second or third century AD), no less, whom Mahāyāna Buddhism has to thank for his teaching of the 'Middle Way' with its central concept of *śūnyatā* (Chinese: *k'ung/kong*; Japanese: *kū*), the 'absolute void', who is said to have compared Buddhahood with the full moon, 'open expanse, empty and bright'. In a poem attributed to him we read:

> The body, appearing in the form of the round moon,
> Makes all of Buddha's Being manifest.
> Mark then: teaching is not something external,
> It is neither for the eye nor for the ear.[21]

From this starting point Zen seems to have developed, very early on, a method of teaching and learning based on the multi-layered symbolism connected with the circle: a heuristic and speculative approach, a sort of ludic conjecture. Nan-yüeh Huai-jang (Nanyue Huairang, died in 775) was the first *ch'an* master to draw circles in the air with his hand when he was teaching, the better to bring home to his pupils symbolically the nature of true enlightenment. This idea was further developed in the Wei-yang school into a complex dialectic of ninety-seven circular figures, comprehensible only to initiates. Medieval Zen artists seem to have devoted no more than sporadic attention to this sort of circle symbolism. It was not until the latter-day renaissance of Zen in Japan, and especially the representatives of the so-called Zenga, a movement in Zen Buddhist painting which gained momentum from the seventeenth century onwards, that the circle was once again taken up as a symbol of the perfected spirit, the plenitude and the emptiness of the all-embracing universe, and of the Buddha-being beyond time and space, which transcends all multiplicity and all contradictions;

though it must be said that much of the spiritual gravity and the artistic density of older Zen art is notably missing in Zenga. We find the Zen priest Isshi Monju of the Eigenji near Kyōto, who was born in 1608 and who died an untimely death in 1646, explaining such a circle as follows:

Only see! The true Buddha-being
neither withdraws itself from you, nor closes itself to you.
Open your eyes, fool![22]

The Nature of
Zen Buddhist Painting

Neither Zen Buddhism nor its art ever modified their profound antipathy to every form of stereotyped symbolism. Until the rise of Zenga there were only timid attempts to make some use of pure, abstract and inscrutable symbols.

> We might say that Zen seeks to transcend all traditional forms of symbolism, and reaches out to a new and higher order of symbolism; significantly, however, these higher-order symbols turn out to be most ordinary things, lifted as fancy prompts from the realm of everyday experience.[23]

The Zen mind is receptive and open to these symbols of transcendent order, to suggestive abbreviations and ciphers, to unconventional metaphors and allegories, as mediated via its basic view of nature and of things; and it is open to representation of redemptive figures, venerable patriarchs and masters, as long as such representation is on a person-to-person level, as direct portraiture or even as anecdotal report. What Zen painting seeks to accomplish is to facilitate direct penetration to consummate insight, to open the eyes to the essential nature of things, and to proclaim the great history, the unbroken and living lineage of the Zen school.

In contrast to classical Mahāyāna art, therefore, it consciously and deliberately eschews numinous personification and symbolic representation of the Absolute, and any attempt to make enlightenment effective *per artem*, however majestic the means. Instead, it has recourse to the ordinary things of the everyday world, the things that go to make up our everyday lives and experience: animals, flowers, fruits, stones and the all-embracing landscape. Here, the picture has quite another religious function, one that has a much more accessible relationship with the real world. Zen painting relinquishes both the authoritarian character of orthodox Buddhist religious art,

and its claim to provide objectivation of a numinous presence and a magic-religious substance. The Zen painting is subjectivised and becomes the evocative Other in a polarity with the beholder. It is then a witness to spiritual origins, a document of personal bonds and experiences, an encouraging pointer to the aim which is enlightenment, a proof of mastery gained, or a spur to private exercise and imitation. In comparison with works of the esoteric Buddhist school, and indeed with those of the more popular Amitābha type, Zen pictures make a decidedly tellurian impression; they are demythologised, and are often, in the light of what we have said, rather difficult to recognise as works of art bearing any religious connotation at all. They have 'open distance – nothing sacred'.

During the Muromachi period (1336-1568) the practice of combining a religious picture with two ostensibly secular paintings to form a triptych became popular in artistically minded Zen circles, among painters in the monasteries as well as among the curators and owners of the shōgunal Ashikaga collection. Older Chinese works were also combined in this newly fashionable way. For centre-piece choice usually fell on a major redemptive figure in Zen Buddhism, the historical Buddha Śākyamuni returning from the mountains (Japanese: *Shussan Shaka*) or the Bodhisattva Avalokiteśvara, robed in white and seated in a beautiful landscape (Japanese: *Byakue Kannon*); while the flanking scrolls showed landscapes or representations of a pair of tigers or dragons, flowers, birds or monkeys.

In the *Gyomotsu on-e mokuroku*, the inventory of Chinese paintings in the Ashikaga collection in Kyōto, compiled by Nōami (1397-1471) the artistic adviser and curator of the eighth Shōgun Yoshimasa (1435-1490), a whole series of such triptychs is detailed. The best-known examples still exant are: three hanging scrolls by the Chinese painter-monk Mu-ch'i

Plum branches in blossom, inscription by Hakuun Egyō (1223-1297). Rikkyoku-an, Tōfukuji, Kyōto. Side scrolls of a triptych facing a Shussan Shaka *representation in the centre*

*Śākyamuni Returning from the Mountains (*Shussan Shaka*) (detail); inscription by Hakuun Egyō, Rikkyoku-an. Centre-piece of a triptych, flanked by representations of plum branches in bloom*

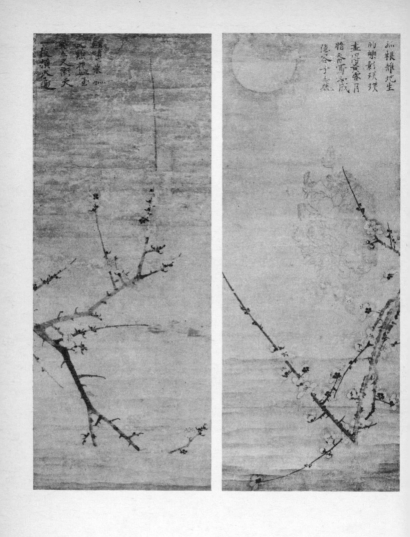

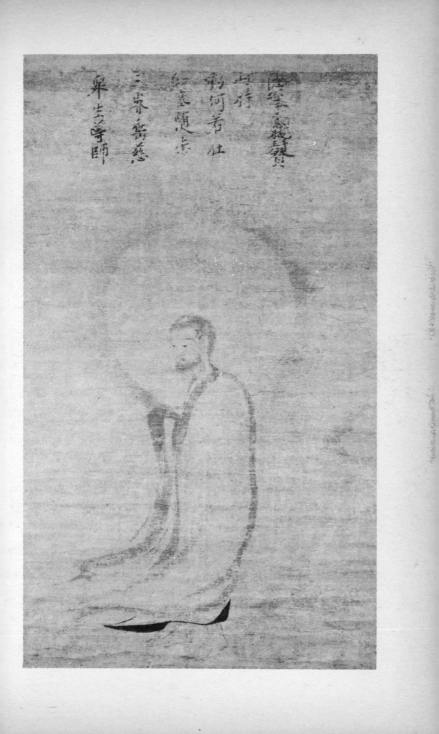

(Muqi, died between 1269 and 1274), now in the Daitokuji in Kyōto, showing the white-robed Bodhisattva Kuanyin, flanked on the one hand by a female ape with her offspring on one arm, and on the other by a stately crane; the *Shussan Shaka* picture by Liang K'ai (Liang Kai), flanked by two snow landscapes; a Japanese version of Śākyamuni returning from the mountains by an anonymous artist contemporary with the fourth abbot of the Tōfukuji, Hakuun Egyō (1223-1297), who wrote the inscription on the painting, and also on the flanking pictures of plum blossom; all three hanging scrolls belong to the Rikkyoku-an; the triptych traditionally ascribed to the obscure Muro-machi painter Isshi (active in the first quarter of the fifteenth century) with a central picture of *Byakue Kannon* floating over the waves in a lotus leaf, and two paintings of plum tree branches, one of them heaped with snow.

In China, triptychs depicting figures of the Buddhist pantheon had been a standard form of religious painting for centuries; and although we cannot point with any certainty to examples of the sort of thing we have been describing, it is not difficult to imagine thematic combinations of this kind catching on in the tolerant and mutually stimulating cultural atmosphere of the literati and the *ch'an* monks of the Sung (Song) period. But the secondary collocations which took place in Japan enable us to form some inferences as to how Zen Buddhist cognoscenti and believers understood such works in the fourteenth and fifteenth centuries. They saw their revered Buddhist redemptive figures closely connected and in inner harmony with nature, with landscape, animals and plants. In the Zen sense, all of these were manifestations of the Buddha-nature. Thus it was that, in his lines for a *Shussan Shaka* picture, now lost, the 53rd abbot of the Daitokuji, Tōyō Eichō (1428-1504) could write: 'The plum blossom flowers before the gates of the village, they too have completed their way.'

We find similar pictorial allusions in the *Shōbō-genzō*, 'The Eye and Treasury of the True Law', a fundamental Zen work in 95 volumes composed by Kigen Dōgen (1200-1253) during the last two decades of his life. Dōgen was the founder of the Sōtō school and one of the first authoritative masters in the whole field of Japanese Zen. The 59th volume of his monumental work is entitled *Baige*, 'Plum blossoms'. Here, the author

begins by expounding a parable about an old plum tree, a parable with which his much admired Chinese teacher Ch'ang-weng Ju-ching (Changweng Rujing, 1163-1228) once addressed his students. Dōgen now embarks on a detailed explanation of the significance of plum blossoms as a metaphor for the highest state of enlightenment of Śākyamuni (*mujō-shōgaku*):

> Once, my late master said to the monks: 'When Śākyamuni lost his ordinary sight and attained enlightened vision, one branch of a plum tree blossomed in the snow. But now small branches have appeared and the beautiful blossoms laugh at the spring wind blowing wildly.'

Later Dōgen goes on to say:

> A plum tree blooming in the snow is the manifestation of the udumbara flower [which Śākyamuni held up before Mahākāśyapa]. We have the opportunity to see the Eye and Treasury of the True Law of the Tathāgata in our everyday life. Yet most of the time we lose the chance to smile and show our understanding. However, my late master has transmitted the principle of a plum tree blooming in the snow and that clearly reveals the enlightenment of Buddha. The wisdom of enlightenment is the supreme wisdom, and if we study the plum blossoms more deeply we will undoubtedly realize this. A plum blossom is the observation that 'Above the heavens and throughout the earth I am the only honored one' – each thing is the most honored thing in the world. . . . Snow must cover the earth and the earth must be full of snow. No snow, no earth. When snow covers the earth it is the enlightened eye of venerable Śākyamuni. We should know that flowers and the earth transcend life and death. Since they transcend life and death the enlightened eye transcends life and death. This is called supreme Buddhist enlightenment. The right time to comprehend this is when one branch of a plum tree blooms in the snow. Flowers and the earth are the life beyond life. 'Covered with snow' means all over, back and front. The entire world is our mind, the mind of a flower.

Consequently, the entire world is a plum blossom, i.e., the eye of Śākyamuni Buddha.[24]

Also full of allusions of this nature is the anthology *Baika-mujinzō*, 'Inexhaustible Stock of Plum Blossoms', which contains poems and colophons on pictures recorded by the Zen priest Banri Shūkyū (died in 1502).

Zen masters liked to employ parables and metaphors to guide and instruct their students. One way of facilitating the process of 'seeing into one's own nature to attain Buddhahood' was by studying the popular 'Ten Oxherding Songs'. This usually illustrated parable explained, allegorically, the different possible degrees of understanding of the true nature of reality. The eighth stage in the gradual development of man's ability to grasp the essence of Zen truth is usually symbolised by an empty circle, an adequate emblem of the Absolute. This perfect form without beginning and end was used in Zen coteries of both China and Japan from early times to express the nature of enlightened consciousness. In the tenfold parable of the ox and its herdsman, however, it does not represent the final phase; it is followed in the ninth stage by a representation of plum blossoms combined with bamboo and rock. The metaphorical association with purity of spirit made the plum blossom a fitting subject-matter for poetry as well as ink painting, for Zen people and literati alike.

Symbolising as they did the purity of the refined and enlightened spirit, plum blossom, bamboo and rock became known as the 'Three Pure Ones' (Chinese: *san-ch'ing/sanqing*; Japanese: *sansei*). Already during the Sung (Song) and Yüan (Yuan) dynasties, we find plum blossom associated with bamboo and pine tree as one of the 'Three Friends of Winter' (*sui-han san-yu/suihan sanyou*). Writing in 1355 the Chinese scholar Hu Han remarked in this connection: 'The gentleman respects the pine tree for its chastity, the bamboo for its straightness, and the plum blossom for its purity.' Thus the image of a white sea of plum blossom came to be associated with the purity of unblemished snow, of winter-time, and, in the widest sense, of survival in the hardest season of the year. Śākyamuni had endured six long years in the ice and snow of the lonely mountains before he returned to the world to voice

his teaching. Thus the flanking pictures of plum blossom in the Rikkyoku-an triptych, and both of the winter landscapes by Liang K'ai fit in very well with the religious theme of the *Shussan Shaka*, however 'worldly' the pictures might seem at first glance. And let us not forget that in China such words as 'ice' and 'cold' were taken over as metaphors for 'tranquillity' for the Buddhist lexicon from late Taoist concepts. In his three poems on the Rikkyoku-an triptych the Zen master Hakuun Egyō reinforces the overt symbolic meaning that grew out of the union of the ascetic figure of the historical Buddha Śākyamuni and the blossoming plum branches: that spiritual and metaphysical significance pervades the splendours and the beauty of this world.

Aesthetic-artistic principles are happily wedded here to basic religious insights. Worldly and sacral themes achieve a symbiosis; indeed, in the last resort, the border line between the two is cancelled in Zen understanding. From the mid-fourteenth century onwards, Japanese artists working within the field of Zen Buddhism seem to have created a series of triptychs which were specifically designed to visualise the non-difference between the ordinary, everyday 'this-worldly', and the Absolute. One of the oldest works of this type still extant was painted by the Zen monk Ue Gukei, active between 1361 and 1375 in Kyōto and Kamakura. Gukei's *Byakue Kannon* picture is replete with unspoilt spontaneity and devout simplicity; two equally natural and spontaneous ink landscapes with fisherman and woodcutter form the wings. Copies of works from the Kanō school go to show that the 'Rainy Landscape' in the Tōkyō National Museum by the same master along with another landscape, now lost, formed the flanking pieces to a *Byakue Kannon* picture, no longer extant. Avalokiteśvara, embodiment of compassion and mercy, was perhaps the most frequently depicted Buddhist deity in Japanese Zen painting, demonstrating as subject of the central scroll of such triptychs one further important aspect of medieval Zen Buddhist art: the fusion of religious and seemingly worldly values, the unity of spiritual and natural themes.

About a hundred years later, around the middle of the fifteenth century, the Zen monk Chūan Shinkō living in the Seirai-an of the Kenchōji in Kamakura, painted three remarkable

hanging scrolls in ink on coarse silk, now belonging to the Sansō collection. They were most likely created as a single unit. The centre of the triptych is occupied by the most benign of all Bodhisattvas, the white-robed Kannon, sitting facing the viewer on a rock round which waves are breaking. The background consists of a highly decorative and yet astoundingly mysterious infinite sea of waves which recedes till it is lost in the far distance. It lends the figure of the Bodhisattva, sunk in contemplation, with two circular transparent halos round his head and body, a wonderful 'open distance' and otherworldliness, which is further intensified by the two compact and densely ordered landscapes in the outer scrolls, which block off the spectator's view. On the left painting we see the renowned T'ang poet Li Po (Li Bo, 701-762), sitting near a waterfall; while the left scroll shows the no less celebrated poet T'ao Yüan-ming (Tao Yuanming, 365-427) standing by a mountain stream. Both poets are turning respectfully, though not overcome by awe, towards the strangely unreal and yet closely encountered apparition of the Bodhisattva; they seem to be gazing at his face. Despite the differences in setting, the three paintings share the same decisive, conceptually powerful mode of composition and brushwork. Thus there is little doubt that from its inception this work was intended to be a triptych.

But what was in the mind of this gifted Zen painter-monk when he conceived the work? We can only guess at the meaning. Looking at the triptych without any pre-conceived ideas, we might well conclude that here *Byakue Kannon* is appearing as a kind of vision to the two great Chinese poets. During the T'ai-ho (Taihe) era (827-836), for example, the Bodhisattva appeared in a vision to the T'ang Emperor Wen-tsung (Wenzong) when the latter was eating a clam, and the *ch'an* priest Wei-cheng (Weizheng) from the T'ai-i-shan (Taiyishan) was summoned to explain the fantastic apparition. We may be sure that this and other episodes were handed down in the lettered and cultivated monastic communities of Japan, especially in the great Zen monasteries of Kamakura and Kyōto, and used there as subjects for pictures; and we must remember that Li Po and T'ao Yüan-ming enjoyed the deepest admiration and veneration in those same circles.

It looks as though in painting his triptych this medieval

monk and painter, Chūan Shinkō, was concerned to effect a historical rapprochement between the two cultural heroes of the past and the benign Bodhisattva Kannon, now, thanks to Zen, no longer ensconced in unapproachable aloofness. In the most literal sense, he places the Bodhisattva 'side by side' with historical personalities, probably to point up in tangible form the homogeneity between the sacred and the profane, between the here-and-how and the beyond, between Nirvāṇa and Saṁsāra. Of course, this is all speculation, but, in the absence of hints or suggestions from the master himself, we feel compelled, where triptychs of this sort are concerned, to interpret all three pictures as a unified work of art in the spirit of Zen.

In the light of this experience of the unity of the phenomenal and the absolute – an experience which is fundamental to Zen – it is not difficult to see why the religious content of a Zen picture can be encompassed and grasped via themes which in themselves are unmistakably worldly. The eye of the Zen Buddhist has been opened to the 'True Dharma', and it recognises every creation and every thing, however ordinary and 'profane', as identical with the Absolute, as a manifestation of Buddha-being, at once unique and yet encapsulating the whole universe. Since every thing *is* this final truth, there is no need to seek special 'symbolic' forms to represent it, as is the case in orthodox Buddhist art. A picture may show a landscape, an inconspicuous plant or fruit, a spray of plum blossom, a monkey or an ox and herdsman, a crane, a heron or a sparrow; but over and above the direct statement and the aesthetic content, such a picture reveals the 'whole truth' of Zen: a truth which is reduced in the *Hannya-shin-gyō*, 'The Heart Sūtra', to the brief formula: 'form is emptiness and the very emptiness does not differ from form, nor does form differ from emptiness.'

Like the Zen experience itself, the work of art which gives expression to that experience is, in the final analysis, indescribable and inexplicable. A Zen work of art *is*: it does not *mean*. It is true that alongside Zen pictures of such super-refinement, others exist which do admit of some interpretation – even if it is not all that easy to arrive at a convincing one. Sometimes, then, we must turn to what the artist or some congenial friend

of his has *written* about a Zen work of art, if we are to gain, not complete clarification, but at least a partial key to its iconographic content and the world-view expressed therein: a world-view distilled in sovereign freedom from original and personal experience.

A few examples may help to make this clear. When the Chinese *ch'an* master Ch'u-shih Fan-ch'i (Chushi Fanqi, 1297-1371) writes *sui-ch'ing yü-chien* (*suiqing yujian*) – 'If the water clears, fish appear' – on a picture of a heron painted by the Japanese Zen monk Mokuan Reien, who was working on the Chinese mainland early in the fourteenth century, this is not just a bald statement of fact; it is likely that this phrase has a specific Zen connotation. The bird sitting tense on a willow tree, ready to strike as its glittering prey comes into view, is presumably meant to represent the Zen disciple whose spirit, purified of the dross of worldly thoughts and feelings, has his gaze firmly fixed on his final goal – enlightenment. Muddy water becoming clear is probably a metaphor for the disappearance of delusion. The heron will seize the fish in the clearing waters with one instantaneous swoop, and the purified Zen mind will swoop on final clarity with the same velocity. The night heron (*go-isagi* in Japanese) was often chosen by Zen monks, and by painters associated with them in the Muromachi period, to play this paradigmatic role, and even if such paintings as Ryōzen's or Tanan Chiden's have no inscriptions to rely on they might be understood as simile for the Zen Buddhist's experience of sudden enlightenment.

The Zen quest for spiritual enlightenment is adequately expressed in a simple, unassuming composition of two stalky bare trees and a wagtail perched alert on a weathered rock. The concept of religious insight as revealed in all natural manifestations appears to have dictated the artist's immediacy in the spare, expressive rendering of his subject with a few dry, broadly rounded brushstrokes. The poem unobtrusively balanced in the upper right corner of the scroll was written by Taikyo Genju, a Zen monk of Kamakura, documented between 1320 and 1374. It seems to be an expression of the writer's own spiritual yearnings:

The withered tree has no leaves on its branches;

The wagtail picks about in infertile moss.
The interior of the stone contains one foot of jade.
When will one be able to open it?
Taikyo-sō.

Here, the comparison between the lively little bird searching for nourishment in spare surroundings and the Zen adept on the track of deep-hidden truth which is as precious as jade, is unmistakable. Taikyo Genju, who pursued his search for truth in Yüan China and probably absorbed there the current literati ideas of poetry, calligraphy and painting as related facets of a single personal artistic expression, as a fusion of words and images and a mergence of brush and ink and paper or silk, may also be responsible for the pictorial composition of the scroll in the Mary and Jackson Burke collection, New York. Another painting depicting a wagtail on a rock under sprays of bamboo is now owned by the Yale University Art Gallery, New Haven. In its simple, asymmetrical composition, its almost ascetic reduction of modest pictorial elements, and its dry, rough, immediate brushwork it is so closely related to the Burke scroll that one is inclined to attribute both paintings to the same hand.

Another seemingly playful representation of two wagtails, one perched on a grassy river bank peering intently in the water and another poised in the air with spread wings calling out to his mate below, turns out to be the visualisation of the same fundamental Zen idea, the quest for true enlightenment. This, at least, is suggested by the inscription placed between the two birds and balancing the tall marsh grass on the left. The poem in Chinese was written by a certain Genhan, probably a late sixteenth- or early seventeenth-century Zen priest associated with the Myōshinji in Kyōto; it may be translated:

What does the inquisitive wagtail see?
The other one is in flight,
And a light breeze stirs the sand.
In search of its original state,
It flew far south of the Ch'ing River.
There are not many that have travelled
Even as far as the Yellow River.[25]

The writer obviously relates the wagtail's 'search of its original state' to a Zen adept's search for the realisation of his own innate nature. He employs the bird's long journey to various rivers in China as a poetic metaphor for the infinite yearning for spiritual enlightenment.

The concept of religious insight as revealed in all natural manifestations appears also in the inscription of a portrait representing the 28th Tōfukuji abbot, Daidō Ichii (1292-1370). The charming little hanging scroll in the Nara National Museum has been convincingly attributed to Kichizan Minchō (1352-1431). It shows the Zen master sitting peacefully under a pine tree on a rocky plateau. Daidō is depicted in a relaxed posture and with a benign expression on his face.

> Everything about his appearance is carefully calculated to engender a sense of trust and intimacy and to make him seem approachable The stone steps leading up to the platform are flanked by two spirited creatures, a deer and a goose, who face the aged priest and seem about to ascend the steps. The Buddhist belief in the fundamental importance and unity of all sentient life – a tenet particularly revered in Zen – is expressed here with great artistic insight.[26]

The inscription above the picture was written by Shōkai Reiken (1315-1396) in 1394, some twenty-four years after Daidō's death. He followed the portrayed Zen master on the abbot's chair of the Tōfukuji in the 43rd generation, and therefore undoubtedly knew Daidō Ichii. The first part of the colophon has been translated as follows:

> A platform of large and small rocks with a 'Diamond Throne'
> Heaven and earth, composed alike of only one body
> The realms of causality and emotion transcended
> The enlightened deer and goose, unfaltering in their trust.[27]

Here, the experienced, octogenarian Zen priest Shōkai Reiken points straight to the fundamental article of Buddhist faith: that the Buddha-being informs all things in the world of experience right down to the most humble and inconspicuous, the stones

and the animals; and that they are not separate from, do not differ from the one and only Absolute – the void.

Zen Iconography:
Themes and Genres

Apart from this religious-metaphysical view of Being in general and the nature of things, in which reality as a datum is so transparent that the ultimate emptiness can be discerned, the creators of Zen Buddhist works of art often make use of concrete personalities and processes and relate the objective content of their painting to the Enlightened One himself, to his disciples, to the Way leading to, or the experience itself of Enlightenment. There were certain inevitable consequences of Zen ideology and Zen theory of art: on the one hand, a large number of orthodox Buddhist redeemer-figures were eliminated from the traditional Mahāyāna pantheon, and, on the other, figures borrowed earlier, such as the historical Buddha Śākyamuni or the Bodhisattva Avalokiteśvara, were reinterpreted in terms of a demythologised here-and-now and as exemplars in direct personal contact with the seeker after truth. On the artistic plane, this meant a transition from a remote and abstract spiritualisation and supernatural sanctity, compounded with a lavish display of cult symbols, to an empirical and tellurian vitality, presented in terms of an endearing simplicity. Along with the introduction of new motifs and new types of pictures, this gave Zen painting a quite specific iconography, sharply differentiated from that of traditional Buddhist painting: a key factor therein being the thematic and formal juxtaposition of apparent disparates – as we have already seen when discussing the assembly of typical Zen triptychs.

In the wake of innovation and the accompanying shift in accentuation, came a re-evaluation of themes. Classical Buddhist religious painting had been virtually dominated by the complex and stylised representation of figures; and while figures continue to provide the main content of Zen pictures, other themes now appear: above all, nature. In general, nature plays a major role in Zen painting. Where figures are not

shown standing or sitting in deep composure, free of all decorative adornment, before – or, better, *in* – empty space, they appear in intimate harmony with nature: never its masters, but knowingly and lovingly embedded in it.

> Nature is no longer mere background, side-show or symbolical adjunct, but an essential element of the picture, equally or, on occasion, even more deeply concerned in the exposition of the truth and of reality than the redeemer figure himself.[28]

We have already said something about the nature, the meaning and the content of some typical Zen pictures. In what follows, we shall present some of the more important themes in Zen painting, taking up, as we proceed, certain further questions of Zen iconography. We shall adhere to the schema normally followed by Zen masters when cataloguing inscriptions and colophons composed by them for inclusion in their 'Collected Sayings' (Chinese: *yü-lu/yulu;* Japanese: *goroku*); the reason being that here the sequence of themes is clearly ordered by iconographic values. As a typical example, and as one of the earliest known sources for such an ordering, let us take the list of pictures for which the *ch'an* master Fo-yen Ch'ing-yüan (Foyan Qingyuan, 1067-1120) wrote verses. It begins with 'Śākyamuni Returning from the Mountains'; then come Avalokiteśvara (in some other *yü-lu/yulu*, the Arhats and Pu-tai/Budai), the 'Three Saints of Mount T'ien-t'ai (Tiantai)', Han-shan (Hanshan), Shih-te (Shide), and Feng-kan (Fenggan), the 'Great Master Bodhidharma' and other historical *ch'an* patriarchs. These verses are listed under the collective title *Fo-tsu-tsan* (*Fozizan*): 'Inscriptions for (Pictures of) Buddhist Forefathers', or *Chen-tsan* (*Zhenzan*): 'True Inscriptions'; and they are usually followed by the so-called *Tzu-tsan* (*Zizan*; Japanese: *jisan*) – dedicatory inscriptions in the author's own hand on the portraits of Zen masters. In the final chapter of the 'Collected Sayings' we find, *inter alia*, *Chi-sung* (*Jisong*; Japanese: *geju*; Sanskrit: *gāthā*), 'Eulogies and Didactic Poems', a heterogeneous category including pictures with inscriptions and ostensibly secular themes: parable pictures such as the 'Ten Oxherding Series', representations of bamboo, orchids, plum blossom, pictures of monkeys and birds, and landscapes.

On the basis of Zen hagiographic literature, we can further subdivide the *Fo-tsu* (*Fozi*) group as follows: *Tsu-shih-t'u* (*Zishitu*; Japanese: *soshi-zu*) 'Pictures of the (historical *ch'an*) patriarchs; and, *San-sheng-t'u* (*Sanshengtu*; Japanese: *sansei-zu*) 'Pictures of free, or uncommitted saints'. It was precisely this last category that achieved great popularity in Zen painting. This popularity is probably not a result of the fact that some of its most prominent representatives were regarded as *avatāras*, *vestigium pedis* 'traces left behind' by cardinal Buddhas and Bodhisattvas: Feng-kan (Fenggan; Japanese: Bukan) as an incarnation of Amitābha, Pu-tai (Budai; Japanese: Hotei) of Maitreya, Han-shan (Hanshan; Japanese: Kanzan) of Mañjuśrī, and Shih-te (Shide; Japanese: Jittoku) of Samantabhadra, to mention only the most important. Rather, it is because these semi-legendary 'untrammelled saints' who could not be very easily fitted into the Zen system of teaching, by reason of their exuberant spiritual freedom, their unconventional life-style and behaviour and their eccentric utterances, were very readily accepted as exemplars by disciples of Zen.

THE HISTORICAL BUDDHA ŚĀKYAMUNI

The supreme exemplar for all Zen Buddhists, however, is and remains the historical Buddha, Śākyamuni. In the so-called *Tsung-p'ai-t'u* (*Zongpaitu*), the 'Genealogies of the (Zen) School', he is shown as the Tathāgata, surrounded by the radiance of enlightenment. He sits facing the viewer on a lotus, with a circular nimbus; in his right hand, he holds a flower, and he bears the marks of his spiritual fulfilment, the *ūrṇā* on his forehead and the *uṣṇīṣa* on his head. And yet, in a Zen picture such as this, he does not figure as a metaphysical and idealised world-ruler, withdrawn from all realisation in time and space; rather, he appears as the historical initiator, the primal figure in a long lineage of Zen-Buddhist patriarchs. The flower held

Śākyamuni Holding a Flower in his Hand (detail), by Kichizan Minchō (1352-1431), dated 1426. Rokuō-in, Tōfukuji, Kyōto. Centre-piece of a series of seven hanging scrolls with portraits of patriarchs (see illustration p. 90)

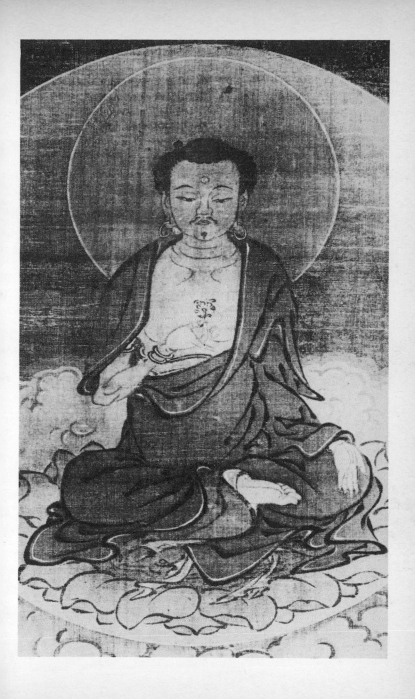

before his breast is an unmistakable reference to the original experience of Zen. Thus, in spite of the hieratic aura of the *en face* view, these representations of Śākyamuni have a narrative and illustrative component which marks them off quite specifically from the formal and stereotyped cult-picture.

A Chinese genealogy dating from the first half of the thirteenth century has been preserved in the Tōfukuji in Kyōto. It is possible that Enni Ben'en (Shōichi Kokushi, 1202-1280), the founder of this great Zen temple, was given the picture by his revered teacher Wu-chun Shih-fan (Wuzhun Shifan, 1177-1249) with whom he had studied for six years in China; for Wu-chun Shih-fan and his Japanese master-pupil conclude the succession of *ch'an* patriarchs, whose names are inter-connected to provide a continuous lineage leading back over the shadowy figures, known only by number, of the early Chinese and Indian forefathers to Śākyamuni himself. He alone appears *in effigie* as the source of the whole genealogical system and of Zen in general. He has been thus portrayed by the Japanese painter-monk Kichizan Minchō (1352-1431) in the centre-piece of his series of portraits comprising seven hanging scrolls, painted in the year 1426, and now in the Rokuō-in in Kyōto. For each of the thirty half-length portraits, the Zen abbot Genchū Shūgaku (1359-1428) wrote short biographical notes which run counter to the direction of gaze. On each scroll, five Zen masters are arrayed in three-quarter profile. The chain beginning with Śākyamuni ends with the Japanese abbots Musō Soseki (1275-1351) and Shun'oku Myōha (1311-1388).

Śākyamuni's role as founder of religion on earth is even more strongly accentuated in two other Zen themes – his ascetic practices in his search for enlightenment (Japanese: *Kugyō Shaka*) and his return from the mountains (Japanese: *Shussan Shaka*), after he had realised that the extreme asceticism and self-mortification he had practised for six long years in total solitude could lead him no nearer to the goal of enlightenment. The second of these themes, in particular – the return from the mountains – became one of the most popular and most frequently treated themes in Zen circles, precisely because it shows the historical Buddha in recognisably human guise. The question whether a *Shussan Shaka* picture confronts us with a Buddha reaching enlightenment as he faces the

shining morning star, or with an ascetic weakened by hunger and cold, is one that can only be answered in each individual case by a study of the inscription on the picture.[29]

Any Zen priest taking up the theme of Śākyamuni's return from the mountains, and setting about writing a quatrain for a painting depicting this theme, had always to come to terms anew with two factors: his understanding of Buddha's enlightenment, and his own progress along the difficult road of spiritual purification. In the last resort, any act of unilateral decision-taking is, from the Zen point of view, a retrograde step into the web of logical-discursive thinking. Zen Buddhism knows nothing of an 'Either-or' but only 'this as well'. This open-minded attitude to the *Shussan Shaka* theme, which is indeed formulated neutrally and undogmatically as 'Śākyamuni emerging from the mountains' instead of 'Return of the Enlightened One', is reflected in an extremely subtle poem written by the Chinese *ch'an* master I-shan I-ning (Yishan Yining, 1247-1317) for a painting of this theme now lost:

> To lead the Self from inside the door is easy.
> To go out through the door from the Inner of the Self is difficult.
> In the six years (Śākyamuni) broke nothing and joined nothing together.
> (Like) the Great Bear (he) turns his face towards the south.[30]

These lines are to be found in the 'Collected Sayings' of I-shan I-ning who devoted the last eighteen years of his life to spreading Zen in Japan, where he became one of the most influential teachers. He was revered as a markedly intellectual representative of the Chinese *ch'an* clergy. He was as securely at home in the field of Confucian philosophy as he was in the Chinese tradition of historiography and in various branches of literature. The Japanese have him to thank for the introduction of poetic forms, techniques and stylistic trends which were particularly highly valued during the Sung (Song) Dynasty, and finally he emerged as one of those responsible for founding that long-lived literary movement, known in the history of Japanese literature as *Gozan bungaku*, 'The Literature of the Five Mountains' (i.e. of the five great Zen monasteries).

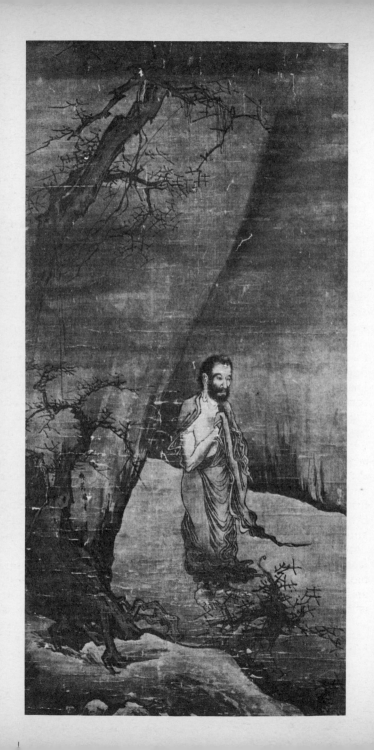

This episode – the return of Śākyamuni from the mountains – is not to be found in any of the older Mahāyāna canonical texts which give a detailed account of the historical Buddha's life and works. Accordingly it is not to be found in the classical Buddhist art of the T'ang and pre-T'ang periods: neither in the biographical narrative pictures in the cave-temples nor the wall-paintings which once adorned the great Chinese monasteries (these alas irrevocably destroyed in the orgies of destruction connected with the Buddhist persecution of 844/45) nor in the traditional picture-sequences showing the 'Eight Events' in the life of the Buddha (Chinese: *Shih-chia pa-hsiang/Shijia baxiang*; Japanese: *Shaka hassō*). This suggests that the theme of the Buddha's return from the mountains first arose in the *ch'an* circles active in the revitalisation of Buddhism in the post-T'ang period, and was developed by artists associated with these circles in the tenth century into a most impressive and, as the sequel was to show, a most effective piece of imagery.

The accepted and undeniable masterwork – and, at the same time, one of the oldest extant versions of the *Shussan Shaka* theme dating from the first half of the thirteenth century – was done by the renowned court painter Liang K'ai (Liang Kai). Dietrich Seckel has called it 'in spiritual content and artistic form, one of the most significant pictures of the *homo religiosus* in the whole history of art'.[31] The picture shows the historical Buddha pausing hesitantly at the mouth of a ravine with steep rocky walls, as he makes his way back into the world from the solitude of the mountains. The frail figure of the ascetic, tested in suffering, is imbued with inner composure and deep seriousness. He stands barefoot on the snowy path; his hands are concealed in his garment, and held before his bare breast. His head is bent slightly forwards. The mouth is broad and firmly closed, the eyes are narrow and drawn upwards, with long eyebrows, the nose is noticeably lengthened – features which identify Śākyamuni as an Indian. His unkempt hair and beard testify to his years of seclusion in the mountains, and the thin bracelet on his right upper arm reminds us that he is the scion of a princely house. On his head there is a

*Śākyamuni Returning from the Mountains (*Shussan Shaka*), by Liang K'ai (first half of the thirteenth century). Hinohara collection, Tōkyō*

suggestion of the excrescence known as the *uṣṇīṣa*, and the ears
are exaggeratedly large – these features being two of the most
important bodily characteristics of the Buddha.

But Liang K'ai (Liang Kai), in common with most other
Chinese painters and in contrast with the practice of their
Japanese colleagues, has not painted a nimbus round the head
of the Buddha. Śākyamuni's gaze does not seem to be fixed on
any external object in particular: in profound and withdrawn
composure he seems to be concentrating on his own inner Self.
From the mountains behind him there blows a gentle breeze
which forms ruffled folds round the hem of his garment and
makes corners of it flap out in front; it is as though a divine
afflatus were lending the momentarily hesitant redeemer-figure
encouragement and stimulus as he prepares to take the difficult
step back into the world. The only colour in the picture which
is otherwise done in ink on silk is the warm muted red of the
garment, echoed in the lips and in the arm-bracelet. The three-
quarters profile presentation of the figure, the fluttering
garment and the path which comes from an indefinite
background and tends slightly downwards, give the complex
and densely ordered composition a clear orientation towards
the right. And yet the figure of the Buddha forms the quiescent
centre and focus of concentration between the lines of the
composition which cross each other diagonally; not least
because it provides the only perpendicular assertion in the
picture. Parallel to the silhouette of the foreground cliff
debouching in the lower right-hand corner, runs the rear
demarcation of the snowy path which hugs the abrupt upward
thrust of the strangely incomprehensible massif. This is cut
across by a rocky wall almost as high as the picture; the wall
leans to the right and forms an exact diagonal to the picture.
The cliff, like the upper part of the bare, ghostly-skeletal tree,
stands at right angles to the other two main components in the
picture – the foreground rock and the path. Only the bizarre
shape of the thick, dried-up old tree trunk with its clutching
roots, pushes beyond the left-hand margin of the picture and
breaks up this subtly conceived asymmetric pattern of opposing
parallels at right angles to each other.

Along with the masterly graduation of the several compon-

ents, it is the clear differentiation in their formal handling that helps to suggest a spatial depth of unfathomable dimensions. Moist washes, applied flatly and fading into a soft uniform grey, bathe the ravine, especially the upper part, in a vague nebulous haze. Against this, the leafless branches and twigs in the immediate foreground stand out in sharp contrast. Short strokes done with a sharp brush and jet-black ink combine T-shapes and crosses, and are not devoid of a certain abstract quality related to calligraphy. The precise articulation of the formal language proceeds thus from foreground to background, leading from linear graphic values to plane painted surfaces which then dissolve in an empty backdrop.

Soon after it was painted, at the latest in the fourteenth century, Liang K'ai's (Liang Kai's) picture must have found its way to Japan, presumably taken there by one or another of the numerous Chinese or Japanese pilgrim monks, as it can be fairly positively identified with a *Shussan Shaka* scroll mentioned in association with two landscapes in the catalogue of the shogunal Ashikaga collection. Today, the work is in the Hinohara collection in Tōkyō. The picture evoked an enormous response in Japan, and had a rich progeny. The *Shussan Shaka* version produced by the Zen monk and painter Ue Gukei, certainly active between 1361 and 1375, could hardly have been painted in ignorance of the great Sung (Song) masterpiece which must have been the object of devout admiration in initiated circles.

Over against the tradition set by Liang K'ai (Liang Kai), which offered a literal interpretation of Sākyamuni's return from the mountains, and placed the Buddha figure in a more or less detailed landscape, painters working in monochrome ink techniques concentrated on portrayal of the figure itself. Either they discarded the landscape altogether or restricted themselves to the abbreviated suggestion of a few key elements. In works belonging to this type we find a consciously unpretentious and spontaneous linear treatment of figures, well suited to ink painting, which is in sharp contrast to the academic polish, the conservatism, even the archaistic line-techniques displayed in works of the other school. The oldest Chinese *Shussan Shaka* picture in monochrome ink so far identified was acquired by

the Cleveland Museum of Art in 1970. It bears an inscription, dated 1244, in the hand of the important *ch'an* master Ch'ih-chüeh Tao-ch'ung (Chijue Daochong, 1170-1251), which, in translation, runs somewhat as follows:

> Since entering the mountain, too dried out and emaciated,
> Frosty cold over the snow,
> After having a twinkling of revelation with impassioned
> eyes
> Why then do you want to come back to the world?

The second day of the eighth month in the *chia-ch'en* (*jiachen*) year of the Ch'un-yu (Chunyu) reign [1244], eulogized by Tao-ch'ung (Daochong), resident of T'ai-po (Taibo) mountain.[32]

In the simplicity of its overall conception the painting resembles the oldest Japanese version extant of the *Shussan Shaka*. This picture, which is in the Seattle Art Museum, is presumed to have been painted at the beginning of the thirteenth century, in the Kōzanji at Kyōto, on the basis of a Sung (Song) work. The drawing has been done with jet-black ink and a relatively dry brush in very cursory and extempore fashion, and it bears two seals of the well-known Kegon monastery, which became, under the leadership of the great reformer, Myōe Shōnin (1173-1232), one of the most influential centres of religious and artistic creativity in medieval Japan. Here it was that imported Chinese religious pictures, Buddhist paintings, book illustrations, iconographic sketches and stone rubbings were copied in great numbers, leading to the extension and enhancement of Buddhist iconography throughout Japan; and it is clear that this process was not primarily determined by the purely religious significance of the works of art. Myōe Shōnin of the Kōzanji was a tolerant, cultured abbot, a man of many interests. He was friendly with Myōan Eisai (1141-1215), who had studied in China, the man who brought the teachings of the Rinzai school to Japan, and the founder of the first Japanese Zen monastery, and therefore well acquainted with the ideology and the practices of Zen Buddhism. So it comes as no surprise that a series of typically Zen Buddhist pictures appeared in the Kegon monastery, including the ink drawing of

the *Shussan Shaka* now in Seattle, and several related representations of the Bodhisattva Avalokiteśvara, to which we now turn our attention.

THE BODHISATTVAS

In the world of Zen, Avalokiteśvara is without a doubt the most popular of all the Bodhisattvas. Like Śākyamuni, however, in Zen art, the 'Lord who looks down (on the sufferings of the world)' as he is known (Chinese: Kuan[shih]yin/ Guan[shi]yin; Japanese: Kannon [or Kanzeon], does not confront us in the elaborate trappings of sacral splendour and supernatural majesty. Rather, he meets the seeker after enlightenment as a simple helpmate, gracious and accessible, his feet firmly planted in earthly reality: for the Chinese, indeed, on their native soil, as they very early on imagined the residence of the Bodhisattva, the Mount Potalaka mentioned in the *Avataṁsaka-sūtra* (Chinese: *Hua-yen-ching/Huayanjing*; Japanese: *Kegon-kyō*), to be on a small island off-shore from Ning-p'o (Ningpo) in the modern province of Chekiang (Zhejiang); Potalaka was transformed into P'u-t'o-lo-chia (Putolojia; Japanese: Fudaraka).

In the Zen Buddhist context, then, a favourite setting for Kuanyin (Guanyin) is a rock round which the waves break, and on which he sits in a relaxed and contemplative pose; sometimes it is a cave, a bamboo grove or a waterfall, less frequently he is shown sitting on a lotus leaf which floats on the waters. Zen painting does not totally discard the *en face* presentation which orthodox religious painting preferred for redeemer-figures on such an exalted level; but the Bodhisattva is preferably shown in a decidedly informal three-quarters profile attitude, often leaning, casually one might say, against a rock, or even cooling his feet in the rushing waters of a mountain stream – as in one of the hanging scrolls of the Muromachi period (fifteenth century), now in the Kenchōji in Kamakura, showing the thirty-three magnificent manifestations of Kannon. It was precisely such extensive illustrative cycles which, *pari passu* with the development of the Potalaka concept

in illustrative and narrative terms, offered an opportunity
for unorthodox iconographic innovation and fantastic details
of embellishment. In these Kannon pictures, nature becomes an
essential component: a component which is mystically trans-
figured by the radiant presence of the Bodhisattva, and due not
least to the transparent circular nimbus which is often shown
round his head. Tradition has it that as early as the ninth
century, the T'ang (Tang) painter Chou Fang (Zhou Fang,
active between 780 and 810) represented Kuanyin (Guanyin) in
a landscape setting.

In Zen art, Avalokiteśvara is most frequently shown in the
Pāṇḍaravāsinī form, wearing a simple white robe. In China,
this form is known as *Pai-i Kuanyin* (*Baiyi Guanyin*), in Japan
as *Byakue Kannon*. It is not clear when this form first made its
appearance. According to Chapters 2 and 3 of the *Hsüan-ho
hua-p'u* (*Xuanhe huapu*), the 'Catalogue of the Imperial
Collection of Paintings of the Hsüan-ho (Xuanhe era, 1119-
1125)', whose foreword is dated 1120, there were in the
possession of the artistically erudite Sung (Song) Emperor Hui-
tsung (Huizong, 1082-1135), himself a gifted painter, three
early representations of the white-robed Bodhisattva: two of
these dating from the first half of the tenth century by Tu Tzu-
huai (Du Zihuai) and Ts'ao Chung-yüan (Cao Zhongyuan),
and the third by the eighth-century Hsin Ch'eng (Xin Cheng),
of whose origins nothing is known. He is said to have settled in
the cultivated and developed region of Shu in south-west China
(modern Ssu-ch'uan/Sichuan) where he made a name for
himself as a specialist in Buddhist figure themes. In his
catalogue of famous painters in Ssu-ch'uan (Sichuan), the *I-
chou ming-hua lu* (*Yizhou minghualu*, chapter 1), which was
probably completed in 1106, Huang Hsiu-fu (Huang Xiufu)
tells us that in the year 780 Hsin Ch'eng (Xin Cheng) was
commissioned to carry out wall paintings for the Ta-sheng-tz'u-
ssu (Dashengcisi), one of the great Buddhist temples in Ch'eng-
tu (Chengdu). Again, the influential Sung (Song) scholar-painter
Li Kung-lin (Li Gonglin, *c.* 1049-1106) was evidently much
preoccupied with the theme of the white-robed Kuanyin

*Kuanyin in a White Robe (*Pai-i Kuanyin*); Yüan period (late thirteenth
century). Engakuji, Kamakura*

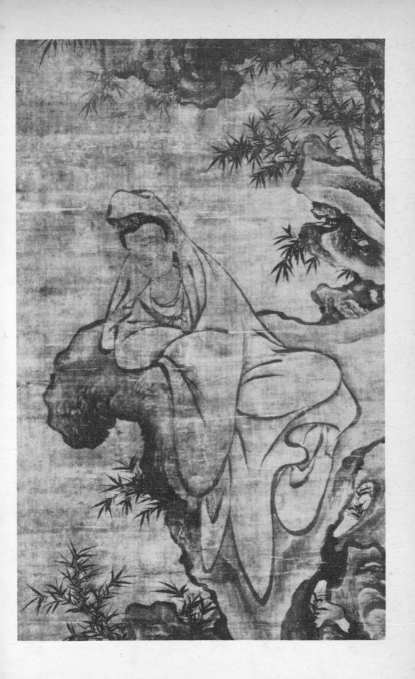

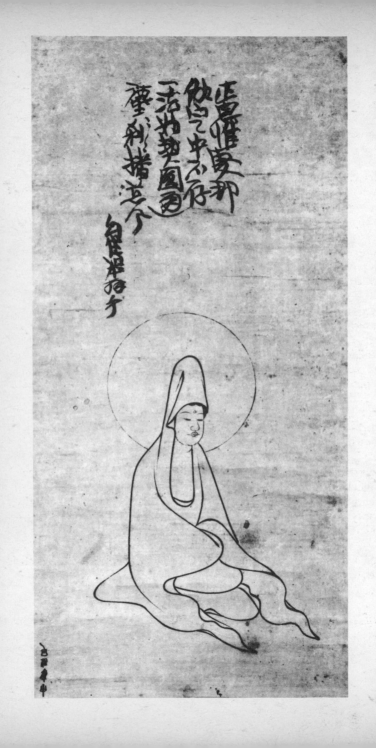

(Guanyin), although no original work from his hand has survived. One of his representations is known to us from a stone engraving dated 1132.

During the second half of the twelfth century, even conservative circles of Buddhist figure-painters seem to have been very well acquainted with the Pai-i Kuanyin (Baiyi Guanyin) theme, preferably treated in monochrome ink. Between 1178 and 1188 a series of paintings of the '500 Arhats' comprising originally 100 hanging scrolls, was carried out by the painters Chou Chi-ch'ang (Zhou Jichang) and Lin T'ing-kuei (Lin Tingguei) – of whom nothing further is known – for the Hui-an-yüan (Huianyuan) monastery, situated to the south-east of Ning-p'o (Ningpo). One of these paintings shows five Arhats admiring an ink-drawing of Kuanyin (Guanyin) robed in white. The Bodhisattva sits on a rocky plateau close to an overhanging cliff, behind which a waterfall plunges into the abyss. He is leaning sideways on a rock in a relaxed position, supporting his chin with his right hand. In the riot of colour surrounding it, this black-and-white drawing has the effect of an exotic 'foreign body': which is exactly the effect it seems to be having on the Arhats who are viewing this no doubt typically *ch'an* work with some astonishment and amusement.

The earliest independent Byakue Kannon pictures which are still extant date from the thirteenth century. For the most important example among them we are indebted to the *ch'an* monk Mu-ch'i (Muqi). It is signed by the painter in the bottom left-hand corner and bears his seal. This Kuanyin (Guanyin) picture is the centre-piece of the triptych which we mentioned earlier, whose flanking scrolls show a crane and an ape with her young. Collector seals on all three pictures show that the triptych was once in the possession of Ashikaga Yoshimitsu (1358-1408); that is to say, it must have been taken to Japan at a relatively early date. In the sixteenth century, Taigen Sūfu (died in 1555), the 25th abbot of the Myōshinji, acquired the picture and presented it to the Daitokuji in Kyōto, where it has been reverently preserved up to the present day.

Kuanyin in a White Robe (Pai-i Kuanyin), by Chüeh-chi Yung-chung (early fourteenth century); inscription by Chung-feng Ming-pen (1263-1323). Cleveland Museum of Art

Apart from Avalokiteśvara, two other Bodhisattvas were accepted into the iconographic repertory of Zen painting, but they never achieved anything like the same popularity. These are Mañjuśrī (Chinese: Wen-shu/Wenshu; Japanese: Monju) and Samantabhadra (Chinese: P'u-hsien/Puxian; Japanese: Fugen), who figure already in older iconography as attendants of Śākyamuni. They incorporate two aspects of the historical Buddha: on the one hand his insight and wisdom, and on the other hand his redemptive power, his energy and his dynamism. In their Zen Buddhist representation, they too appear in earthly, human simplicity, sometimes with fresh young faces and straggly hair hanging down; they wear simple monastic garments, without any trace of lavish adornment.

Their dignity, power and wisdom entitle them to specific mounts – a lion for Monju and a white elephant for Fugen. But these creatures do not fare proudly through the clouds with lotus blossoms under their feet, nor are they bedecked with lavish trappings, saddles or canopies as in traditional sacral art. As a rule they are shown lying comfortably on the ground, and not infrequently we can detect a mischievous smile on the face of the elephant. The elephant also lacks the six tusks which symbolise in orthodox art the 'Six Supernatural Insights or Perfections' (*pāramitās*) of the Bodhisattva, or the conquest of the six sources of temptation. Monju and Fugen, reclining, relaxed and in contemplative repose, on their allotted creatures, are usually shown in three-quarter profile against an empty background.

Among the oldest Japanese works of this Zen Buddhist type are two ink paintings on silk, from the Yōmei-in in the Tōfukuji. The inscriptions for these scrolls were done by Zōsan Junkū (1233-1308), the sixth abbot of this great Zen monastery, a year before his death. An exceptional case is provided by a representation of Fugen in the Freer Gallery of Art, Washington, DC, by Takuma Eiga (active in the late fourteenth century) who has placed a Bodhisattva, often erroneously identified as Monju, in a landscape setting.

THE ARHATS

The strict ascetic discipline of the Arhats (Chinese: Lohan; Japanese: Rakan), and their determination to reach enlightenment through their own dynamism (Chinese: *tzu-li/zili*; Japanese: *jiriki*) ensured that these Buddha-disciples, whose antecedents go back to the oldest stratum of Buddhist iconography, should be seen as embodying the very essence of Zen Buddhist monastic virtue. The 'venerable ones' who have raised themselves above the earthly circle of *saṁsāra*, usually figure in specific formations, most frequently in groups of sixteen. They are distinguished one from another by specific attributes, ranging from superhuman deeds and miracles to individual characteristics and gestures; and they are always presented as rugged old men, sometimes endowed with a strange spiritual potency.

Their iconography was not rigidly canonised, and this gave artists plenty of scope for creative variation and individuality. And yet, in the course of the thirteenth and fourteenth centuries, the arhat-cycles which were produced in Zen Buddhism, less for private spiritual exercise than as works designed for public ritual, seem to have petrified into stereotyped series with very largely similar component designs; a process in which the Japanese medieval painters seem to have benefited not a little from their Chinese models. Two main streams of Arhat representation go back, on the one hand to the poet, painter and calligrapher Kuan-hsiu (Guanxiu, 832-912), who was active in the last years of the T'ang (Tang) dynasty, and, on the other, to the Sung (Song) master Li Kung-lin (Li Gonglin, c. 1049-1106).

Kuan-hsiu (Guanxiu) is one of the first *ch'an* artists whose work and life we can discern in more or less clear contours; but alas the Lohan figures he created − under the influence of dream visions, it is said − are known to us only through copies or stone rubbings. He was an eccentric figure, closely bound up with Taoism, and he had the power to fix moments of religious ecstasy in the distorted faces of his Arhats, and to confront us with convincing examples of deepest belief, will power and inflexible earnestness in the struggle for spiritual liberation. But

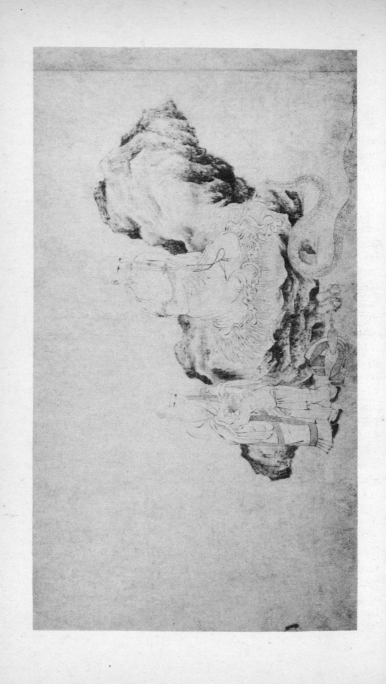

the earliest series of sixteen Arhat configurations may date in fact from an even earlier time. The authors of the *Hsüan-ho hua-p'u* (*Xuanhe huapu*, chapter 10), writing in the early twelfth century, mention two such Lohan cycles, one on four, the other on eight scrolls, to be found in the imperial collection among the works of the celebrated T'ang (Tang) poet and painter Wang Wei (699-759). In his early years Wang Wei had been a court official, and after the death of his wife in 730, he turned to deep belief in Buddhism. He created wall paintings for several Buddhist monasteries in and around Ch'ang-an (Changan), and very significantly chose as his literary name the characters *Mo-chieh* (*Mojie*), by analogy with the Chinese form of the name Vimalakīrti – *Wei-mo-chieh* (*Weimojie*) – the half-legendary Indian sage who had reached the deepest insight as a lay disciple.

The learned court official, poet and painter, Li Kung-lin (Li Gonglin) had established close bonds of friendship with the leading lights in the Buddhist clergy of his time and locality. He was known for his rich inventiveness, his unorthodox ideas and iconographic innovations, which led to many a figure of the traditional Buddhist pantheon being seen in an entirely new light. He it was who brought the so-called *pai-miao* (*baimiao*) technique – a method of painting in lines without colours, known since the eighth century – to highest perfection. A painter-monk named Fan-lung (Fanlong) who was working in his following during the twelfth century, is accredited with an excellent handscroll, now in the Freer Gallery of Art in Washington, DC. It shows sixteen Lohan with their disciples and worshippers, in an extraordinarily subtle line technique which may rank as the best example we have of Li Kung-lin's (Li Gonglin's) *pai-miao* (*baimiao*) style. Certainly it is not by chance that two colophons at the end of the scroll are by distinguished *ch'an* priests: Yüan-sou Hsing-tuan (Yuansou Xingduan, 1254-1341), the 48th abbot of the Ching-shan (Jingshan), and the great abbot Chung-feng Ming-pen (Zhong-feng Mingben, 1263-1323), who, after he has described and praised the work, remarks: 'Lao-pien T'i-t'ien (Laobian Tidian)

Detail from a handscroll showing Sixteen Arhats, attributed to Fan-lung (twelfth century). Freer Gallery of Art, Washington DC

stores this painting in his sack. One day after meditation he brought this out to show it to me and asked me to inscribe after the painting. Respectfully written by Ming-pen (Mingben), the old priest who resides at the Hsi-t'ien-mu-shan (Xitianmu-shan).'[33] There can be no doubt that representations of Arhats in the tradition of Li Kung-lin (Li Gonglin) were very popular in *ch'an* circles and were very warmly received, especially during the fourteenth century.

Both in China and in Japan, painters liked to place their Arhat figures in fantastic landscapes: desolate caves in the rocks, charming gardens, or at least in front of a screen with a landscape painting. Often, Buddha-disciples who have attained to inner liberation are shown accompanied by a servant, or by an animal symbolising their magical powers. Often again they are accompanied by quite ordinary creatures. Thus, in several related representations of the 16th Arhat, Cūdapanthaka, we find him seated meditating in a cave, surrounded by a flock of cheeky sparrows. They seem to feel secure and happy in the presence of the holy man, who is not in the least put out by the fact that no less than a dozen of them are hopping about on his lap and hiding in his garments.

In contrast to this intimate, not to say loving relationship between creatures of a lower order and the world-transcending Buddha-disciple, the *ch'an* painter-monk Mu-ch'i (Muqi) throws another and more dramatic light on the relationship in a superb monochrome painting which is clearly independent, not forming part of a series; the picture is now in the Seikadō Foundation in Tōkyō. Mu-ch'i (Muqi) shows us a Lohan in a mist-covered mountain cave, his ugly face marked by the strain of world-rejecting asceticism. A huge snake is approaching him, with open jaws and aggressive mien. It has already laid its head over his left shoulder and is staring upwards at him as though challenging him. But the Arhat, the protector of Buddha-teaching appointed by Śākyamuni himself, is so deeply sunk in meditation that he takes no notice: effortlessly overcoming the dangers germane to his natural environment through the power of his enlightenment which can hold in thrall all the forces of the cosmos.

PU-TAI (BUDAI)

If the Arhats represent the serious, disciplined and ascetic aspect of the spirit of Zen, in figures like Pu-tai (Budai), Han-shan (Hanshan) and Shih-te (Shide) or Feng-kan (Fenggan) we come across a new religious dimension, one marked by cheerfulness, *joie de vivre*, unconventionality and humour. Over the years, so many legends and anecdotes have collected around Pu-tai (Japanese: Hotei) that it is no longer possible to disentangle the true historical facts of his life. It is clear that he was an itinerant Chinese mendicant monk named Ch'i-tz'u (Qici), who hailed from Ssu-ming (Siming, i.e. Ning-p'o) and who died in 916 (or 905) in the Yüeh-lin-ssu (Yuelinsi), a *ch'an* monastery in which he had, exceptionally, spent three years. All sources describe him as an unfailingly good-humoured character, fond of practical jokes, with a pot belly and an equally large sack in which he collected his alms and into which he also put stones and wood. His popular nickname, Pu-tai (Budai), means 'hemp-sack', but is certainly a euphemism for his ample belly. On his way from place to place he is said to have kept on murmuring things which no one could understand; he also played with children, laughed a lot and danced.

This enigmatic figure, regarded by posterity as an incarnation of the future Buddha, Maitreya, was seized upon by Zen painters as a protagonist of the free-and-easy life-style typical of Zen, careless of needs and indifferent to authority. We see him laughing as he points at the moon or into empty space, patting his belly which his garment is never able to cover, yawning luxuriously and stretching himself sleepily; sometimes he rests pensively on his beggar's sack, playfully tries to draw the 'pillow' from under the head of a child who has fallen asleep on his sack, or watches a cock-fight. Then again, an eye may suddenly appear on his back, and his follower Chiang Tsung-pa (Jiang Zongba) scours the spot; or he is shown happily marching through the countryside with his sack slung over his shoulder on the end of his pilgrim's staff. In Japanese popular belief Hotei ranks among the popular 'Seven Gods of Good Fortune' and is regarded as the patron saint of children.

It was not long after his death, so we are told in a late tenth-

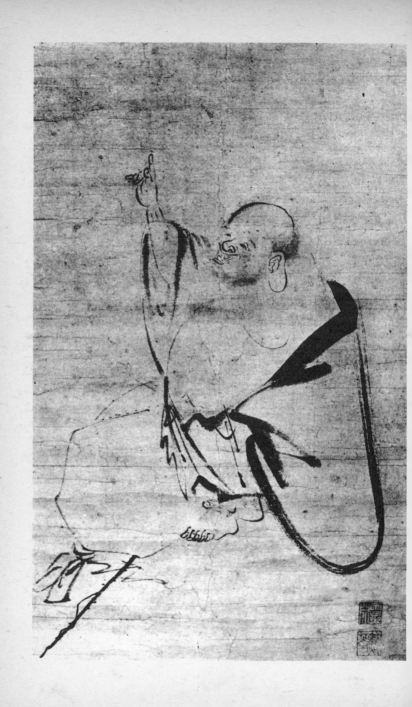

century source, that pictures of the eccentric *ch'an* mendicant began to be painted in the coastal regions of East China, in the present-day province of Chekiang (Zhejiang). The *Butsunichi-an kōmotsu mokuroku*, an inventory of Chinese art treasures, especially paintings and specimens of calligraphy, which was prepared in 1363 in the Butsunichi-an, a small subtemple of the Engakuji in Kamakura on the basis of an earlier work (1320) and amplified in 1365, mentions an imported Pu-tai (Butai) picture, which must have been painted in 1163 at the latest, as it bears an inscription by the eminent *ch'an* master Ta-hui Tsung-kao (Dahui Zonggao) who died in that year. This picture may perhaps be identical with one of the two pictures whose inscriptions are recorded in the *yü-lu* (*yulu*, chapter 20), the 'Recorded Sayings' of the priest.

Again, in a relatively early source – the 'Collected Works' of the *ch'an* master Mi-an Han-chieh (Mian Hanjie, 1107-1186) – we find a reference to a Pu-tai (Budai) representation in the twelfth century; and the *Ju-ching Ho-shang yü-lu* (*Rujing Heshang yulu*, chapter 2) mentions a poem which Dōgen's teacher Ch'ang-weng Ju-ching (Changweng Rujing, 1163-1228) composed for a picture entitled 'Pu-tai (Budai) listens to the wind in the pines'. The theme is reminiscent of a short handscroll in the Senoku Hakkokan (Sumitomo collection) in Kyōto, which shows the fat bald-headed mendicant in a forest clearing between big pines whose tops are partially shrouded in mist. This interesting and under-estimated picture, painted in ink on silk, has been wrongly attributed to Ma K'uei (Ma Kui), the brother of the court painter Ma Yüan (Ma Yuan), who was active in the imperial academy round about 1200; and it is one of the few Zen Buddhist figure paintings in the handscroll format. The transverse scroll had established itself in East Asian painting as the best medium for narrative themes with illustrations, and, thanks to the decorative pseudo-biographical tales and the fantastic episodes which proliferated round these half-historical or legendary figures, had gained a foothold in Zen painting too.

Hotei (detail) by Mokuan Reien (died 1345). MOA Museum of Art, Atami

Sung (Song) and Yüan (Yuan) paintings of the *san-sheng* category, most of them hanging scrolls, reached Japan in great numbers very early on. In the *Gyomotsu on-e mokuroku* (fifteenth century) no fewer than nine Pu-tai (Budai) representations are catalogued as belonging to the collection of the Ashikaga Shōguns. These include a work by Ma Yüan (Ma Yuan) bearing an inscription (added at a later date) by the *ch'an* monk Tsung-lo Chi-t'an (Zonglo Jitan, 1318-1391), and an unusual half-figure portrait, for which the *ch'an* priest Chien-weng Chü-ching (Jianweng Jujing), who was active towards the end of the Southern Sung (Song) dynasty, is said to have written the inscription. What is probably the oldest independent Japanese representation of Hotei dates from the end of the thirteenth century. It bears an inscription dated in accordance with 1290 by the Zen prelate Nampo Jōmyō (1235-1308) who had studied in China. The artist is anonymous and the picture is unfortunately not in the best of condition; but in this picture of Hotei, laughing happily as he rests in indolent comfort on his well-stuffed sack, the Shinju-an of the Daitokuji in Kyōto possesses one of the earliest Japanese Zen paintings in monochrome ink technique.

THE THREE SAGES OF T'IEN-T'AI-SHAN (TIANTAISHAN)

The celebrated Zen hagiography published by Tao-yüan (Daoyuan) in 1004 – the *Ching-te ch'uan-teng lu* (*Jingde chuandenglu*), i.e. the 'Records [made during] the Ching-te (Jingde era, 1004-1007) on the Transmission of the Lamp' – gives biographies of a total of 1701 Indian and Chinese *ch'an* masters, going back to the 'Seven Buddhas of the Past'; and among these we find Feng-kan (Fenggan; Japanese: Bukan), Han-shan (Hanshan; Japanese: Kanzan) and Shih-te (Shide; Japanese: Jittoku) who, as we read, are said to have reached the 'gate of Zen' though they were not particularly well known (chapter 27). In fact, we are concerned here with three legendary figures who have been granted a somewhat doubtful historical authenticity on the basis of the foreword to a T'ang (Tang) collection of poems. Under the title *Han-shan shih*

(*Hanshanshi*), the anthology contains 300 'Poems of the Cold Mountain'.

The author of the foreword is taken to be Lü-ch'iu Yin (Lüqiu Yin), a prefect who lived in the neighbourhood of T'ai-chou (Taizhou) towards the end of the eighth and the beginning of the ninth century. Most of the poems in his collection he ascribes to Han-shan, a few to Shih-te (Shide) and Feng-kan (Fenggan); and he remarks that he found them on trees and rocks, on the walls of houses or in rooms in the nearby village. Lü-ch'iu Yin (Lüqiu Yin) describes Han-shan as a queer old fish, poor though learned, with shabby clothes and eccentric habits who lived in the vastnesses of the T'ien-t'ai (Tiantai). He often visited the Kuo-ch'ing-ssu (Guoqingsi) in the not too far distant provincial capital of T'ang-hsing (Tangxing) where he was given leftovers by a monastery kitchen-hand, named Shih-te (Shide). As a small child, Shih-te (Shide) had been found by Feng-kan (Fenggan) and raised in the monastery — hence his name, which means 'foundling'. Han-shan (Hanshan) is said to have spent hours in the monastery corridors talking to himself or laughing aloud, and when the monks who were thus disturbed in their meditations tried to chase him away, he is said to have stopped in his tracks, laughed loudly, clapped his hands — and disappeared.

Shortly before leaving to take up a new post in the neighbourhood of T'ien-t'ai-shan (Tiantaishan), Lü-ch'iu Yin (Lüqiu Yin) was much troubled by violent headaches which no doctor could cure; no one could help him except the *ch'an* master, Feng-kan (Fenggan), from the Kuo-ch'ing-ssu (Guo-qingsi), who was accompanied wherever he went by a friendly tiger. Lü-ch'ui Yin (Lüqiu Yin) inquired of Feng-kan (Fenggan) if there were other Buddhist teachers in his old monastery to whom he could turn for advice in matters of belief; whereupon Feng-kan (Fenggan) referred him to Han-shan (Hanshan) and Shih-te (Shide) who, he claimed, were in fact incarnations of the Bodhisattvas Mañjuśrī and Samantabhadra.

Once installed in his new post as magistrate, Lü-ch'iu Yin (Lüqiu Yin) lost no time in making his way to the Kuo-ch'ing-ssu (Guoqingsi) in search of the two sages. He met them in the kitchen and bowed reverentially to them. Han-shan (Hanshan) and Shih-te (Shide) were just then warming themselves at the

stove. They burst out laughing and began to shout: 'Feng-kan (Fenggan), that big mouth! You don't even recognise the Buddha Amitābha [Feng-kan, Fenggan] when you see him. Why do you bow to us, what is that supposed to mean?' Aroused by the noise, the monks ran to the kitchen where they saw these strange goings-on. Whereupon Han-shan (Hanshan) and Shih-te (Shide), hand in hand, made a run for it, and disappeared into their hiding-place in the neighbouring mountains. Later, when the prefect had gifts in the shape of clothes and medicaments sent to them, Han-shan (Hanshan) greeted the messengers with shouts of 'Thieves, thieves!' and crept out of sight in a cave which closed behind him. Shih-te (Shide) also disappeared.

It was on the basis of this charming story in the foreword, which may well be a purely literary fiction, and of certain poems in the ensuing anthology, that Zen literature and painting developed three of their favourite characters – rough, wild fellows as unbridled in their merriment as they are in their spiritual freedom and inner peace. A typical poem from the 'Cold Mountain' anthology runs as follows in translation:

> Do you have the poems of Han-shan in your house?
> They're better for you than sutra-reading!
> Write them out and paste them on a screen
> Where you can glance them over from time to time.[34]

Han-shan (Hanshan) is often represented with a brush and an empty book scroll, less frequently with a bucket for his leftovers; and sometimes he is shown pointing with one finger upwards into empty space. Shih-te (Shide) is usually provided with a kitchen-broom as his attribute; and from the Sung (Song) dynasty onwards the two were preferably shown as a giggling pair of fools with tousled hair, either together on a hanging scroll or separately in a diptych. Sometimes they are featured in a painting or a pair of hanging scrolls, together with their old spiritual mentor Feng-kan (Fenggan), who is usually shown as a bald-headed and bearded monk.

A particularly charming hanging scroll in ink on silk, showing the three Zen eccentrics, is traditionally attributed to Mu-ch'i (Muqi) but is more likely to be by a member of his circle or by one of his successors. The picture belongs to a private collection in Japan. It is full of humour and psycholo-

gical insight; it shows Han-shan (Hanshan) in the act of starting to write something with a pointed brush on a perpendicular cliff in the left-hand margin of the picture, while the barefoot Shih-te (Shide) has laid aside his broom and is grinding ink on a rock for his inspired friend. Near by, old Feng-kan (Fenggan) crouches, all huddled up, in front of a cave which is just visible in the mist. A mountain stream rushes by. Feng-kan (Fenggan) is stroking his beard with his right hand, and, like Shih-te (Shide) beside him, is following with amusement Han-shan's (Hanshan's) unconventional and off-the-cuff way of writing a poem. When we look closer we can see that he has already written four characters which are actually the opening line of one of the poems recorded in the 'Cold Mountain' anthology:

> My mind is like the autumn moon
> Shining clean and clear in the green pool.
> No, that's not a good comparison.
> Tell me, how shall I explain?[35]

One of the best works uniting Han-shan (Hanshan), Shih-te (Shide) and Feng-kan (Fenggan) in a pair of hanging scrolls, a triptych or a handscroll, is the Japanese diptych produced by the Buddhist figure-painter Reisai, who was demonstrably active between 1435 and 1463; the diptych is now in the Burke Collection of Japanese Art in New York. The right-hand scroll shows a rear view of the bald-pated Bukan, sitting on a flat rock, with the head of his sleeping tiger visible behind it; the left-hand one gives a rear view of Kanzan, gesticulating in lively conversation with his laughing friend, Jittoku. Reisai has placed his figures in the lower quarter of the picture, on stage-like plateaus which drop abruptly away, and he uses schematic clouds floating before an empty background to suggest an infinite expanse of space. Most of the other known representations of this theme show us the unorthodox partners in Zen, Han-shan (Hanshan) and Shih-te (Shide), against a barely suggested landscape stripped down to its essentials; sometimes, indeed, all detail of a purely decorative nature is simply discarded.

Kanzan and Jittoku on the left, with Bukan and his tiger on the right; diptych by Reisai (mid-fifteenth century). The Mary and Jackson Burke Collection of Japanese Art, New York

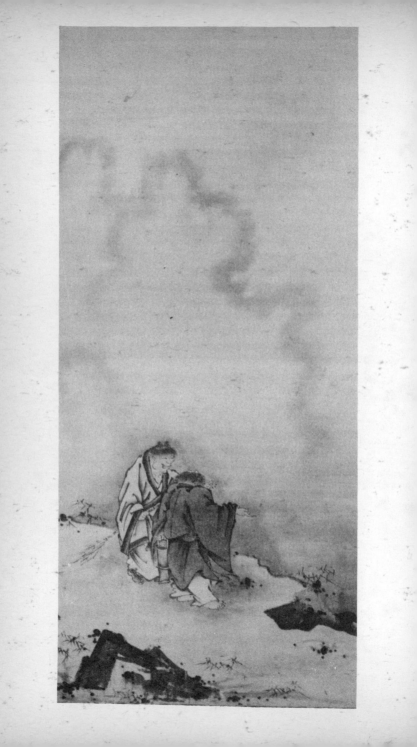

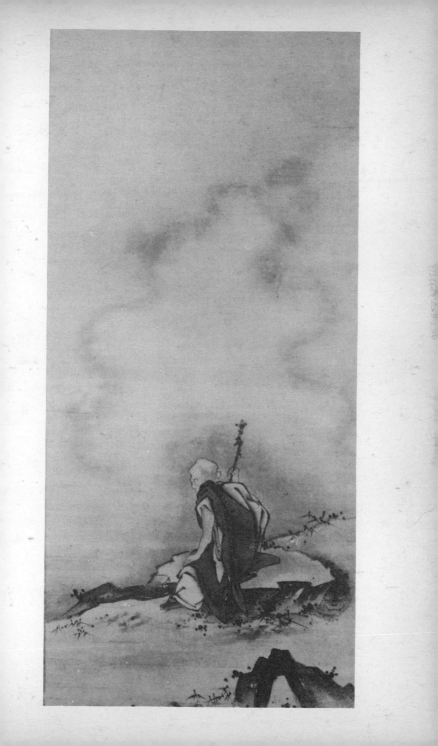

During the fifteenth century, the Ashikaga shōguns had several Chinese pictures dealing with this motif in their collection, including one attributed by Nōami in his catalogue to the scholar-painter Li Kung-lin (Li Gonglin), who died in 1106; and a second, alleged to be by the painter-monk Mu-ch'i (Muqi), who was especially deeply venerated in Japan, and which bore an inscription by the no less renowned abbot Hsü-t'ang Chih-yü (Xutang Zhiyu, 1185-1269). Again, the Engakuji in Kamakura was, according to the *Butsunichi-an kōmotsu mokuroku*, already in the middle of the fourteenth century, in possession of a pair of hanging scrolls, showing Han-shan (Hanshan) and Shih-te (Shide), inscribed by the same *ch'an* master. This goes to show the popularity of the theme in medieval Japan: and from then on a host of delightful variants was produced.

THE FOUR SLEEPERS

From the scurrilous trio of T'ien-t'ai-shan (Tiantaishan), of which Zen literature made such colourful and enigmatic use, there developed a new and unusually pleasing motif in art: Feng-kan's (Fenggan's) tame tiger was brought in as an equal partner with the other three figures, and all four are now shown huddled together in deep slumber as the 'Four Sleepers' (Chinese: *ssu-shui/sishui*; Japanese: *shisui*). It is not clear exactly when this theme was introduced, but it seems to be firmly established in the Zen repertory from the early thirteenth century onwards, although the earliest examples extant today date from about a hundred years later. The earliest evidence we have for artistic preoccupation with this subject is to be found in a poem in the *Ju-ching Ho-shang yü-lu* (*Rujing Heshang yulu*, chapter 2) which the abbot Ch'ang-weng Ju-ching (Changweng Rujing, died in 1228) composed for a representation of the 'Four Sleepers' which is no longer extant. Inscriptions for pictures dealing with the theme are also to be found in the 'Collected Works' of other *ch'an* masters of the Southern Sung (Song) and the Yüan (Yuan) dynasties. The writers are much taken up with dreams which give us in sleep insight into the true nature of things and into our own selves.

Thus, for example, the *ch'an* priest Ch'iao-yin Wu-i (Qiaoyin Wuyi, died in 1334) wrote as follows for a *ssu-shui* (*sishui*) picture which has likewise not survived:

> Man and tiger form a unity.
> Why are they such faithful companions,
> When their hearts and outward appearances are so
> completely diverse?
> Dream-thought changes the confusion.
> The wind shakes pines and gateways.
> It is often late in life that we attain to cheerful and
> contented guise.

And another well-known abbot of the Yüan (Yuan) period, P'ing-shih Ju-chih (Pingshi Ruzhi, 1268-1357) wrote a poem containing the lines:

> Huddled together and woven into a ball, each is sunk in
> his dream,
> the tiger in tiger-self, the man in man-self.

From such utterances it is clear that the 'Four Sleepers' theme was supposed to be a visualisation of that 'insight into one's own nature which leads to becoming a Buddha'. The sleepers symbolise the absolute transcendence of contradiction achieved by the spirit as purified by Zen praxis and liberated from enmeshment in the illusions of here-and-now. In this happy quartet the non-duality of man and beast visualised in peaceful sleep and dream, the repose which comes with enlightenment, the *śūnyatā* which cancels out all contradictions, find adequate form as perhaps in no other theme in Zen painting.

The central Buddhist idea of non-duality was formulated by the third Chinese *ch'an* patriarch, Chien-chih Seng-ts'an (Jianzhi Sengcan, died in 606) in his *Hsin-hsin-ming* (*Xinxin-ming*), the 'Engraving of Belief in Mind', as follows:

> If an eye never falls asleep,
> All dreams will by themselves cease:
> If the mind retains its oneness,
> The ten thousand things are of one suchness.
> When the deep mystery of one suchness is fathomed,
> All of a sudden we forget the external entanglements:

When the ten thousand things are viewed in their oneness,
We return to the origin and remain what we are.

Forget the wherefore of things,
And we attain to a state beyond analogy:
Movement stopped is no movement,
And rest set in motion is no rest.
When dualism does no more obtain,
Even oneness itself remains not as such.

In the higher realm of True Suchness
There is neither 'other' nor 'self':
When a direct identification is asked for,
We can only say, 'Not two.'[36]

In Japan also, the dream was used very early on as a metaphor
for the dialectic of Being and Appearance, and for the
transcending of duality through insight into true Being. In the
Kokin wakashū, the first imperial 'Anthology of Ancient and
Modern Japanese Verse' completed about 905 for Emperor
Daigo (885-930), there is a short poem composed of thirty-one
syllables:

Is the world a dream?
Is it intrinsic? Tell me! –
Neither intrinsic,
Nor dream, as far as I know.
A Something, a Nothing in One.[37]

Right down to the present day, priests skilled with the brush
have never tired of writing the character *meng* (Japanese: *mu*,
yume), 'dream'. Others had it incorporated in their clerical
names, as for example the eminent Musō Kokushi (1275-
1351), 'National Master of the Dream Window'; or the
Chinese *ch'an* monk T'an-e (Tane, 1285-1373) who wrote a
poetic inscription for a picture of the 'Four Sleepers' (now in
the National Museum, Tōkyō) to which we shall return in a
moment. T'an-e (Tane) was known as Meng-t'ang (Mengtang),
'Dream Hall', and as Wu-meng (Wumeng), 'Dream of Nothing-
ness'. This same profound philosophic-poetic name was
assumed by the 30th Tōfukuji abbot, Issei (died 1368), who
had been privileged to receive, when a student in China, a

eulogy on his priestly name Mumu, 'Dream of Nothingness', from the hand of the *ch'an* teacher Yüeh-chiang Cheng-yin (Yuejiang Zhengyin, 1267-post 1333) – the original of which is still extant.

Along with the *ssu-shui-t'u* (*sishuitu*) attested in the *yü-lu* (*yulu*) of the *ch'an* masters, we also find in the *Gyomotsu on-e mokuroku* two representations of the 'Four Sleepers' described as side-pieces, with the almost inevitable attribution to Mu-ch'i (Muqi), which is today not always taken at its face value. However, we do know of three qualitatively top-flight originals dating from the first half of the fourteenth century, which differ greatly in their artistic concept. What is perhaps the oldest treatment of the theme preserved today is by the Japanese Zen painter-monk Mokuan Reien, who worked in China for the two decades preceding his death in 1345; and a certain Hsiang-fu Shao-mi (Xiangfu Shaomi; perhaps Shao-mi from the Hsiang-fu monastery) added the inscription, which takes up once again the theme of the 'Great Dream' dreamt by the 'Four Sleepers' huddled together:

> Old Feng-kan embraces his tiger and sleeps,
> All huddled together with Shih-te and Han-shan
> They dream their big dream, which lingers on,
> While a frail old tree clings to the bottom of the cold
> precipice.
> Shao-mi of the Hsiang-fu [temple] salutes with folded
> hands.[38]

Mokuan's masterpiece – in the Maeda Ikutoku Foundation, Tōkyō – is an example of the monochrome ink style which was much used in Zen circles during the late Sung (Song) and the Yüan (Yuan) periods, a genre which depends for its effect on its spontaneity and its unconventional use of pictorial materials.

In sharp contrast are the other two fourteenth-century versions, which date very probably from the same time as Mokuan's. One, painted in colour on silk, concentrates exclusively on the group of figures; it is now in the Ryōkō-in of the Daitokuji in Kyōto. The other, a monochrome treatment which makes a totally different impression, is almost identical as regards the arrangement and outlines of the figures but is additionally enriched by a lavishly laid-out landscape. In its

finely detailed linear language it connects with the stylistic tradition of Li Kung-lin (Li Gonglin, *c.* 1049-1106). This hanging scroll is now in the Tōkyō National Museum. On the basis of biographical details extracted from inscriptions by the three *ch'an* priests P'ing-shih Ju-chih (Pingshi Ruzhi, 1268-1357), Hua-kuo Tzu-wen (Huaguo Ziwen, 1269-1351) and Meng-t'ang T'an-e (Mengtang Tane, 1285-1373) we may assume that this extraordinary work was produced between 1329 and 1348. The 'Four Sleepers' present the loftiest Zen Buddhist ideals in covert, not to say unprepossessing guise. Raised above the earthly cycle, a point subtly stressed by their removal in peaceful slumber to the land of dreams, they convey to a very high degree the 'simplicity', 'naturalness', 'subtle profundity or deep reserve', 'freedom from attachment' and 'tranquillity', to name only some of the qualities which Hisamatsu Shin'ichi has specified as the essential characteristics of a Zen work of art.

One final proof of the widespread popularity of the 'Four Sleepers' theme, and one remote from its Zen Buddhist origins, is provided by a Turkish miniature dating from the early Osmanli period. This small tondo, which was probably made in the fifteenth century at the court of Mehmet the Conqueror, must certainly have been inspired by a Chinese prototype.

Feng-kan (Fenggan) or Bukan was also treated as a theme on his own in Chinese and Japanese figure painting. Then he is shown riding or resting on his tiger, or standing beside it. He seems to have found his way into the iconographic repertory of Zen painting long before his friends from the Kuo-ch'ing-ssu (Guoqingsi); because, even if the celebrated ink-on-paper representation of a monk resting with his eyes closed on his sleeping tiger is no more than a late thirteenth- or early fourteenth-century copy, the signature bearing the name of the eccentric artist Shih K'o (Shi Ke, died post 975) must surely serve as evidence for the early conversion of the legend into art in the tenth century. The work once belonged to the Shōhōji in Kyōto, and is today, together with its pendant showing a monk, perhaps the second *ch'an* patriarch, Hui-k'o (Huike) in

The Four Sleepers (detail) by Mokuan Reien (died 1345); inscription by Hsiang-fu Shao-mi. Maeda Ikutokukai, Tōkyō

deep meditation, in the Tōkyō National Museum. Here we see Feng-kan (Fenggan) as exemplar of the enlightened Zen patriarch, forgetful of everything around him, whether he is in deep sleep or in meditation. A slightly divergent copy of the pendant to this work was used by a painter, presumably in the Yüan (Yuan) period, to reinterpret the figure of Feng-kan (Fenggan) by adding a sleeping tiger and some elements of landscape; and thereupon to present it in iconographic unity as the centre-piece of a triptych, with Han-shan (Hanshan) and Shih-te (Shide) on the flanking scrolls. These three pictures, painted on silk, belong to the Fujita Art Museum in Ōsaka, and have not had the attention they deserve.

HSIEN-TZU (XIANZI) AND CHU-T'OU (ZHUTOU)

Another two eccentric figures encountered in Zen-Buddhist imagery are Hsien-tzu (Xianzi, also called Hsia-tzu/Xiazi; Japanese: Kensu), or 'Clam', and Chu-t'ou (Zhutou; Japanese: Chotō), the 'Pig's Head'. According to early sources in the eleventh century, Hsien-tzu (Xianzi) was a pupil of the *ch'an* master Tung-shan Liang-chieh (Dongshan Liangjie, 807-869). It was said of him that he roamed the riverside in order to catch shrimps and clams for food, a practice normally not allowed to a devout Buddhist. Enlightenment, it is reported, was attained by him while catching a shrimp. Both Chinese and Japanese artists, including the two important painter-monks, Mu-ch'i (Muqi) and Kaō, presented him from the thirteenth/fourteenth century on, as a bearded old fellow in shabby clothes which he wore for years on end; he has a fishing net and is proudly holding his catch – a live shrimp in his raised hand.

Similarly a monk named Chih-meng (Zhimeng), who lived during the eleventh century, and who came from Wu-chou (Wuzhou) – he is also known as the 'Sage of Chin-hua (Jinhua)' – owes his curious nickname, 'Pig's Head', to his favourite delicacy. The renowned *ch'an* master Ta-hui Tsung-kao (Dahui Zonggao, 1089-1163) who directed the fortunes of the

Kensu the Shrimp-eater, by Kaō (first half of the fourteenth century). Tōkyō National Museum

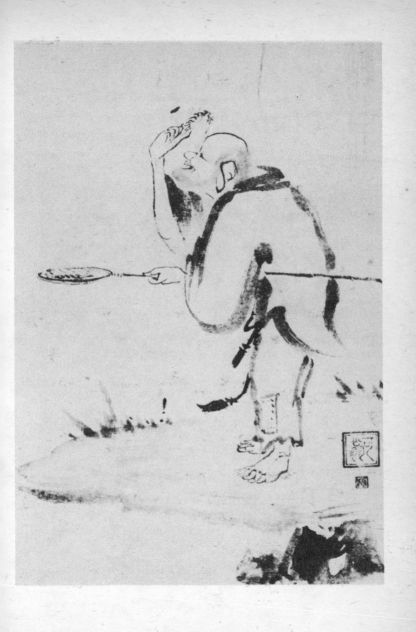

important monastery on the Ching-shan (Jingshan), and who resided in the 19th generation on the Yü-wang-shan (Yuwang-shan) as supreme head, prepared an inscription for a, regrettably lost, picture of Chu-t'ou (Zhutou); his colophon is preserved in his 'Collected Sayings', the *Ta-hui P'u-chiao Ch'an-shih yü-lu* (*Dahui Pujiao Chanshi yulu*, chapter 12). Later Hsien-tzu (Xianzi) and Chu-t'ou (Zhutou) were presented in paired hanging scrolls – presumably because by flaunting their favourite foods they cocked a snook at the vegetarian diet prescribed for the Buddhist clergy.

BODHIDHARMA

From very early on, the focus of attention for Zen painters was unquestionably the founder of *ch'an* in China, the 28th patriarch after Śākyamuni – Bodhidharma (died before 534). Some modern scholars tend to cast doubt on the very existence of this Indian patriarch, and there is no doubt that such historical facts as are contained in the various accounts given by ancient chroniclers are heavily encrusted with legend. One of the most popular episodes in the story is the meeting of Bodhidharma with the Emperor Wu (464-549) of the Liang dynasty. As befitted a worthy promoter of the Buddhist cause in China, the monarch is supposed to have invited the Indian monk to his court at Nanking (Nanjing), in order to learn something of the latest developments in *ch'an* at first hand. But the inquisitive Emperor could make very little of the taciturn and paradoxical answers he got from this strange holy man. The *ch'an* patriarch took the initiative and put an end to this unfruitful dialogue by quitting the imperial court without even taking official leave, and making his way north to a monastery in the state of Wei on the Sung (Song) mountain, where he then spent nine years in meditation.

However much this meeting was related and expanded upon subsequently, it seems to have awakened little interest among painters; at least, no very early treatment of the theme is

Bodhidharma Crossing the Yang-tze on a Reed; inscription by Ch'ang-wêng Ju-ching (1163-1228). Destroyed in war

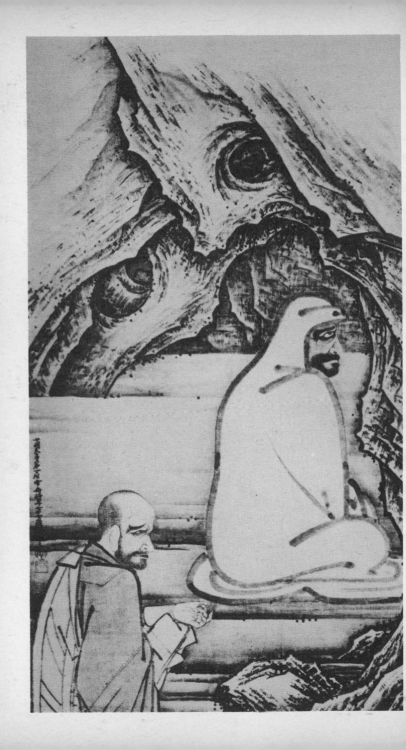

known to us. Very likely there was no great eagerness among *ch'an* painters to blot their founder's newly consolidated reputation by recalling his less than polite behaviour to the Emperor and his less than auspicious start in China. Instead, attention was paid in one phase of the founder's apotheosis, to those no doubt apocryphal episodes in the Bodhidharma life-story, which endowed the Indian patriarch with supernatural and miraculous powers. Thus the legend of his 'Crossing the Yangtze (Yangzi) on a Reed' after his abrupt departure from the court of the Liang Emperor, came to be very popular among painters and literati. The credulous masses took the story as literal truth, while the educated *ch'an* priests saw in it a metaphor for the extraordinary powers of the unconventional patriarch.

There is some evidence to suggest that as early as the beginning of the twelfth century, the story of Bodhidharma's miraculous crossing of the Yangtze (Yangzi) was no longer a novelty. But the oldest representations extant of the theme – known in specialist literature by its Japanese name *Royō (tokō) Daruma* – date only from the thirteenth century. The close relationship between this Bodhidharma type and the figure of Śākyamuni returning from the mountains lies not only in certain formal details – e.g. the garment fluttering out in front as the wind blows from behind the figure, the red colour of the garment (except in monochrome ink drawings), the hands always hidden by the habit and crossed in front of the breast – but also in the conceptual statement, which is in fact summed up by the hands. Dietrich Seckel has shown very convincingly that this gesture of the hands, which is specific to Zen iconography and which is usually found in the *Shussan Shaka* as well as in the *Royō Daruma*, is an indication of the 'silent possession of the truth'. 'For Bodhidharma too, as original exemplar of Zen enlightenment, "non-speech" is characteristic. At the same time, the concealment of (the hands) probably serves to obviate the otherwise unavoidable choice of a specific *mudrā* – a well-formulated statement, an utterance through a

Bodhidharma Facing the Cliff in Meditation with Hui-k'o who has Cut off his own Arm, by Sesshū Tōyō (1420-1506), dated 1496. Sainenji, Aichi prefecture

precise symbolic gesture; in the Zen sense, therefore, we should perhaps speak of a non-*mudrā*, even of an anti-*mudrā*.'[39]

According to the legend, Bodhidharma subjected himself to ascetic privations no less dire than those undertaken by the historical Buddha; and he is said to have spent nine years meditating in front of a rocky cliff in the Shao-lin-ssu (Shaolinsi) near Loyang (Luoyang). The copious collection of biographies which the monk Tao-yüan (Daoyuan) compiled round about 1004, the *Ching-te ch'uan-teng lu* (*Jingde chuandenglu*) mentions the occurrence on Mount Sung (Song); and the *Ch'uan-fa cheng-tsung chi* (*Chuanfa zhengzongji*), the 'Chronicle for the Transmission of the Teaching in the True School' by the *ch'an* priest Fo-jih Ch'i-sung (Fori Qisong, 1007-1072), finished in 1061 and dedicated the following year to the Northern Sung (Song) Emperor Jen-tsung (Renzong, reigned 1022-1063), says that Bodhidharma was called 'the wall-gazing Brahman' because of his curious method of meditation. The term *pi-kuan* (*biguan*), literally 'wall-gazing', is found in very early sources which contain the first reactions to the teaching of Bodhidharma, as noted down by a disciple of the patriarch. The expression seems to refer originally to a particular way of meditating. Some scholars are of the opinion that this may be a metaphor for the ineffable 'steepness and suddenness of enlightenment', rather than a literal description of a posture in meditation, as it was, in the sequel, understood by later writers. Thus, 'Bodhidharma's nine years of deep meditation while "facing a wall" in the Shao-lin-ssu (Shaolinsi)' may well be the product of a misunderstanding on the one hand, and the exuberant imagination of the Sung (Song) literati and painters on the other.

In painting, the theme was considerably intensified by the addition of a directly related event reported in the life-story of Bodhidharma. A *ch'an* disciple named Hui-k'o (Huike) heard tales of the unswerving meditation of the Indian patriarch, and decided to make his way to the Sung-shan (Songshan) and ask the great master to take him on as a pupil. But Bodhidharma ignored him. Finally, Hui-k'o (Huike) cut his left arm off in earnest of his determination to make any and every sacrifice for the *ch'an* succession, and to submit to any adversity. Whereupon Bodhidharma accepted the courageous Chinese applicant,

and appointed him, after he had attained to enlightenment, as second patriarch in what was to be the long chain of succession.

This key episode in Zen is depicted for us in a large hanging scroll by the celebrated Japanese painter-monk Sesshū Tōyō (1420-1506). The picture, which is imbued with deep religious solemnity and overpowering dramatic force, is in the Sainenji in the Aichi prefecture. Sesshū, who had entered a Zen monastery at the age of eleven, painted this moving picture in 1496 when he was 77 (76 by Western reckoning) as he records in his own hand near the left-hand margin. The two *ch'an* patriarchs are shown in strict, analogous profile: the bald-headed Hui-k'o (Huike) with his stubbly beard, staring resolutely ahead, in artistically daring intersection, the amputated limb held in front of his breast, and the black-bearded Indian patriarch in immovable composure, his open eyes fixed unswervingly on the rock-wall.

In this powerful figure, the painter has succeeded in confronting the viewer with a typically Zen-Buddhist paradox: the apparent contradiction implied in performing 'heavy labour of the spirit' to the point of exhaustion, while the body is motionless in repose. Similarly, the striking contrast between the bizarre rocks, with their vibrating dappling and striation, and the few broad bold strokes used to delineate the otherwise white, blank figure of the Bodhidharma, must be seen as an inversion of the natural order through the spirit of Zen: the rocks seem to be awakened to breathing life, while the meditating man approximates to a lifeless and immovable block of stone. In this masterpiece, Sesshū has given us a shocking visualisation of radical Zen logic leading to the total relinquishment of the Self. For those who are in search of true enlightenment, he has provided an exemplary *zenki-zu*, a 'Zen support-picture' of the very first rank.

The fantastic tales adorning the life, the work and the person of the Indian founder of *ch'an* in China, did not end with his death. A legend current already in the tenth century tells how the monk Sung-yün (Songyun) from Tun-huang (Dunhuang) was returning home after a three-year pilgrimage to India whither he had been sent by the Wei Emperor Hsiao-chuang (Xiaozhuang, reigned 528-530), when he met Bodhidharma,

then recently defunct, making his way to the Buddhist homeland. This encounter is supposed to have taken place in Ts'ung-ling (Congling) in Central Asia; and Bodhidharma seemed to have only one of his shoes with him. When Sung-yün (Songyun) told the emperor about the strange meeting, the order went forth to open Bodhidharma's grave – and indeed there was the other shoe!

The theme of 'Bodhidharma Returning to the West with one Shoe' (abbreviated in Japanese to *Sekiriki Daruma*) figured in literature from a relatively early date; and both Chinese and Japanese painters had taken it up by the thirteenth century at the latest. In our opinion, the best representation extant of the theme is to be seen in the Masaki Art Museum in Izumi-Ōtsu near Ōsaka. It bears an inscription dated 1296 from the hand of the Sōfukuji abbot Nampo Jōmyō (1235-1308) who had studied in China. The picture is one of quite exceptional importance for the history of East Asian painting, showing as it does how early ink painting techniques and styles were received in Japan from Sung (Song) China. In type and in the treatment of certain motifs – e.g. the garment blown forwards by the wind – the picture links up with representations of the *Royō Daruma* and the *Shussan Shaka*.

Even if it is hardly possible to trace precise lines of influence, we may justifiably postulate a mutually fructifying interaction between these three themes, a reciprocity sited ultimately in the general intellectual and artistic climate of the period, and one which can be held responsible for the formal similarities in treatment. Each of these themes is concerned with the depiction and the artistic expansion of legendary biographical details, with dynamic and action-filled 'narrative pictures' commemorating historical episodes which have fundamental implications for the Zen school. In this respect they differ sharply from the genre of static representation of redeemer-figures (in the Zen context, it is misleading to talk of a '*Kultbild*' or 'picture for worship' and the term is better avoided) – e.g. representations

Five Zen masters from a series of thirty portraits in six hanging scrolls, flanking a representation of Śākyamuni (see illustration p. 49), by Kichizan Minchō (1352-1431), dated 1426; inscriptions by Genchū Shūgaku (1359-1428), Rokuō-in, Tōfukuji, Kyōto

of the historical Buddha as a religious founder at the head of a long line of patriarchs, or certain pictures of the Bodhisattva Avalokiteśvara.

PORTRAITS OF PATRIARCHS

In contrast to these themes which turn on visualisation of the instantaneous, the momentary, the evanescent, which have to do with a specific spatio-temporal singularity, the essential static portraits of the great *ch'an* patriarchs seek to achieve independence from time and space, a bridging of the spatio-temporal gap.[40] The classical mode of representation of Bodhidharma, now exaggerated to superhuman dimensions, is the half-figure in three-quarter profile. The characteristic traits of these idealised portraits lie in the non-Chinese features of the patriarch in his simple monastic robe, his full beard, his large ears with ear-rings, and, above all, his hypnotic and compelling gaze. In point of fact, there is an apocryphal legend concerning the exaggeration of the eyes, to the effect that Bodhidharma, angered by the fact that out of weariness his eyes had fallen shut during meditation, cut off his eyelids. At the spot where they fell to earth, it was said, a bush had made a miraculous appearance – the tea plant. And in fact the practice of drinking tea was early on adopted in Zen circles, as a means of resisting tiredness during lengthy meditation.

Extant originals allow us to follow the history of the half-figure patriarch portrait as far back as the twelfth century. Certainly one of the most impressive representations of the Indian founder patriarch is the portrait done in a few powerful brush strokes and velvety soft ink washes on paper: the hanging scroll belongs to the Myōshinji in Kyōto, and has long been the central piece of a triptych. The flanking scrolls show Pu-tai (Budai) and Feng-kan (Fenggan). Both paintings are by Li Ch'üeh (Li Que), a painter from whose hand we have unfortunately nothing else; the Pu-tai (Budai) scroll is signed by him in the lower left-hand corner. The anonymous picture of Bodhidharma bears in its upper half a four-line *gāthā*, reading from left to right, by Mieh-weng Wen-li (Mieweng Wenli, 1167-1250). In the quatrain, this important *ch'an* abbot refers

to two episodes in the life-story of the first patriarch – the fruitless encounter with Emperor Wu of Liang, and the mysterious return journey of Bodhidharma, after his death, through the deserts of Central Asia.

One might expect the single portrait to be the oldest type in the evolution of Zen Buddhist portraiture, but in fact the genre starts with the group portrait. The oldest examples which are both documented and still extant, are concerned with portraits of patriarchs in order of succession. The very nature of the iconographic undertaking dictated in advance the most suitable form of representation – the linear series of pictures. In general, this linear series was conceived as a row of single portraits on separate hanging scrolls, arranged in sequence. Sometimes, however, artists varied the format by putting a group comprising five portraits on one single hanging scroll, so that several such scrolls could be seamlessly joined up to form a linear series. Thus, the capacity of a linear series, which may comprise anything between three and forty hanging scrolls, is not exclusively determined by the number of persons represented. In the arrangement of the portraits, strict attention was usually paid to ensuring that the Zen masters represented were genealogically ordered to left and right of the central axis, marked perhaps by a picture of Śākyamuni. As a rule, patriarchs bearing uneven numbers face left: that is to say, their portraits were hung to the right of the central picture, or to the right of an imaginary central axis. Masters with even numbers are shown in three-quarter profile looking to the right: that is, their pictures are hung on the left. And, as such portrait rows are concerned above all with ancient Zen masters, the dominant form of representation is the half-length figure held to be suitable for patriarchal portraits.

Portrait cycles of Buddhist patriarchs have a long history in the Orient, and they are the prerogative of no single school. What especially distinguishes Zen portraits *vis-à-vis* portaits of the Chen-yen (Zhenyan; Japanese: Shingon) or T'ien-t'ai (Tiantai; Japanese: Tendai) patriarchs is their realism, which is closely linked to their religious function, and which has separated and grown out of the prevailing concept of the portrait as an idealisation of the subject. But we must not overlook the fact that representations of the early *ch'an*

patriarchs in the so-called *soshi-zō* are almost exclusively based upon idealised transmission of the master's personality, and that these images fulfil, as in other schools, general functions in worship.

Among the oldest attested series portraying the first six *ch'an* patriarchs in China are the scrolls, now lost, which were still in the extensive collection belonging to the Sung (Song) Emperor, Hui-tsung (Huizong, 1082-1135), a lover of the arts, at the beginning of the twelfth century. Evidence for this is forthcoming from the *Hsüan-ho hua-p'u* (*Xuanhe huapu*, chapter 5) where we find the pictures attributed to the figure painter Ch'en Hung (Chen Hong), who was active at the T'ang (Tang) court around the middle of the eighth century. If this attribution is correct, the pictures were produced at the very time that Shen-hui (Shenhui, 668-760) was engaged in a dispute with his master, Hui-neng (Huineng), the sixth patriarch, regarding the legitimacy of the doctrinal succession, a dispute which was not finally settled until 796 when Emperor Te-tsung (Dezong) convoked a council to deal with it.

Subsequent series portraying the first six *ch'an* patriarchs in China formed part of the standard repertory of Buddhist figure-painting. In the *I-chou ming-hua lu* (*Yizhou minghualu*, preface dated 1006) we find further references to series of wall paintings of this nature in various important temples in what is now Ssu-ch'uan (Sichuan). These were works by artists such as the émigré painter Chang Nan-pen (Zhang Nanben, active in the second half of the ninth century), the *ch'an* painter-monk Ling-tsung (Lingzong), who was also active in Ch'eng-tu (Chengdu) around the middle of the tenth century and painted a series for the Ta-sheng-tz'u-ssu (Dashengcisi), and his cousin Ch'iu Wen-po (Qiu Wenbo, active *c.* 932-965) who did a set for the *ch'an* monastery of Ch'ien-ming-ch'an-yüan (Qianming-chanyuan). At this time, the Ta-sheng-tz'u-ssu (Dashengcisi) possessed a subtemple, the Liu-tsu-yüan (Liuziyuan), devoted specifically to the 'Six Patriarchs'.

Unfortunately, Huang Hsiu-fu (Huang Xiufu), the author of the 'Record of Famous Painters active in I-chou (Yizhou)' tells us nothing about what these early portraits of patriarchs looked like. Perhaps they were half-figure portraits, as later became customary; but they may also have been series of small

scenes showing the *ch'an* patriarchs, surrounded by their pupils, officiating at the formal installation of their successors as repositories of the true teaching – in other words, a sort of 'ordination' scene. We may mention two examples of this sort of picture: first, a copy of the *Ch'uan-fa cheng-tsung ting-tsu t'u-chüan* (*Chuanfa zhengzong dingzu tuquan*) – the 'Illustrated Scroll with the Transmission of the Law in the True School by the Appointed Patriarchs' – which the Japanese monk Jōen completed in 1154 after a Chinese original of 1061, and which was kept in the Kanchi-in of the Tōji at Kyōto until its acquisition by the MOA Museum of Art in Atami; and secondly, an early thirteenth-century ink drawing done by an anonymous artist after a Chinese woodblock print of 1054, which is in the collection of the Kōzanji near Kyōto.

PORTRAITS OF PRIESTS

In Zen Buddhism the portrait occupies a central place; and among the portraits of important masters which have come down to us, those showing an abbot 'in cathedra' are by far the most common. The preferred form for portraits of contemporary priests, and also for posthumous representations of those defunct, is the so-called 'chair portrait' (Chinese: *i-tzu-hsiang/ yizixiang*; Japanese: *isu-zō*) which shows the master sitting with his legs crossed in an ecclesiastical chair with arm-rests and often a high back. The chair (Chinese: *ch'ü-lu/qulu;* Japanese: *kyokuroku*) is often covered with a richly ornamented cloth of fine quality, and in front of it, on a low foot-rest, are the abbot's shoes. His hands are lying in his lap and as a rule he holds a fly-whisk (Chinese: *fu-tzu/fuzi*; Japanese: *hossu*) or an admonition slat (Chinese: *chu-pi/zhubi*; Japanese: *shippei*) which serves to give pupils a well-meant blow on the shoulder, should attention waver during *zazen*.

These priest portraits, which are known in Japanese Zen terminology as *chinsō*, and which are to be distinguished both typologically and iconographically from the *soshi-zō*, the patriarchal portraits, are almost exclusively dominated by one mode of representation – the three-quarter profile view, facing to right or to left. The strict right-angle profile is not found in

Zen Buddhist single portraits, and the *en face* pose is very rare. Except where iconographic considerations demand it, there is no suggestion of a background; and the question whether we are dealing with an indoor or an outdoor setting remains open – deliberately so, so that all our attention can be focused on the subject himself. It is very rare to find a Zen priest portrayed against a landscape background.

An integral component of the *chinsō* is provided by the inscriptions (Chinese: *tsan/zan*; Japanese: *san*) which are normally in the upper third of the picture, that is, above the head of the subject. In the case of contemporary pictures (*juzō*) these inscriptions were composed by the master being portrayed, at the request of one of his pupils, and written down in his own hand. These dedications, which are often in verse, are so personal in content or refer in such arcane terms to certain happenings and oddities in the master-pupil relationship, that they are, as far as non-initiates are concerned, completely or, at best, partly incomprehensible. Zen priests wrote their dedications in both directions on their portraits, from right to left as well as from left to right, which is contrary to general conventions in East Asia. The determining factor here is the direction of the gaze, as the *tsan* (*zan*) normally begins in that part of the picture towards which the subject is looking. This is also true, by the way, for many other kinds of Zen Buddhist figure-paintings.

For a most illuminating commentary on the principles informing representation in both lifetime portraits and posthumous pictures of Zen masters, we have to thank the Chinese *ch'an* priest Chu-hsien Fan-hsien (Zhuxian Fanxian, 1292-1349) who was working in Japan from 1329 onwards, and who not only made a name for himself as a teacher and an abbot in more than one important monastery, but whose talents were also applied to literature and painting. In his *T'ien-chu-chi* (*Tianzhuji*), the 'Collection of the Heavenly Pillar', which is included in chapter 3 of his 'Collected Sayings', we find him inveighing against the rule which had by then – the Yüan (Yuan) period – been long established, according to which a Zen master drawn from life should always be shown looking to his right in heraldic terms; while a portrait of a defunct master should always show him in three-quarter profile

looking to his left. By and large, this differentiation between living and dead subjects, along with its corollary that the inscription should always run counter to the direction of the gaze, was duly observed in Zen painting, as the available material will bear out. Posthumous portraits (izō) were usually inscribed by pupils or by doctrinal successors of the priest portrayed, and, in fact, in the contrary direction to the traditional right-to-left line of script.

The earliest independent 'chair-portrait' of a Zen master that we know of, is that of Mu-an Fa-chung (Muan Fazhong, 1084-1149) in the MOA Museum of Art in Atami. It may well have been painted in his lifetime, for the long-haired bearded priest of the Huang-lung (Huanglong) school is shown in the indicative pose for portraits from life: that is, he is looking to his right. Presumably something happened to prevent him from inscribing his likeness with his own hand; the eulogies on the picture, composed in 1150/51, that is to say, immediately after his death, are by two anonymous successors.

The most important chinsō are no doubt those which were produced during the period from the thirteenth to the fifteenth century. Three of the most beautiful works in Chinese portraiture as a whole were dedicated by the ch'an masters depicted, to their Japanese pupils. In 1238, the great Ching-shan (Jingshan) abbot, Wu-chun Shih-fan (Wuzhun Shifan, 1177-1249) dedicated his likeness to the pilgrim monk, Enni Ben'en (1202-1280), who was studying under his tutelage; in 1241, Enni Ben'en returned from China to Kyōto, where in 1255 he founded the Tōfukuji, and it is there that what is probably the most celebrated of all Zen Buddhist portraits has been preserved and venerated from the thirteenth century until the present day. Twenty years later, in 1258, the influential ch'an master Hsü-t'ang Chih-yü (Xutang Zhiyu, 1185-1269) inscribed his portrait for his disciple Sempō Honryū from the Jōmyōji in Kamakura; today, the picture is in the Myōshinji in Kyōto. Finally, in 1315, the Zen priest Enkei Soyū (1285-1344) returned from a nine-year sojourn in China with a portrait of his master, Chung-feng Ming-pen (Zhongfeng Mingben, 1263-1323) which is signed by an otherwise unknown artist named I-an (Yian). In 1325 Enkei founded the Kōgenji in his old homeland, the province of Tamba, and in this old monastery

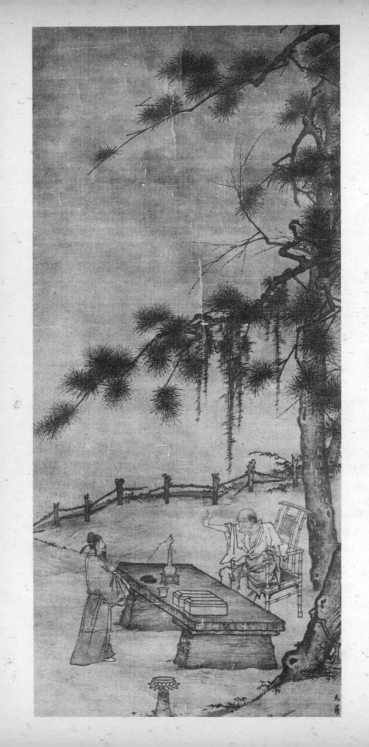

the marvellous picture of the eccentric, long-haired, corpulent *ch'an* master has been preserved. Japanese *chinsō* run into enormous numbers, so that we can do no more than mention the many impressive portraits of such eminent Zen personalities as Enni Ben'en, Musō Soseki (1275-1351) or Ikkyū Sōjun (1394-1481).

PICTURES OF ZEN ENCOUNTERS

A specific category of Zen Buddhist painting is provided by the so-called *zenki-zu* – 'Pictures of Zen Encounters or Zen Activities', sometimes also called 'Zen support-pictures'. The scenic representations originally appeared by preference in handscrolls – a very suitable format as their main function was to tell a story; but they also appeared in separate hanging scrolls. In either form, they set out to encourage and stimulate the seeker after enlightenment by presenting in graphic and paradigmatic form decisive events in the lives of exemplary patriarchs, or encounters and dialogues between an enlightened Zen master who has overcome the world and a representative of some other spiritual culture. The *zenki-zu* fulfil the same sort of function as was served in early Christianity and the Middle Ages by the original devotional literature; and in so far as this is true, we are not misrepresenting them when we think of them as 'devotional pictures', or, in the widest sense, 'visual aids to Zen'.

In their title many of these representations have the disyllable *wen-ta* (*wenda*; Japanese: *mondō*), literally 'question and answer'. In Zen Buddhist writings these didactic 'dialogue-pictures', which have a strong narrative and historical content, are designated as *ch'an-hui-t'u* (*chanhuitu*; Japanese: *zen-e-zu*), that is, 'Pictures of Zen Encounters'. Some kind of systematisation seems to have been fixed as early as in the thirteenth century; thus, in the *yü-lu* (*yulu*) of well-known *ch'an* masters, we not infrequently find as many as twelve or thirteen illustrated episodes in the same or at least similar sequence. The

Li Ao Visiting the ch'an *Master Yao-shan Wei-yen, by Ma Kung-hsien (mid-twelfth century), Nanzenji, Kyōto*

series leads off usually with the story of the *ch'an* priest Huang-po Hsi-yün (Huangbo Xiyun, died *c*. 850) who answered the importunate questioning of a young monk by striking him three times in the face. The novice thus instructed later ascended the throne as the 16th Emperor of the T'ang (Tang) dynasty, under the name of Hsüan-tsung (Xuanzong, reigned from 846 to 859).

Another typical Zen encounter is represented by the visit of Li Ao (died *c*. 844) to the *ch'an* master Yao-shan Wei-yen (Yaoshan Weiyan, 751-834). Li Ao was a Confucian, the governor of Lang-chou (Langzhou) and a friend of the rabid opponent of Buddhism, Han Yü (Han Yu, 786-824). When he came to Yao-shan Wei-yen (Yaoshan Weiyan) seeking instruction, the *ch'an* master simply ignored his illustrious guest. Thus provoked, Li Ao finally lost his patience and said crossly, 'Seeing your face is less impressive than hearing your name', to which the wise *ch'an* master calmly replied, 'How is it that you value the ear more than the eye?' Impressed by this answer, Li Ao bowed in reverence and asked, 'Which is the right way (to enlightenment)?' Yao-shan Wei-yen's (Yaoshan Weiyan's) answer was to point with one finger upwards, and downwards with the other hand, a strange gesture which Li Ao failed to understand. Finally the master added, 'The clouds are in the sky; the water is in the vase.' Now Li Ao understood, and spontaneously recited the following verse:

> His ascetic body is as dry as that of a crane.
> Under a myriad pine-trees lie two bundles of sūtras.
> When I came to ask the way to enlightenment, all he said
> was:
> 'The clouds are in the sky; the water is in the vase.'

Two outstanding pictures dealing with this 'Zen-encounter' theme have come down to us from the Sung (Song) period. In style, these two paintings are diametrically opposed to each other, representing, one might say, the two poles of Zen Buddhist painting. One of them, a hanging scroll, bears in the lower right-hand corner the signature of Ma Kung-hsien (Ma Gongxian), who occupied a high position in the Imperial Academy during the Shao-hsing (Shaoxing) era (1131-1162) and who wore the 'Golden Girdle', a distinguished honour

The Sixth Patriarch, Hui-neng, Chopping Bamboo, by Liang K'ai (first half of the thirteenth century). Tōkyō National Museum

awarded to court painters for exceptional services. The picture has a clear linear structure and is painted in delicate colours on silk. It is now in the Nanzenji in Kyōto. It shows Li Ao in official robes standing before a large natural-stone table, his hands crossed in front of his breast in token of reverence. Behind the table, on a bamboo seat under a towering pine, sits the wizened figure of Yao-shan Wei-yen (Yaoshan Weiyan); he is pointing with his fingers and his face is creased with mirth. On the table is a blossoming plum branch in a bulbous vase with a long neck. Close by are two scroll cases, an open, oval ink-stone and a small bowl.

In sharp contrast to this work, unambiguously committed as it is to academic tradition, which conveys the content in concise narrative terms, the anonymous painter of the other version (on loan to the Princeton University Art Museum) has adopted a free and uninhibited approach to the theme and has had recourse to the expressive potentialities of delicate ink strokes and watery grey washes. Today, the work is mounted as a square hanging scroll, but was originally very probably part of a handscroll. It bears a colophon by the *ch'an* abbot Yen-ch'i Kuang-wen (Yanqi Guangwen, 1189-1263) which he composed between 1254 and 1256 during his term of office in the Ling-yin-ssu (Lingyinsi):

> All moments of enlightenment come like lightning.
> To scorn the eye and extol the ear is
> As though one were between water and clouds.
> Say not that there is no other way!
> > The Abbot of Leng-ch'üan (Lengquan), Kuang-wen
> > (Guangwen)

ENLIGHTENMENT PICTURES

Another group of *zenki-zu* are representations of eminent Zen Buddhist personalities caught in the decisive moment when enlightenment suddenly hit them. At first glance, these pictures often seem very unremarkable as regards content, in that they show everyday situations, ordinary occupations, often border-ing on the trivial: a monk wading through a river, a mendicant

priest under a blossoming tree in a landscape setting, a monk chopping bamboo or sweeping the monastery yard. The first of these themes – the monk wading through the river – refers to the founder of the Ts'ao-tung (Caodong) school (Japanese: Sōtō school), Tung-shan Liang-chieh (Dongshan Liangjie, 807-869) who was crossing a river one day when he saw his reflection in the water and attained enlightenment. The second is the *ch'an* master Ling-yün Chih-ch'in (Lingyun Zhiqin) who lived in the ninth century, and who suddenly experienced *satori* at the sight of peach blossom. The third is the sixth patriarch, Hui-neng (Huineng) who suddenly made the breakthrough to enlightenment when he heard the sounds of bamboo being chopped; and the fourth is Hsiang-yen Chih-hsien (Xiangyan Zhixian, ninth century) who was sweeping the yard as usual one day when a small stone sprang from the broom and hit a hollow bamboo cane, making a slight sound which broke the silence and was enough to trigger enlightenment.

Finally, this category of Zen Buddhist 'enlightenment pictures' also comprises such themes as 'Pu-tai (Budai) Watching a Cock-fight' or 'Hsien-tzu (Xianzi) Catching a Shrimp'. Without a knowledge of Zen literature and where there is no commentary, such works are difficult if not impossible to understand. Many of these themes occur as chance episodes in biographical compilations; others again figure as meditation exercises in well-known *kōan* collections.

PARABLE PICTURES

The 'parable pictures' form yet another category of *zenki-zu*; and, at first glance, they are no more likely to disclose their paradigmatic character than are the 'enlightenment pictures'. Zen masters were particularly fond of using one particular parable as a means of introducing students to and instructing them in Zen – the parable of the 'Ox and its Herdsman' which is held to epitomise various levels of awareness and knowledge. When the Ashikaga Shōgun Yoshimitsu asked the influential Zen abbot Zekkai Chūshin (1336-1405) to explain the basic tenets of Zen Buddhism to him, the abbot used this parable which appears in many versions, both in painting and in

literature, as didactic textbook for his lessons with the regent.
The simile of the ox and herdsman is intended to help smooth
the step-wise path (conceived mostly in ten stages) to insight
into the true nature of things.

The earliest sets of 'Ten Oxherding Pictures' (Chinese: *shih-niu-t'u*/*shiniutu*; Japanese: *jūgyu-zu*) seem to have appeared in
China around the middle of the eleventh century. In some of
these, the steps on the way of Zen are symbolised by an ox
which is transformed from being pitch-black through ten
gradual stages of lightening in colour till it appears as snow-white, and finally vanishes from sight altogether, so that an
empty circle logically represents the release from adhesion to
the phenomenal world. Another series of 'Oxherding Pictures',
with an accompanying text, which ultimately derives from the
Chinese *ch'an* master K'uo-an Chih-yüan (Kuoan Zhiyuan, *c.*
1150), found widespread popularity during the fourteenth/fif-teenth century in Japan, where it has been transmitted in
several handwritten, painted and printed editions. Here, each
stage on the way to supreme understanding is set out in an
explanatory prose paragraph followed by four lines in verse.
These short poems emphasise the same ideas once more.

1 LOOKING FOR THE OX

To begin with, we never really lost him, so what is the use
of chasing him and looking for him? The herdsman
turned his back on himself and so became estranged from
his ox. It moved away into clouds of dust and was lost.

The herdsman's home and mountains recede into the
far distance; the mountain paths and roads suddenly
become confused. The desire to catch the ox and the fear
of losing him burn like fire; doubts assail him about the
right course to take.

Alone in the wilderness, lost in the jungle, he is searching,
 searching!
The swelling waters, far-away mountains, and unending
 path;
Exhausted and in despair, he knows not where to go,
He only hears the evening cicadas singing in the
 maple-woods.

2 SEEING THE FOOTPRINTS OF THE OX

By relying on the *sūtras* and explaining their meaning, he carefully studies the doctrine and begins to understand the first signs. He realizes that all vessels [of the Law] are made of one metal and that the Ten Thousand Things are composed of the same substance as he himself. But he does not yet distinguish between right and wrong doctrines, between truth and falsehood. He has not yet entered that gate. He has discovered the footprints of the ox, but that discovery is, as yet, only tentative.

By the water, under the trees, scattered are the traces of
 the lost:
Fragrant woods are growing thick – did he find the way?
However remote, over the hills and far away, the ox may
 wander,
His nose reaches the heavens and none can conceal it.

3 SEEING THE OX

Following the sound [of the mooing of the ox] he enters the gate. He sees what is inside and gets a clear understanding of its nature. His six senses are composed and there is no confusion. This manifests itself in his actions. It is like salt in seawater or glue in paint [invisible, indivisible, yet omnipresent]. He has only to lift his eyebrows and look up to realise that there is nothing here different from himself.

Yonder perching on a branch a nightingale sings
 cheerfully;
The sun is warm, the soothing breeze blows through the
 willows green on the bank;
The ox is there all by himself, nowhere is there room to
 hide himself;
The splendid head decorated with stately horns, what
 painter can reproduce him?

4 CATCHING THE OX

The ox has been hiding in the wilderness for a long time, but the herdsman finally discovers him near a ditch. He is difficult to catch, however, for the beautiful wilderness still attracts him, and he still keeps longing for the

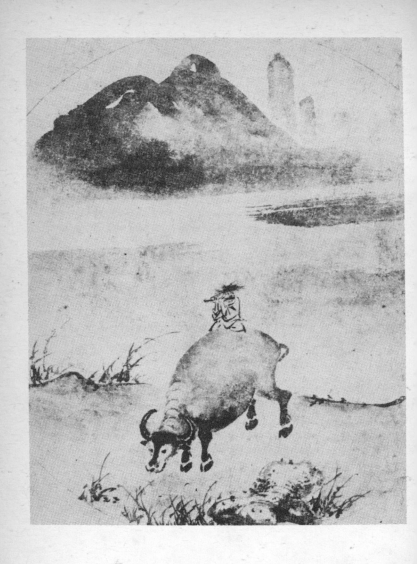

The Flute-playing Herdsman Rides home on the Back of his Ox (the sixth stage from a series of 'Oxherding Pictures') (detail); attributed to Li Sung (early thirteenth century). Private collection, Japan

fragrant grasses. His obstinate heart still asserts itself; his unruly nature is still alive. If the herdsman wants to make him submissive, he certainly will have to use the whip.

> With the energy of his whole soul, he has at last taken
> hold of the ox:
> But how wild the ox's will is, how ungovernable his
> power!
> At times he struts up a plateau,
> When lo! he is lost in a misty, impenetrable
> mountain-pass.

5 HERDING THE OX

As soon as one idea arises, other thoughts are bound to follow. Through Enlightenment all these thoughts turn into truth, but when there is delusion they all turn into falsehood. These thoughts do not come from our environment, but only from within our own heart. One must keep a firm hold on the nose-cord and not waver.

> Never let yourself be separated from the whip and the
> tether,
> Lest he should wander away into a world of defilement:
> When he is properly tended, he will grow pure and
> docile;
> Even without chain, nothing binding, he will by himself
> follow you.

6 RETURNING HOME ON THE BACK OF THE OX

The battle is over. There is no longer any question of finding or losing the ox. Singing a woodcutter's pastoral song and playing a rustic children's melody on his flute, the herdsman sits sideways on the ox's back. His eyes gaze at the clouds above. When called he will not turn around, when pulled he will not halt.

> Riding the ox he leisurely wends his way home:
> Enveloped in the evening mist, how tunefully the flute
> vanishes away!
> Singing a ditty, beating time, his heart is filled with a joy
> indescribable!
> That he is now one of those who know, need it be told?

7 THE OX FORGOTTEN, THE MAN REMAINS

There is but one Dharma, and the ox represents its guiding principle. It illustrates the difference between the hare net [and the hare] and elucidates the distinction between the fish trap [and the fish]. [This experience] is like gold being extracted from ore or like the moon coming out of the clouds: one cold ray of light, or an awe-inspiring sound from beyond the aeons of time.

Riding on the ox he is at last back in his home,
Where lo! there is no more the ox, and how serenely he
 sits all alone!
Though the red sun is held up in the sky, he seems to be
 still quietly asleep;
Under a straw-thatched roof are his whip and rope idly
 lying beside him.

8 BOTH MAN AND OX FORGOTTEN

All desire has been eliminated; religious thoughts have all become void. There is no use to linger on where the Buddha resides; where no Buddha exists one must quickly pass by. One is no longer attached to either, and even a thousand eyes will find it difficult to detect it. The Hundred Birds bringing flowers in their beaks are nothing more than a farce on real sanctity.

All is empty, the whip, the rope, the man, and the ox:
Who has ever surveyed the vastness of Heaven?
Over the furnace burning ablaze, not a flake of snow can
 fall:
When this state of things obtains, manifest is the spirit of
 the ancient master.

9 RETURNING TO THE FUNDAMENTAL,
BACK TO THE SOURCE

Clear and pure from the beginning, without even a speck of dust, he observes the growth and decay of forms, remaining in the immutable attitude of non-activity. He does not identify himself with transitory transformations, so why should he continue the pretence of self-disciplining? The water is blue, the mountains are green. Sitting by himself he observes the ebb and flow, the rhythm of the Universe.

To return to the Origin, to be back at the Source —
 already a false step this!
Far better it is to stay home, blind and deaf, straightway
 and without much ado.
Sitting within the hut he takes no cognizance of things
 outside,
Behold the water flowing on — whither nobody knows;
 and those flowers red and fresh — for whom are they?

10 ENTERING THE CITY WITH HANDS HANGING DOWN

The Brushwood Gate is firmly closed, and the thousand
sages are unaware of his presence. He hides his innermost
thoughts, and has turned his back on the well-trod path
of the saints of antiquity. Picking up his gourd, he goes to
the city; carrying his staff, he returns home. Visiting
wineshops and fish stalls, his transforming presence brings
Buddhahood to them all.

Barechested and barefooted, he comes out into the
 market-place;
Daubed with mud and ashes, how broadly he smiles!
There is no need for the miraculous power of the gods,
For he touches, and lo! the dead trees come into full
 bloom.[41]

From one of the early 'Ten Oxherding' sets, four pictures are
known to us, one of which has survived in the form of a Kano
school copy of 1675. From this period at the latest, the small
square hanging scrolls are attributed to Li Sung (Li Song, active
c. 1190-1230). Whatever doubts one may have regarding this
traditional attribution, it is certain that the scenes, circularly
composed in fine brush-lines and with delicate ink-washes,
bespeak the hand of a gifted Sung (Song) master; and the
probably authentic inscriptions by the *ch'an* priest Shao-lin
Miao-sung (Shaolin Miaosong), who directed the Ching-tz'u-
ssu (Jingcisi) as its 29th head, and who, as 33rd abbot on the
Ching-shan (Jingshan), was Wu-chun Shih-fan's (Wuzhun
Shifan's, 1177-1249) direct predecessor, point to a date for the
composition of the series somewhere in the first third of the
thirteenth century.
About a hundred years later, according to reliable sources,

the Japanese artist Mutō Shūi whom we have to thank for the wonderful half-figure portrait of his Zen master, Musō Soseki (1275-1351) in the Myōchi-in in Kyōto, painted 'Ten Oxherding Pictures' which are, alas, no longer extant. It must have been an extraordinarily important work, for Musō presented it (together with a frontispiece in his own hand) to the ex-Emperor Sūkō (=Fushimi) who was living in the Kōmyō-in; and in 1382 the handscroll moved no less an experienced expert in literature and art than the Zen priest Gidō Shūshin (1325-1388) to make two entries in his diary. A complete set of ten circular pictures mounted in one handscroll, illustrating the 'Ten Oxherding Songs', has been traditionally attributed to the Zen Buddhist painter-monk Shūbun (active c. 1423-1460). It is no surprise that this series of paintings came to be associated with his name since it was handed down to the present day in the Shōkokuji, the famous Zen monastery in Kyōto where Shūbun had lived. The compositional scheme and certain stylistic features lead us to postulate derivation from the woodblock illustrations in one or more printed versions based on K'uo-an's (Kuoan's) original. No doubt, the same background underlies the *jūgyū-zu* handscroll which is preserved in the Hōshun-in of the Daitokuji. According to Japanese experts, this scroll belongs to the early stage of development of the Kano school in the fifteenth century.

The prompting and educative parable of the ox and its herdsman is paralleled in Zen art by prophylactic and admonitory pictures designed to point out those misleading paths which may present themselves to the seeker after understanding of his own Self, but which lead far afield from the true goal. The most popular symbol of the unenlightened self hopelessly enmeshed in the realm of earthly phenomena is the monkey trying to catch the reflection of the moon in the water (rarely shown in actual treatment of the theme) and thereby failing to see the real moon. On one humorous version of this monkey theme, in the Hosokawa collection in Tōkyō, the painter, Hakuin Ekaku (1685-1768), the powerful renovator of late Zen in Japan and a leading master of the so-called Zenga, has bequeathed us the following verse:

A monkey reaches out for the moon reflected in the water;

He will go on trying till he dies.
If he lets go, he sinks to the bottom.
The light shines brightly in all directions.[42]

Among the many versions of the monkey theme which are associated – even in early Japanese sources – with the name of the celebrated Chinese *ch'an* painter-monk, Mu-ch'i (Muqi), is a hanging scroll bearing an inscription by Hsü-t'ang Chih-yü (Xutang Zhiyu, 1185-1269). This picture, which is mentioned in the *Butsunichi-an kōmotsu mokuroku* – that is to say, a century after its putative origin, it was already in the Engakuji at Kamakura – shows a 'Monkey practising *zazen*'. The practice of sitting in meditation was central in most Zen monasteries, and virtually all serious adepts placed high moral value on it. Dōgen Zenji (1200-1253) who brought the Sōtō school of Zen to Japan, wrote as follows in his 'General Instructions for the Promotion of *zazen*':

> If you truly wish to attain to enlightenment, lose no time in practising *zazen*. Cast off all bonds, calm the ten thousand things, think not of good and evil, judge not concerning right and wrong, arrest the flow of consciousness, put a stop to the activity of wishing, imagining, judging, think not of becoming a Buddha![43]

We must ask ourselves, however, what it means when a *ch'an* monk like Mu-ch'i (Muqi), who was well acquainted with the practice, shows us a monkey deep in meditation. Is it meant as a parody? As a covert dig at the contemporary clergy? Or is it a tribute to the monkey as 'The Great Holy One who equals Heaven' (*ch'i-t'ien ta-sheng/qitian dasheng*) to whom in South China temples were actually consecrated? Probably what we have here is sarcastic criticism of a religious practice which had become altogether too one-sided, which had degenerated into an end in itself and which a monkey with a penchant for practical jokes might well try to imitate. The T'ang (Tang) master Nan-yüeh Huai-jang (Nanyue Huairang, 677-744) had already warned of the peril of spiritual cramp in the automatic practice of *zazen*. One day, he discomfited his pupil Ma-tsu Tao-i (Mazi Daoyi, 709-788), a highly zealous monk who never stopped meditating, by presenting him with a parable which seemed to poke fun at reason. 'Why', he asked him, 'do

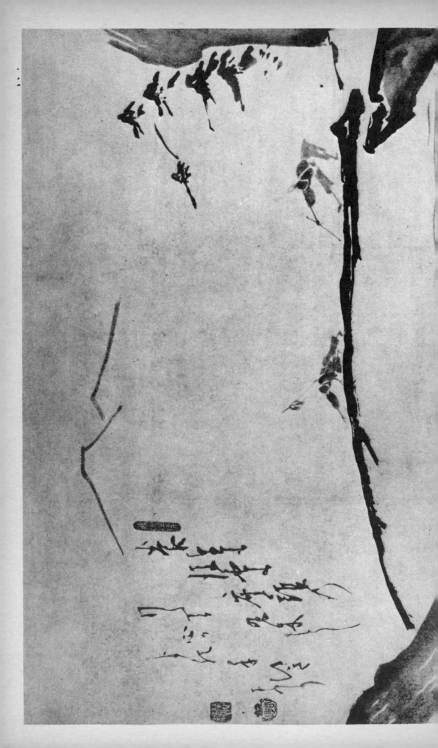

you practice *zazen?*' Ma-tsu (Mazi) answered, 'I want to become a Buddha.' Whereupon Huai-jang (Huairang) picked up a tile and began to polish it on a stone. His pupil asked him in some embarrassment what was the reason for this strange behaviour, and the master explained that he wanted to make the tile into a mirror. Ma-tsu (Mazi) was unconvinced: 'How can a tile become a mirror by polishing it?' he asked. To which Huai-jang (Huairang) replied: 'How can one become a Buddha by practising *zazen?*' In *ch'an* circles of the period, the mirror was already a current metaphor for the pure, enlightened spirit; and by reminding his pupil (in the deepest sense of the word) of this, the master was making it clear that the idea that one must *become* a Buddha is actually an obstacle on the path to the basic experience of Zen: namely, the insight that every creature already *is* or *has* Buddha-being.

Centuries later, the last great representative of modern Zen in Japan, Gibon Sengai (1750-1837) followed Mu-ch'i's (Muqi's) example of the meditating monkey with another cryptic work in the same spirit of critical irony. A few pale-grey brush-strokes giving the contours of a frog are accompanied by the line: 'If a man becomes a Buddha by practising *zazen*'[44] The following line remains unuttered but the implied thought is clear: because of its posture, a frog seems to be practising *zazen* all the time, so it should have become a Buddha long ago.

Josetsu, a Zen monk and painter who was active in the Shōkokuji at the beginning of the fifteenth century, also had recourse to metaphor to demonstrate the senselessness of trying to reach the essence of Zen via the convulsive use of unsuitable means, methods and instruments. One of his most famous paintings, in the Taizō-in of the Myōshinji in Kyōto, done in ink and delicate colours on paper, shows an old man by a mountain stream who is trying to catch a slippery catfish with a narrow-necked bottle-gourd — an obviously hopeless enterprise. It is probable that the Ashikaga Shōgun Yoshimochi (1386-1428), a talented painter himself and a Zen enthusiast, commissioned Josetsu to illustrate this Zen literary riddle known in specialist literature as *Hyōnen-zu*: the occasion being

Blind Men Feeling their Way across a Bridge, by Hakuin Ekaku (1685-1768). Private collection, Hamburg

a meeting of the Kyōto clerical literati around 1413. No fewer than thirty-one Zen 'literati-monks' (*bunjinsō*), including such important *gozan* representatives as Daigaku Shūsū (1345-1423), Gyokuen Bompō (1348-post 1420), Genchū Shūgaku (1359-1428) and Daigu Shōchi (died in 1439) were assembled to compose short poems on the theme. They wrote them on a sheet of paper to be attached to the reverse side of a small screen used to display Josetsu's picture. Subsequently the calligraphies were mounted above the painting thus forming one hanging scroll. The combination of painting, poetry and calligraphy in a single art-form was particularly popular in Zen circles in Japan during the first half of the fifteenth century. In the programmatic claims made by these *shigajiku*, 'Scrolls with Poems and Painting', we may see the first pioneering steps towards the creation of a *Gesamtkunstwerk*, conceptually multi-layered in each of its aspects.

From at the latest the period of the highly original *ch'an* master, Chao-chou Ts'ung-shen (Zhaozhou Congshen, 778-897), a man renowned for his paradoxical utterances, the bottle-gourd, a typical attribute of Taoist magi in China from the earliest times, was regarded in Zen circles too as something special. The gradual shedding of feelings and desires was compared to penetration of the gourd, as was also relapse into meditation in the seated position. It is initially difficult to get into the gourd, as the opening is so small; then the view-point becomes wider, but soon one lands in a further impasse. When this in turn is overcome, one has the feeling of being on a calm lake. In the long run, however, the bottle-gourd must be destroyed, if we are to penetrate to complete independence of all the limitations and constrictions of the phenomenal world. And as late as the turn of the eighteenth and nineteenth centuries, we find Sengai (1750-1837), much admired for his exuberant and humorous imagination, painting a calabash floating on the waves: an image which he explains, in an accompanying inscription, as a simile for final truth which, however hard we try to reach it, always manages to elude our grasp. Now it dives under, now it bobs up again – the one thing we cannot do is catch hold of it, though it swims there before our eyes.

It is only blind trust and unremitting adherence to the belief

in the goal of enlightenment which will lead us, quite unexpectedly and often in old age, when we have ceased to hope for it, to the other shore. This is what Hakuin (1685-1768) seeks to convey in several almost identical parable-pictures, showing two or three blind men cautiously feeling their way across a dangerously narrow bridge. His commentary to these pictures runs as follows:

> For life in old age let an example be
> The groping of the blind, who are crossing a bridge.[45]

In the spiritual climate of Zen, the breakthrough to enlightened vision could happen in the course of ordinary everyday life. This basic attitude is given artistic expression in a pair of pictures, for example, showing a 'Priest Sewing under Morning Sun' (Chinese: *chao-yang pu-chui/zhaoyang buzhui*; Japanese: *chōyō hotetsu*) and a 'Priest Reading his Sūtra-assignment by Moonlight' (Chinese: *tui-yüeh liao-ching/duiyue liaojing*; Japanese: *taigetsu ryōkyō*). In the view of Zuikei Shūhō (1391-1473), a priest of the Shōkokuji in Kyōto, it was a Sung (Song) poet named Wang Feng-ch'en (Wang Fengchen) who gave an impetus to this typically Zen product, through his couplet which we have just quoted.

The fact that short inscriptions on pictures were recorded in the *yü-lu* (*yulu*) of well-known *ch'an* masters, e.g. of Hsü-t'ang Chih-yü (Xutang Zhiyu, 1185-1269) or of Yüeh-chien Wen-ming (Yuejian Wenming, mid-thirteenth century) goes to show how popular these perennially associated themes were during the late Sung (Song) period. The earliest example still extant, and at the same time the best, a *chao-yang/tui-yüeh* (*zhaoyang/dui-yue*) picture of much charm and subtle humour, is the pair of hanging scrolls painted by the otherwise unknown Wu Chu-tzu (Wu Zhuzi) in the year 1295, now in the Tokugawa Bijutsukan in Nagoya. The right-hand picture shows a bald-headed monk on a rocky outcropping who is trying to thread a needle; the thread passes round his big toe and is held in the left corner of his mouth. On the companion scroll, another aged priest crouches with crossed legs on a rock; he is holding a manuscript scroll close up to his eyes in order to decipher the *sūtra* text in moonlight which is not otherwise indicated in the picture.

Structurally, the diptych is conceived as a whole with the

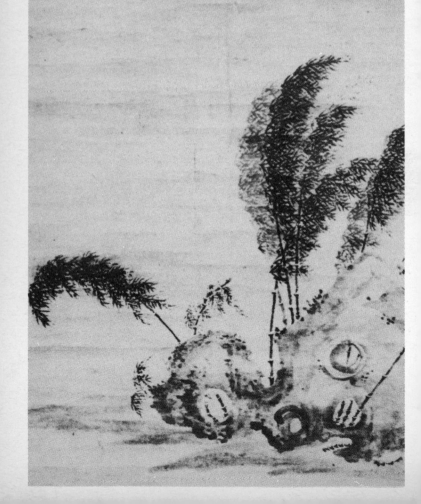

two figures facing each other, in sweeping grey brush-strokes with a few deeper touches of ink. Towards the upper edge of each scroll near the outer margin is an inscription in the artist's hand, which follows older convention by running along the same line of vision of the monks (shown in three-quarter profile). In Japan too, the *chōyō/taigetsu* theme was treated over and over again from the early fourteenth century onwards, as a constant and paradigmatic admonition to the Zen devotees to remember two important aspects of monastic life: on the one hand, the constant intermingling of intellectual and manual activities, neither of which can claim precedence over the other: spiritual-religious discipline and the physical routine of handicrafts, to which one must freely give oneself. On the other hand the obligation to remain, from early morning to late evening, from the first ray of sunshine to the light of the moon, wakeful and receptive in all that one does, ready for the sudden and unexpected breakthrough to self-awareness: the moment of 'seeing into one's own nature'.

BAMBOOS AND ORCHIDS

We have already spoken in some detail about the iconographic significance in Zen art of certain plants and animals, for example the monkey, the ox and plum blossom; and now a few remarks may be in order on the hidden layers of meaning to be discovered by the discerning eye in many other apparently ordinary everyday objects. From the graphic repertory of the cultured amateur painters, the literati, Zen painters borrowed two themes which made a very special appeal to them – the bamboo and the orchid, usually shown in association with bizarre rocks. Their charming form, their elegance and the properties associated with them in the oriental mind make both plants an inexhaustible source of inspiration and an ideal vehicle for the expression of specifically Zen Buddhist ideas. In addition, the close technical and artistic connection that exists in this particular area between calligraphy and painting offered

Rocks and Bamboo in the Wind; inscription by Ch'ing-cho Cheng-ch'eng (1274-1340). Nezu Art Museum, Tōkyō

the dilettante monk an invaluable opportunity for the spontaneous jotting-down of spiritual insights or personal impressions. And what mattered here was less polished virtuosity than an artless and unassuming, often playful insouciance.

For orientals, the bamboo embodies fundamental ethical values: its straight growth is compared with the upright character of an exemplary gentleman, its hard, regular stem with inner rectitude; though flexible, it is stable and firm like a noble spirit, and its leaves remain green throughout the seasons, suggesting the constancy, the power of resistance and the unshakable loyalty of a moral paragon. Furthermore, in apparent contradiction with its outward strength, it is hollow inside: which corresponds to the Zen ideal of 'inner emptiness' (Chinese: *k'ung/kong*; Japanese: *kū*). The bamboo possesses all of these virtues in simple and unassuming form, and it is small wonder that in Zen circles the ethical values symbolised by the plant, such as uprightness, strength, simplicity and purity, were deeply admired.

It also becomes clear why, from at least the tenth century onwards, Zen abbots in both China and Japan, had some of the rooms in their monasteries decorated with pictures of bamboo. As one of the 'Four Gentlemen' (Chinese: *ssu-chün-tzu/sijunzi*; Japanese: *shikunshi*) the bamboo joins the plum blossom, the orchid and the chrysanthemum in representing the four seasons; and as one of the 'Three Pure Ones' (Chinese: *san-ch'ing/sanqing*; Japanese: *sansei*) it was, together with old trees and rocks (or, according to another tradition, plum blossom and rocks) associated with high ethical and aesthetical standards, from the time of the statesman, poet, painter and calligrapher Su Tung-p'o (Su Dongpo, 1036-1101) onwards. This explains why in their writings Su and his friends never tired of urging meditative immersion in the nature of the bamboo which could lead to mystical identification with it. Ideas such as these were bound to find fruitful soil among Zen disciples, and the many poems and colophons on paintings by Zen Buddhist monks on the theme of the bamboo that have come down to us bespeak deep understanding and inner consensus. The Chinese *ch'an* priest Ch'ing-cho Cheng-ch'eng (Qingzhuo Zhengcheng, 1274-1340), who was working in Japan from 1326 on, begins the poem he wrote on an ink

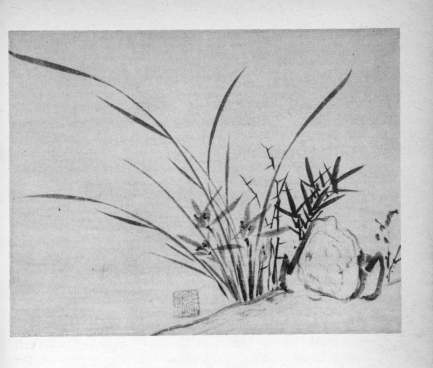

Orchids and Rocks, by Tesshū Tokusai (died 1366). Sansō Collection, USA

painting of 'Windblown Bamboo among Rocks' (now in the Nezu Museum, Tōkyō) with the line:

> The purity of rocks, how could it resemble the purity
> of bamboo!

The word *ch'ing* (*qing*), meaning 'pure', which the author has as first component in his four-character clerical name, appears no less than five times in the four-line verse. This is a striking testimony to the high value placed by the Zen adept on the moral ideal symbolised by the bamboo.

Nor was the artistic treatment of the orchid (epidendron) with its long, thin, pliant leaves, its subdued blossom and its exquisite perfume, left in the hands of the dilettante literati. On the contrary, it is probably no coincidence that some of the most famous and most skilful painters of orchids were in fact Zen Buddhist monks: such as, on the Chinese side, Hsüeh-ch'uang P'u-ming (Xuechuang Puming, died post 1349) who was active in the Yün-yen-ssu (Yunyansi) and Ch'eng-t'ien-ssu (Chengtiansi) at Soochow (Suzhou) and, on the Japanese side, the abbots he influenced – Tesshū Tokusai (died in 1366) and Gyokuen Bompō (1348-post 1420). Contemporary and conservative critics, it is true, ranked Hsüeh-ch'uang's (Xuechuang's) pictures as, at best, suitable 'only for display in monk's quarters' but this *ch'an* abbot must have enjoyed exceptional popularity as a painter, for we learn from other sources that every household in Soochow (Suzhou) had an orchid study from his hand.

Blossoming as it does in out-of-the-way places, the orchid was equally regarded as a symbol of womanly elegance, joyous elation, modesty and restrained nobility. In the Yüan (Yuan) period, when China was under Mongol occupation (1279-1368) the orchid became, especially for artists and intellectuals, a symbol of loyalty to the *ancien régime*, the overthrown Sung (Song) dynasty. Depicted then as no more than a play of lines against an empty background – that is to say, not rising from 'soil stolen by the invaders' – it became an emblem of political and spiritual underground resistance and of refusal to serve the barbarian conquerors. In his representations of orchids, Hsüeh-ch'uang P'u-ming (Xuechuang Puming) was of course mainly

Radish, by Jonan Etetsu (1444-1507). Sansō collection, USA

concerned with Buddhist ideas. He often arranges the leaves in pairs, the longer ones symbolising the spiritual lineage of the Mahāyāna – 'Leaves of the Great Vehicle' – while the shorter leaves were 'Leaves of the Lesser Vehicle' – the Hīnayāna.

Literati and Zen clergy alike were fond of depicting orchids in all sorts of weather: in wind, sunshine, moonlight, rain and snow. The *ch'an* priest Hsi-sou Shao-t'an (Xisou Shaotan, active 1249-1275), for example, wrote poems for three four-part series of this nature, which are to be found in chapter 6 of his 'Collected Works'; and Yen-ch'i Kuang-wen (Yanqi Guang-wen, 1189-1263), a *ch'an* master well known for his many colophons on paintings, added a quatrain to a picture of orchids traditionally attributed to Yü-chien (Yujian). The combination of orchid with bamboo, thorn-bush and rocks has figured in China since the thirteenth century, in Japan since the fourteenth, as part of the standard repertoire of the artist with literary inclinations.

FRUIT AND VEGETABLES

Fruit and vegetables seem rather prosaic subjects in comparison with the elegance of bamboo and orchid paintings, and it was only in the monastic setting of Zen that they might appear to merit attention. The radish (Japanese: *daikon*) and the turnip (Japanese: *kabu*) – both of them items in the strictly vegetarian diet of the monastery – are the vegetables most frequently selected for individual representation. Kigen Dōgen, who was a stickler for the rigorous observation of monastic discipline, pointed out that daily tasks in the kitchens were just as important as daily meditation or reading *sūtras*, and that centuries earlier the most venerable *ch'an* masters had held the office of *tenzo* or 'head chef'. In his *Tenzo-kyōkun* of 1237 Dōgen maintains that the vegetables chosen for the meal can be compared with the taste of *daigo*, one of the Five Tastes (*gomi*). As a fine-quality, nourishing extract of milk it was said to be the best of drinks which could also be used to cure all kinds of illness, and which served as a simile for the Buddha-nature, the true Teaching or Nirvāṇa. In Sanskrit it was called *sarpirmaṇḍa*:

If one chooses a simple vegetable and feeds the monks with it, then, provided that the [chef] has prepared it in due devotion to the law of the Buddha, it will be equal to foods tasting of *daigo*. Just as all rivers flow into the Great Pure Sea of the Buddha-law, there is basically neither *daigo* taste nor vegetable taste, but only that of the Great Sea And if one nourishes a shoot of the True Teaching (*dōge*) and nurtures the Holy Seed-corn of Buddha, all the more are the *daigo* taste and the taste of vegetables identical and in no way different . . . This is worth heeding. Let one reflect earnestly that the vegetable nourishes the seed from which Buddha arises, and causes the shoot of True Thinking to grow. Therefore let no one despise vegetables, but value them. He who wants to lead the way [to the Truth] in the world of men and of heaven, must be capable of bringing men closer to knowledge with the help of the simple vegetable.[46]

Given such claims, it is not surprising to find fruit and vegetables, radishes and turnips, aubergines and cabbages, persimmons (*kaki*) and horse-chestnuts being promoted to the status of suitable subjects of Zen art, and painter-monks like Mu-ch'i (Muqi), Jonan Etetsu (1444-1507) or Sesson Shūkei (*c.* 1504-*c.* 1589) giving them a firm footing in their iconographic repertoire. Nature's simplest products contain, as Dōgen asserts, the essence of the Buddha-law: they give an authentic 'fore-taste' of the final truth of Zen, one which is translated into visual-metaphoric terms in the ink drawings of the masters. And this being so, what we have to consider here is not simply still-life but specifically Zen Buddhist 'ciphers of transcendence', sparse and austere in their objectivity and soberly direct in what they convey.[47]

BIRDS: COCKS, SPARROWS AND WILD GEESE

What we have been saying about vegetables goes also for a series of pictures of birds which seem at first glance to have little to do with religion, and several unpedantic pieces of

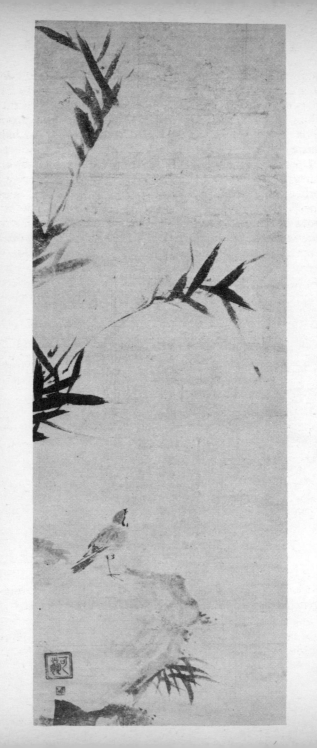

calligraphy, in which, however, basic concepts of Buddhist ethics are visualised, and the Zen concept of a spiritualised nature is made manifest. Let us take for example the picture of a 'White Cock under Bamboo' by the *ch'an* painter-monk Lo-ch'uang (Lochuang) who was active in the second half of the thirteenth century in the Liu-t'ung-ssu (Liutongsi) at the West Lake near Hangchow (Hangzhou) – that is to say, in the same monastery where Mu-ch'i (Muqi) had just recently been, or perhaps still was, abbot. Lo-ch'uang (Lochuang) himself provides a decoding for this picture, which is now in the Tōkyō National Museum. From the earliest times, the cock, the tenth creature in the Chinese zodiac, has been regarded in China as a main representative of the male *yang* principle. The white cock was revered as a holy creature, which possessed the power of holding evil influences at bay, and the colour of his plumage was an unmistakable pointer to the purity and the clarity of his mind.

Lo-ch'uang (Lochuang) covered the background with a uniformly grey ink-wash so that the cock may assume clear contours. Energy, decisiveness and harshness mark the features of the head which is proudly raised and facing left in profile. Following traditional custom, mainly observed in Zen portraiture, the master wrote his quatrain against the facing direction of the main subject, that is, from left to right. It is clear that, for him, the inscription was not of equal entitlement with the picture itself, but something compositionally subordinate, an auxiliary aid to its understanding:

> His mind is fixed on the beginning of the fifth
> night-watch.
> Deep and secret he conceals his Five Virtues.
> Looking up he awaits the time of brightness.
> The East is already delicately tinted.
> Lo-ch'uang (Lochuang)

The nocturnal scene is set in the first, third and fourth lines. In anticipation of first light, the cock is concentrating on his daily

Sparrow and Bamboo, by Kaō (first half of the fourteenth century). Yamato Bunkakan, Nara

duties as the responsible head of his flock, mindful as we are
told in the second line, of his 'Five Virtues'. In an ancient
commentary, the *Han-shih wai-chuan* (*Hanshi waizhuan*) of
Han Ying (*c.* 135 BC), which sets out to clarify the moral
principles contained in the classic 'Book of Songs', the *Shih-
ching* (*Shijing*), we are told that the cock is characterised by the
following five virtues: his crown-like comb symbolises literary
cultivation (*wen*), the spurs on his legs indicate his warlike
spirit (*wu*), his fearlessness and gallantry when faced by
enemies show his courage (*yung/yong*), his unselfish benevo-
lence is demonstrated by the fact that when he finds food he
summons his hens (*jen/ren*) and his precise, dependable instinct
for time and punctuality point to his reliability (*hsin/xin*).

These five qualities which the cock incorporated for
educated Chinese from the Han period onwards, and which
were certainly familiar to Lo-ch'uang (Lochuang), can apply in
the widest sense to any man of noble spirit, but are here no
doubt, translated into visual terms by a *ch'an* priest with the
lofty virtues of an exemplary abbot in mind. At the fifth watch,
round about 4 a.m., that is, life begins to stir in a Zen
monastery, and it is on this diurnal point that the abbot's
thoughts are fixed: well before day-break he is mustering his
five virtues, mindful of the well-being of the monks entrusted to
his charge. It is my opinion, therefore that in this, perhaps the
only painting by Lo-ch'uang (Lochuang) that has come down
to us, we are being reminded of fundamental principles of Zen
Buddhist ethics. Furthermore, the white cock is a reminder that
it was at the beginning of the fifth night-watch, as he was
looking at the morning star gleaming in the eastern sky, that the
historical Buddha Śākyamuni experienced his Great Enlighten-
ment, the 'Time of Brightness' referred to in the third line of the
poem – an experience on which the thinking and striving of all
Zen Buddhists is focused.

A moving testimony to the conviction that the Absolute can
be revealed in the simplest of forms, and a liking for the
humblest representatives of nature, is provided by a 'Eulogy for
a Dead Sparrow' by Ikkyū Sōjun (1394-1481) dating from the
year 1453, which is now in the Hatakeyama Kinenkan in
Tōkyō. In this 'Requiem' the eccentric Zen priest treats the
sparrow as a pupil, who has attained enlightenment, by giving

it a confirmation name; indeed, he goes so far as to compare its death with the Buddha's entry into Nirvāṇa:

> I once raised a young sparrow that I loved dearly.
> One day it died suddenly, and I felt an intense sense of grief.
> So I buried it with all the ceremonies proper for a man.
> At first I had called it *Jaku-jisha* ['Attendant Sparrow'].
> But I later changed this to *Shaku-jisha* ['Śākyamuni's Attendant'].
> Finally, I gave it the Buddhist sobriquet *Sonrin* ['Honored Forest'].
> And I attest to this in this *gāthā*:

> His bright gold body, sixteen feet long [lying between]
> The twin sāl trees on the morning of his final nirvāṇa,
> Liberated, free of the heretical cycle of saṁsāra,
> Spring of a thousand mountains, ten thousand trees,
> and a hundred flowers.
> 1453, eighth month, nineteenth day,
> Kyōunshi Sōjun.[48]

Metaphorical comparisons with central figures in the succession of the historical Buddha Śākyamuni are also to be found in an unfortunately badly damaged picture of 'Two Sparrows in Bamboo' by the Zen Buddhist painter-monk Ue Gukei, who was demonstrably at work in Kamakura between 1361 and 1375. Several references to him in the *Kūge-shū*, an anthology compiled by one of the central figures in Zen circles of Kamakura and Kyōto, Gidō Shūshin (1325-1388), indicate that he was a pupil of Gidō's friend Tesshū Tokusai (died in 1366). Gukei signed this charming little painting in the bottom right-hand corner, and on the upper-right hand part the Zen priest Tenan Kaigi (died in 1361) wrote a short poem. He was the eighth abbot of the Daijiji in Kumamoto Prefecture, where the hanging scroll has been handed down to the present time. The quatrain reads from left to right(!):

> Flying come the sparrows of Kāśyapa.
> Out surges the dragon of Maudgalyāyana.
> In the grove is the sacred child.
> Who is to open a Bodhisattva's palace?
> Tenan.[49]

Kāśyapa and Maudgalyāyana are reckoned among the Ten Great Disciples of the historical Buddha. The latter is renowned in Buddhist tradition for his spiritual power and his mastery of supernatural forces, while Kāśyapa is known for his silent understanding of the essence of Buddha's teaching — an understanding made manifest by his smile when he alone among the audience grasped what Śākyamuni meant by holding up a flower in response to a far-reaching question on belief.

Sparrows were without doubt a favourite theme among Zen Buddhist painter-monks: little feathered friends whose un-trammelled freedom and *joie-de-vivre* incorporated the ideal of liberation from earthly fetters which Zen adepts sought. Even if no poems or other written comments expressly identify a picture as such, most representations of sparrows have to be seen in the light of the religious intention of the priest-artist. After all, it is a generally underlying Zen notion that Buddha-nature is omnipresent in all sentient beings and phenomena even in their smallest, most mundane form; and it is not by chance that unpretentious pictures of this kind are particularly valued in Japan among devotees of the tea ceremony, which ultimately originated and developed in the Zen monasteries.

The antecedents of the parable of the 'Ox and its Herdsman' can be traced back all the way to India. A Hīnayāna *sūtra* describes eleven ways of looking after cattle, and compares this with the duties incumbent upon a Buddhist monk. Less familiar to most of us are the hidden layers of meaning in paintings showing wild geese and reeds, a pictorial theme which might have its original iconographic source also in old Indian Buddhist traditions. 'Reeds-and-Geese' had been popular in China from the late tenth century onwards. They came to acquire a religious significance in medieval Zen circles in both China and Japan. Four main aspects of wild geese — their flight (*hi*), their honking cry (*myō*), their sleep (*shuku*) and their feeding (*shoku*) — were used as metaphors for the 'Four Correct Demeanours' of Zen Buddhist monastic discipline, known in Chinese as *ssu-wei-i* (*siweiyi*), in Japanese as *shi-igi*: correct walking (*gyō*), correct dwelling (*jū*), correct sitting (*za*) and correct reclining (*ga*). It is true, we cannot make an exact correspondence between the four aspects of wild geese in nature and the four demeanours of Zen priests, but the

relationship between them is more than a mere numerical identity. It is not clear whether these 'Wild Geese-and-Reeds' pictures were meant from their inception to be taken in an allegorical sense, or whether it was the Zen masters of the thirteenth and fourteenth centuries who first gave them this paradigmatic association.

In the second part of the *Kundaikan sayūchōki*, a manual compiled towards the end of the fifteenth century for the shōgunal collection of Chinese art, we find a discussion as to how the works of art in the official reception room (*zashiki*) of the Ashikaga residence should be arranged. It contains a sketch of a set of four 'Geese-and-Reeds' hanging scrolls on the *tokonoma* wall, arranged from right to left in the order of crying, flying, sleeping and feeding. The collocation of four typical stages in the daily life of the wild geese is certainly not a chance one; the reference to exemplary monastic discipline would at that time have been perfectly obvious to everyone, and it no doubt served as a reminder for the priests and lay brethren going in and out of the Ashikaga residence, where, as Zen adepts, they were more than welcome. It is plain that 'Wild Geese-and-Reeds' sets of this sort were painted and hung to exercise an encouraging and admonitory influence on the viewer; that is to say, they served more than a purely decorative purpose. This also explains why so many interiors of Chinese and Japanese Zen monasteries were adorned with this particular pictorial theme. This is not only attested in the literature of the period; we also find evidence in the medieval handscrolls or *emaki* – e.g. in scroll No. 12 of the fourteenth-century *Genjō-sanzō-e*, the illustrated biography of the celebrated Chinese T'ang (Tang) priest Hsüan-tsang (Xuanzang, 603-664), now in the Fujita Bijutsukan in Ōsaka. Even today, one often encounters representations of wild geese and reeds on sliding doors (*fusuma*) or folding screens (*byōbu*) in the Zen monasteries of Japan.

As to why wild geese should be chosen as a metaphor of monastic discipline, we have no definite proof; but a speculation may be allowed. It is certain that in China wild geese were

Wild Geese and Reeds; inscription by I-shan I-ning (1247-1317). Private collection, Japan

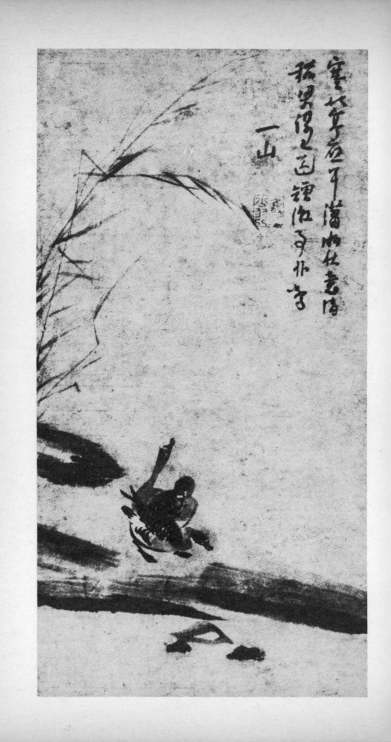

deeply admired because of their unfailing instinct for time and place of migration, for the extraordinary precision of their flight pattern and the unswerving loyalty to each other displayed by pairs. Ethologists have emphasised an exemplary degree of conjugal fidelity as one of the most noteworthy characteristics of the genus. In China, thanks to the intimate relationship between man and nature and to a gift for ethological observation which Western consciousness has very largely shed, wild geese have always been and still are regarded as symbolising marital fidelity. Finally, the wild goose figures widely in Chinese literature and history as a reliable messenger. In Buddhist sources, we sometimes find the wild goose as a motif in a Zen *kōan*. But such references throw little light, if any, on our question. More promising is an old Indian tale about wild geese, which was incorporated into the didactic moralising Buddhist literature where it was amplified and shaped to conform to Buddhist ethics. Without going into detail regarding the purely literary embellishments in the various versions, here is the gist of the story.

In a previous existence the historical Buddha Śākyamuni was the king of the wild geese. One day he flew with his skein of geese from the Citrakūta Mountain to a famous and very beautiful pond near Benares, where he was caught in a trap and was left hanging by one leg from the snare. He waited until his flock had eaten their fill; then he gave a warning cry, the geese rose up in great alarm and flew away. Only his faithful army commander Sumukha, an incarnation of Śākyamuni's disciple Ānanda, remained at his side, in spite of the Buddha's entreaties that he too should make his escape. When the trapper arrived on the scene, he was amazed to find that only one of the two geese was actually snared. Sumukha explained the matter to him, telling him of the virtue of loyalty between friends and to one's master, and the trapper was so moved that he released the king of the wild geese there and then. To thank him for his generous act and to see to it that he should be suitably rewarded, the two birds decided to be presented to the king of Benares, in whose service the trapper was employed. The king listened with amazement to the moving story, and had his obedient servant richly rewarded. Thereupon the king of the wild geese made his teaching known to the king of Benares and

discussed with him the law of right conduct, before returning with Sumukha to his subjects on Mount Citrakūta.

Illustrations of episodes from the so-called *Haṁsa-Jātaka*, are found among the wall paintings of the fifth and sixth century in the Buddhist caves of Ajanta in India (Caves II and XVII); and there are four splendid stone reliefs dealing with the same theme at the Borobudur in Java, dating from about 800. It seems not unlikely that this legend of one of Śākyamuni's earlier existences provided the impetus for the allegory of the wild geese which was obviously so highly thought of in medieval Zen circles in both China and Japan: after all, here we have the archetypes of Buddhist monasticism, the ultimate source Śākyamuni and one of his first two disciples, Ānanda, taking on the guise of wild geese as an analogue of correct, exemplary monastic demeanour in whatever situation, as an everlasting token of essential Buddhist ethics.

The eminent Japanese Zen priest Tesshū Tokusai was particularly preoccupied with the 'Wild Geese-and-Reeds' theme, clearly in response to his own inner convictions and his own ethical attitudes. It is known that his life was marked by strict monastic discipline, and that spiritually he was completely taken up with his intellectual and artistic endeavours. In his paintings he concentrated almost exclusively on ostensibly worldly and everyday subjects, such as monkeys and oxen as well as orchids, bamboo and rocks. Tesshū Tokusai had been trained under Musō Soseki (1275-1351) in Kyōto, and during the 1330s, following the precedent of other *gozan* monks, continued his studies in China. He served as primate in the Ch'eng-t'ien-ssu (Chengtiansi) in Soochow (Suzhou) where, in 1344, the *ch'an* master Hsüeh-ch'uang P'u-ming (Xuechuang Puming), who specialised in orchid painting, was appointed to the abbot's chair. Tesshū probably met the respected Chinese painter-monk in Soochow (Suzhou) and he must have been familiar with his paintings. Only one year before Hsüeh-ch'uang (Xuechuang) assumed the abbacy of the Ch'eng-t'ien-ssu (Chengtiansi) Tesshū had returned to Japan. In 1362 he became the abbot of one of the most important Zen monasteries in Kyōto, the Manjuji, and four years later he died in the Ryūkō-in, a subtemple in the precincts of the Tenryūji.

One of Tesshū's closest friends and a fellow disciple of Musō

Soseki was the eminent *gozan* priest Gidō Shūshin (1325-1388). Renowned both for his own outstanding literary accomplishments and his trenchant criticism of the superficiality of Zen monks' secular pursuits, he praised Tesshū's excellence in painting and calligraphy. In a eulogy on a fine ink painting of 'Orchids, Bamboo, Thorns and Rocks' written after Tesshū had passed away, Gidō expresses not only his admiration for his friend's artistic achievements but also his emotional attachment to him: 'When the old Zen priest played with painting, his brush was divine; both painting and calligraphy were unique and outstanding From time to time I open the scroll and tears wet my scarf.'[50] Parts of his literary output have survived in an anthology entitled *Embushū*. It contains a poem in memory of a dead wild goose. Like Ikkyū's 'Requiem' for his sparrow, Sonrin, it is imbued with a deep affection for an innocent creature. The poem has the title 'Mourning the Death of a Goose':

> Long ago I dug a pond and planted reeds for you,
> Always anxious that you might be bitten by a fox and die.
> How I regret that you spent your life evading hunter's
> arrows
> Only to leave me now, but not as a messenger carrying
> my letter.
> I could make friends with ground birds, but I have little
> time for them;
> I could talk with parrots, but I have no interest in their
> chatter.
> I pray that you will revive as a bird on the Pond in the
> West
> And await me there, preening the feathers of your green
> coat.[51]

In one of his best works, a pair of hanging scrolls in ink on silk (now in the Metropolitan Museum of Art, New York) Tesshū Tokusai has depicted all four aspects of the wild goose theme: twenty-five birds figure in each scroll, six of them flying, the others in groups on flat sandbanks, eating busily, having a nap, or raising their heads to utter their harsh cry. The execution is perhaps over-cautious, and there is a sameness in detail, a fondness for parallelism and repetition; but the geese

are shot through and through with the pulsating beat of life, and they exude an aura of late autumnal loneliness and chill, underlined by the stiff, pointed wind-blown sedge, which Tesshū has painted with startling, almost aggressive vivacity. Both scrolls bear the artist's square seal, one in the upper right, the other in the upper left. One of the pictures has in addition a short dedicatory inscription for a Chinese friend, but this is unfortunately damaged and incomplete.

Among the oldest extant representations showing reeds and wild geese in their four basic aspects as analogues of the correct behaviour of a Zen monk, are two hanging scrolls which once probably formed a pair but which today, as a result of successive remountings, vary slightly in size: they date from the early fourteenth century and are now in private Japanese collections. In the left-hand picture, three geese are sitting on a spit of land, close behind each other: the one in front is feeding, the second is sleeping and the third is stretching its neck upwards as it gives its cry. The right-hand scroll shows two geese flying away over sedge which is being lashed by wind and rain. The poetic inscriptions on each painting are by the Chinese *ch'an* master I-shan I-ning (Yishan Yining, 1247-1317) who was active in Japan from 1299 till his death, where he was greatly esteemed in clerical, intellectual and political circles. Many pictures bearing inscriptions in his hand are extant in Japan.

The two quatrains are written in two vertical lines. In them, the master has used his great literary skill to suggest the approach of winter and longing for the clear autumn days on the banks of the Hsiao and Hsiang (Xiao and Xiang) — two rivers renowned in Chinese literature for their scenic beauty. They are in the southern Chinese province of Hunan, and flow into the Tung-t'ing (Dongting) lake; and it was to this area that the geese returned every year to winter. This encourages us to assume that it was here, in the provinces of Hunan and Chekiang (Zhejiang) that artists first turned their attention to wild geese and reeds. The theme is used independently from the end of the tenth century on, and its spread in the eleventh century is associated with the names of the court painter Ts'ui Po (Cui Bo), the painter-monk Hui-ch'ung (Huichong) and of the imperial scion Chao Tsung-han (Zhao Zonghan). Its

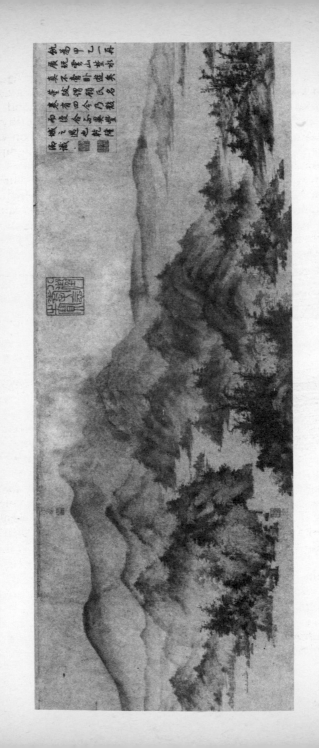

original intention was to give expression to a feeling of melancholy: it evokes thoughts of withering plants and grass in the cold of winter, the march of the seasons and the corresponding migration of many birds, the irresistible rhythm of nature; but if the emphasis is on the transitory and on what passes away, there is also a pointer to new life springing up, to return and to reunion.

It was inevitable that such ideas should appeal to the literati of the Northern Sung (Song) dynasty. One poem, which the celebrated Su Tung-p'o (Su Dongpo, 1036-1101) composed when he saw a picture of wild geese and reeds by Hui-ch'ung (Huichong), runs as follows:

> Hui-ch'ung's reeds-and-geese in mist and rain
> Lure me out to sit by the Hsiao and Hsiang Rivers and Tung-t'ing Lake,
> And make me want to hire a skiff to go home.
> Such is what a painting must do, as the ancients rightly said.[52]

LANDSCAPE: EIGHT VIEWS OF HSIAO (XIAO) AND HSIANG (XIANG)

It is from this purely literary viewpoint too that what is probably the most typical coupling of wild geese and reeds is treated in pictures entitled 'Wild Geese Descending to Sandbar', one of the 'Eight Views of Hsiao (Xiao) and Hsiang (Xiang)'. The first sets of the *Hsiao-Hsiang pa-ching* (*Xiaoxiang bajing*; Japanese: *Shōshō hakkei*) were allegedly painted by Sung Ti (Song Di, *c.* 1015-1080) and during the late eleventh century the titles of the individual themes appear to have taken the established order in which they are now known:

Wild Geese Descending to Sandbar
Returning Sail off Distant Shore
Mountain Market, Clear with Rising Mist

Detail from the handscroll, 'The Dream Journey to the Hsiao and Hsiang', by Li from Shu-ch'eng (c. 1170). Tōkyō National Museum

River and Sky in Evening Snow
Autumn Moon over Lake Tung-t'ing (Dongting)
Night Rain on Hsiao (Xiao) and Hsiang (Xiang)
Evening Bell from Mist-shrouded Temple
Fishing Village in Evening Glow.[53]

The Hsiao-and-Hsiang (Xiao-and-Xiang) theme itself very probably extends back into T'ang (Tang) times. In a eulogy on a new screen by an amateur painter named Liu, who was officiating as a judge, the great poet Tu Fu (Du Fu, 712-770) concurs that the landscape on the screen may well be a representation of the two celebrated rivers:

> I have heard it said that you first painted the landscape of your home district, and that now you are yielding to your desire to paint interesting ideal landscapes Confronted with this picture, spirit and mind are consoled, and one realises that you have indeed put your heart into painting on silk
> If this picture does not show part of the rocky Hsüan-p'u (Xuanpu) of the K'un-lun (Kunlun) Mountains, it may be taken from the region of the rivers Hsiao (Xiao) and Hsiang (Xiang) which now flow past here.[54]

Poetry-filled landscapes like this, their lineaments determined by weather conditions, by season of the year or hour of the day, by quality of light, by distant sounds, must have appealed very deeply to the eyes and the spirit of the Zen adept; for here was nature revealing herself in all her pulsating variety, her inexhaustible riches and her timeless quietude. These were landscapes for the mind as much as for the eye, mappings of existential experience into which the visionary beholder could transpose himself, and in which he was offered intensive experience of the infinity and richness of nature, and her ceaseless flux in the stream of existence. From needs such as these there arose – probably shortly before 1170 – one of the most beautiful ink paintings extant from any period. It is a handscroll, more than four metres long, now in the Tōkyō National Museum, entitled 'Home Traveler's Vista of Hsiao (Xiao) and Hsiang (Xiang)' (*Hsiao-Hsiang wo-yu t'u*/Xiao-

xiang woyu tu). According to the colophons dated 1170/1, the otherwise unknown *ch'an* monk Yün-ku Yüan-chao (Yungu Yuanzhao) commissioned the picture from an artist named Li who came from Shu-ch'eng (Shucheng) in Anhui Province: his reason being that, for thirty years, he had journeyed around without ever seeing the two famous rivers; now in his old age, he could fulfil his desire and at least pay them a visit lying on his back and looking at a picture of the marvellous scenery.

In delicately evanescent and aqueous greys, there opens up before our eyes a wide panorama of rivers and mountains, in which the ground of the unpainted paper has a main function as integrating component of the whole composition. This blank ground suggests wide expanses of water, mist-shrouded gorges and valleys, and the vastness of the sky. The velvety softness of the ink washes with its richly modulated gradation of tone creates a homogeneous atmosphere, into which every detail blends; and it sets the tempo for the flowing movement in the picture from right to left, which is based on smooth transitions and spatial intersections, with no abrupt caesura to bring the eye to a stop. The painter has almost completely eschewed firm contours and precise linear statement. Only where he is indicating the presence of buildings, bridges, boats and figures, does he allow himself a fine, restrained line technique. And yet, this indefinite haziness is by no means amorphous. It is true that if we take any section of the landscape and enlarge it, the counterpoint of aqueous wash and ink tinges with the activated background will tell us nothing further about the object or objects thus isolated; but we are made all the more aware of the immediacy of the creative act itself, and hence of the sensitive and spiritualised character of this artist. Contemplating this magical landscape, the *ch'an* monk Yün-ku (Yungu) must have found it easy indeed to make his dream journey, to traverse hundreds of miles with the eye of the spirit, and find himself serenely transported into the longed-for vision of Hsiao (Xiao) and Hsiang (Xiang).

How surprisingly close reality and unreality may lie to each other, and how in Zen the annulment of the frontier between them is felt to be a pointer towards the insight into the true nature of things, is strikingly set out by a sixteenth-century Chinese *ch'an* monk in a letter to a friend:

In my youth I once read [in the writings of Seng-chao (Sengzhao, 384-414)] that 'even whirlwinds that tear up mountains by the roots are really at rest, that the turbulent stream is not flowing, that the warm air dancing over the lakes in spring is not moving, and sun and moon as they fare on their paths are not really circling.' For many years I doubted these words. But then I spent a winter in P'u-fang (Pufang) with Master Miao-feng (Miaofeng). We were preparing a new edition [of the works of Seng-chao (Sengzhao)] and I was reading the proofs. When I came to the sentences [quoted above] I suddenly saw their meaning, and I was enlightened. My joy was boundless. I sprang up and threw myself at the feet of the image of Buddha – but strangely my body remained motionless. I drew the door curtain aside and stepped outside to look about me. A gust of wind shook the garden trees, and falling leaves whirled through the air. But as I saw it, not a single leaf moved, and then I knew that the storm which tears up the mountains by the roots is (really) completely at rest.[55]

But the objects in the picture, mountains and woods, rocks, and water, flowers, animals, and men – forms sprung from the void – stand there fully revealed in their actuality, plunged in the concrete situation of the Here and Now – and yet not in a mere Here and Now. Hence the impression of continual evanescence, as though the definite were being absorbed back into the indefinite, the formed into the formless, thus making visible the primal Ground from which they come.[56]

This applies very well to the versions of the traditional 'Eight Views of Hsiao (Xiao) and Hsiang (Xiang)' which are attributed to the painter-monks Mu-ch'i (Muqi) and Yü-chien (Yujian), who were working near the end of the Southern Sung (Song) dynasty. Sections from sets by both of these painters are still to be seen in Japan. Via a progressive loosening and slurring of the formal structure and a filtering and reduction of objects therein to shorthand indications, highly suggestive pictures are generated which demand the active collaboration of the viewer, and have an immediate effect on the imagination.

Everything is discarded except what is absolutely necessary; and yet the sketch-like quality of such works has nothing to do with what Western art understands by the word 'sketch': what we have here is the definitive product, spontaneously formulated, of a spiritual 'taking-thought'. Neither Mu-ch'i (Muqi) nor Yü-chien (Yujian) nor, indeed, their successors, the Japanese painters of the Muromachi period (1336-1573) were concerned with the exact reproduction of reality; rather, they sought to grasp the inner vitality of things, their inner essence, and their ear was quietly receptive to the 'spirit resonance', if we may use a classic expression from the ancient Chinese theory of art.

How landscape paintings should be appreciated by devoted Zen adepts was expounded by the eminent Japanese Zen master Dōgen on 6 November 1243 in a lecture on 'Plum Blossoms' recorded in his famous work *Shōbō-genzō* (vol. 59); referring to his deeply revered Chinese teacher Ch'ang-weng Ju-ching (Changweng Rujing, 1163-1228) he sets out:

> My late master, an ancient Buddha, said, 'Our original face possesses no life or death; spring is in the plum blossoms, as beautiful as a painted landscape.' When we paint a spring landscape we must not only paint willows, or red and green plums and peaches; we must paint spring itself. If you only paint those objects it is not a real painting. It has to be nothing but spring itself. And there has been no one in either India or China who can paint spring like my late master. His skill was very precise. The 'spring' we have been referring to is this 'spring' of the painted landscape. Spring must occur effortlessly in the painting. Plum. blossoms are necessary for this kind of painting. Spring must be put in the tree. Nyojō's [Ju-ching's (Rujing's)] skillful means are truly wonderful.[57]

SHIGAJIKU: SCROLLS WITH POEMS AND PAiNTINGS

From the fourteenth century on, landscape painting in Japan as practised by Zen Buddhist masters was very much under

Chinese influence; and, along with the classic Hsiao-and-Hsiang (Xiao-and-Xiang) theme, it was mainly representation of landscape in the four seasons of the year (*shiki sansui-zu*) that attracted Zen adepts. Their efforts to produce as comprehensive an expression as possible of their culture, their tastes and their common interests, were instrumental in the first half of the fifteenth century in helping to create a new kind of picture which they called *shigajiku* – 'Scrolls with Poems and Paintings'. On many of the narrow, elongated scrolls the poetic inscriptions dominate the visual impression so much that the painting in the lower part seems almost of secondary interest. The main concern was to document the getting-together of like-minded friends, the meeting of literary coteries (*yūsha*), led by well-known *bunjinsō* or 'literati-monks', as they took shape in Kyōto round the great Zen monasteries.[58] The collocation of calligraphy and painting, of word and image, of brush, ink and paper, however charming, was of secondary importance. For their possessors, such composite works had a very special affective value: most of them were presented to Zen priests as parting gifts or as tokens of friendship. The picture is often of a solitary hut, a hermit's study, or a pavilion by the side of a lake or on a river-bank, in the depths of the mountains: but these are not the mountains of the familiar homeland setting, but idealised mountains in the far-off landscape of China – something which most Zen monks had never seen with their own eyes, but which they knew all the more intimately from literature and painting.

Shosaizu – 'Pictures of a Writing-studio' – as this type of *shigajiku* is called, do not show a specific building in a specific, well-defined place. What the Zen adept saw in such a literary hermitage was rather an ideal place for self-identification, for finding one's true self. To make at least a temporary spiritual getaway from the busy world of a big-town monastery, the monk would hang a *shosaizu* up in his private studio, trusting that he could project his thoughts and his wish for peace and quiet into the picture. One of the earliest *shosaizu* is a hanging scroll, now in the Konchi-in of the Nanzen-ji at Kyōto,

Cottage by a Mountain Stream, attributed to Kichizan Minchō (1352-1431), dated 1413. Konchi-in, Nanzenji, Kyōto

attributed to Minchō (1352-1431). *Kei'in-shōchiku*, 'Cottage by a Mountain Stream' has a preface dated 1413, in which the Zen priest Taihaku Shingen, writing two years before his death, says that the monastery has become a 'noisy and annoying place — but one must face up to the noise of the market-place with a heart as quiet as water', and this is why such a painting is 'a picture for the heart' (*shinga*). Six of the most prominent *gozan* literati in Kyōto, including Daigaku Shūsū (1345-1423) and Gyokuen Bompō (1348-post 1423) contributed poetic inscriptions which are, in tone and diction, as faithful to Chinese tradition as is the picture itself.

Painting in the Service of Zen: Duties and Functions

The lavish decoration of Buddhist monasteries was an essential function of Buddhist sacral art in the Far East. One of the foremost functions of religious pictures was the so-called *chuang-yen* (*zhuangyan*; Japanese: *shōgon*), 'sanctification through ornamental splendour': the visualisation of the supernatural beauty of the holy figures and of the numinous sphere in which they resided, thus actualising the sacred presence in men's hearts. As the religious focus in ritual, the Buddhist painting became the crystallisation point of reverence and devotion; it could serve as a basis for the transition to transcendence, or it could be a precious sacrificial or votive offering. A Zen picture, on the other hand, is never called upon to acquire a magically evoked surrogate reality, and act as a contact point between the worshipper and what is worshipped. Rather, its functions are limited to a few basic requirements: for one viewer it may be a kind of memento, for another, it may have a hortatory or encouraging effect; it may be a document of spiritual or amicable bonds, a token of ethico-moral values or, finally, a general statement of Zen Buddhist ideology.

It is natural that a school which seeks to free itself from the fetters of strict orthodox ritual, dogma and iconography, and which lays its main stress on the life and personality of its founder and its great patriarchs and on the uninterrupted handing-down of authentic teaching 'from mind to mind', should be especially interested in recapitulating the decisive events in the lives of these, its great forebears. Thus the portraits of patriarchs – usually in series, showing successive generations of Zen Buddhist founder-figures, outstanding masters of a school or famous abbots of well-known monasteries – serve as timeless figures reminding the Zen community of their spiritual heritage. They serve as memorial and votive

pictures which were hung in the Founder's Hall or above the altar in the Lecture Hall, at commemorative celebrations, such as the *k'ai-shan-chi* (*kaishanji*; Japanese: *kaisan-ki*) the 'Memento mori rite [in honour of] the Mountain-Opener', or on the anniversary of the day of the founder's death. In the case of the historical Buddha Śākyamuni, two of the most important celebrations in the liturgical year were in honour of his birthday and the anniversary of his death; and a third was the eighth day of the last month (Chinese: *la-pa/laba*; Japanese: *rōhachi*, also *rōhatsu*) the day when looking at the morning star, Śākyamuni achieved the breakthrough to enlightenment. On the occasion of this, the great emancipation, a meditation session lasting seven days takes place in Zen monasteries. This exercise is known in Japanese Zen as *rōhachi-sesshin*, and it concludes with the recitation of the hymn on the 'Great Compassion' (*daihi*) performed before a *Shussan Shaka-zu*, a picture of 'Buddha Returning from the Mountains'.

The fifth day of the tenth month is sacred to the memory of Bodhidharma, the first *ch'an* patriarch in China; and on this day portraits of him, featuring incidents in his life and work, decorate the precincts of Zen monasteries. The commemorative function is also discharged by those Zen portraits made immediately after the death of a high priest, and which are therefore still eloquent of his personality. These portraits were borne in funeral processions and ceremonies. The third anniversary of the death of the Chinese Zen master I-shan I-ning (Yishan Yining, 1247-1317) who was so deeply venerated in Japan, was celebrated by the monastic community of the Nanzenji in Kyōto on the twenty-fourth day of the ninth month in 1320. The ex-Emperor Go-Uda (1267-1324) who was taking part in this 'High Mass' wrote a eulogy in his own hand on the picture of the abbot which was being used in the ceremony. This ruler had abdicated from the throne in 1287, and in his day he had shown I-shan I-ning (Yishan Yining) boundless trust, support and reverence. For a Zen disciple entering a monastery, the initiation ceremony was less of an official mass than a private religious exercise carried out in an intimate circle of like-minded friends. However, it too was an occasion when the portraits of eminent Zen masters were sometimes unrolled. We know from the Ashikaga Shōgun Yoshimitsu (1358-1408)

that when he took monastic orders in 1395, he received the tonsure seated before a portrait of the venerated, and politically extremely influential Musō Soseki (1275-1351), the founder abbot of the Tenryūji; and that he urged those present – his friends, noblemen and high military dignitaries – to follow his example.

Chinsō – portraits of Zen masters painted from life – had a dual purpose. For the Zen pupil, the portrait of his master together with the master's dedication, was, firstly, a visible token of the spiritual bonds linking them: a Zen *point d'appui*, spiritual sustenance, which the recipient hung up in his study so that he could communicate with the exemplar even in his physical absence. Secondly, the portrait of a Zen master provided the disciple with documentation and authentication of the true doctrinal succession. In this capacity, the picture took on the function of a *yin-k'o* (*yinke*; Japanese: *inka*), a certificate of mastery attained.

In our discussion of various forms of Zen Buddhist painting we have already mentioned its task of providing the Zen disciple with paradigmatic examples in support of his own efforts, its role as sign-post. It remains only to mention an admittedly secondary, purely decorative role played by many of these works, which embellished monastery rooms in the shape of sliding doors or folding screens; or which, in their role as 'tea-pictures' (*cha-gake*) formed the aesthetic catalyst in that apotheosis of cultured refinement and restful simplicity – the tea ceremony.

Formal Principles and Technical Means

Zen Buddhism lays claim to 'a special tradition outside scriptures'; it aims at an absolute Nought lying beyond all form and colour, at emptiness, and it has virtually abandoned any attempt to present religion in terms of lavish show and decoration. Almost inevitably, then, the painting associated with it was bound to break with the traditional conventions of orthodox Mahāyāna art and take to other paths, following very different formal principles and making use of very different artistic techniques and materials. Thus, Zen painting has never attempted to depict even its loftiest religious beings, the Buddha himself and the Bodhisattvas, in numinous glory and supernatural remoteness. This is why it could afford to dispense with two formal principles which played an essential part in traditional religious painting: on the one hand, the representation of graduated levels of existence, extending from the highest and most ineffable sphere of the Buddha in all its other-worldly harmony and incorporeal abstraction, down to the tellurian sphere of men; and on the other hand, the principle of hieratic scaling which differentiated figures in size and structural prominence in accordance with their religious ranking.

The sacred figures of Zen remain always on the level of human and earthly experience. Even when spiritually idealised or given heroic intensification, they remain identifiable as our earthly partners, empirically accessible. Figures formed by and imbued with the spirit of Zen always have – apart from a few exceptions – a historical dimension. In general, we may say that Zen painting takes as its starting point what is present and commonplace; it lays value on biographical details and it takes for granted what is anecdotal and legendary and integrates it into the work just as readily as it deals with what is everyday and unpretentious. However, it does not seek to offer a stocktaking corresponding exactly to appearances, by means of

148

either realistic or illusionist means. It is only the *chinsō* – the portraits of Zen Buddhist masters done from life – that try, in keeping with their *raison d'être* as delegates, to present the spiritual presence of the subject with as great a degree of verisimilitude as possible, and independently of space or time. Here, Zen painting too follows relatively strict rules, which, as we saw, go so far as to make direction of gaze the determining factor in deciding in which direction an inscription is to run: a convention which has left its mark on a large part of Zen Buddhist figure-painting.

In other respects, however, Zen painting enjoys a freedom from rules, systems and principles which is difficult if not impossible to define in detail. When we were discussing the aesthetics of Zen and its attitude to art, we saw that the typical Zen work of art is marked by such characteristics as asymmetry, simplicity and naturalness. Axiality, parallelism, *en front* presentation – whatever is associated with symmetry is discarded in favour of a rhythmic correspondence and balance which seem to arise spontaneously in a single act of cognition, carried out with somnambulistic security. The objects in the picture 'go together' of themselves, as it were, obedient not to some rationally designed plan of composition or ordering principle, but to an inner logic and an inner necessity. From this are generated latent tensions: between painted and unpainted surfaces, between line and wash, between light and dark, between object and space. Zen painting has been able to reduce its objects to their essentials while avoiding any crucial diminution in their real status, and to eliminate whatever diverts attention from the core of the artistic statement. *Pari passu* with this distillation of a concentrate goes the subordination of colour: indeed, to a great extent, colour is discarded. In portrait painting, it is true, we are shown Zen abbots in splendid and colourful regalia: elsewhere, especially in pictures of Arhats, we also encounter the use of colours. Śākyamuni and Bodhidharma usually appear in a simple red monk's robe.

The basis of Zen art, however, is the monochrome ink-painting. This is what best meets Zen demands for spontaneous, individual expression, for meditative absorption, for simplicity and, in the last resort, for an all-embracing emptiness. At its apogee, Zen Buddhist ink-painting could draw on techniques

which had developed over centuries in secular painting in China, and which had reached a high pitch of perfection. The so-called 'broken ink' technique (Chinese: *p'o-mo/pomo*; Japanese: *haboku*), the application of the fluid medium in graduated washes, without any suggestion of firm contours or colours, opened up hitherto unsuspected possibilities for individual and emotional artistic expression. The technique probably harks back to the painter-poet Wang Wei (699-759) who was idealised by the literati painters; and full realisation of the potential for artistic expression residing in this new technique was probably reserved for those painters of the Southern Sung (Song) dynasty (1127-1279) who were accorded the highest veneration in Zen circles in both China and Japan.

About the same time, towards the end of the seventh and the beginning of the eighth century, another new technique came to be used, one which even then was felt to be eccentric – the 'splashed ink' manner; and it so happens that in Chinese this is also read *p'o-mo* (*pomo*), though written with different characters; in Japanese it is read *hatsuboku*. This technique owes much of its artistic charm to painters who ignored traditional norms and acted in accordance with their inner freedom: a charm arising from their light-hearted play with brush and ink, and from the chance effects thus naturally generated. As classic examples of radical abbreviation, of reduction to a few essential elements, we may take the sections preserved in Japan, from the two sets of the 'Eight Views of Hsiao (Xiao) and Hsiang (Xiang)' which are attributed to the Sung (Song) painter-monks Mu-ch'i (Muqi) and Yü-chien (Yujian). On the Japanese side, the Zen priest Sesshū Tōyō (1420-1506) painted in 1495 a landscape (now in the Tōkyō National Museum) which is the most celebrated work in this technique so congenial to the free spirit of Zen.

Similar tendencies had been making themselves felt in the field of calligraphy; and around the middle of the eighth century they reached a first apogee in the impetuous creations of the 'mad monk' Huai-su (725-c. 785) who is said to have exercised his hand – especially when he was drunk – on banana leaves, wooden boards, clothes and walls. His eccentric style of writing was admired not only among the unconventional Sung (Song) literati, but, significantly, was from the thirteenth to

the fourteenth century onwards very warmly received by Chinese and Japanese Zen monks. For example, it is from this source that the free, cursive style of I-shan I-ning (Yishan Yining, 1247-1317) ultimately derives, and Gidō Shūshin (1325-1388) compared in a colophon the loose style of writing of his friend Tesshū Tokusai to the calligraphy of the wild T'ang (Tang) monk.

For the painter too, the apparently haphazard handling of his materials presented an opportunity for an unprecedented freedom and immediacy in self-expression. Now he could give visual form to his most fleeting reactions. Here, the accent is on 'jotting down the [instantaneous] idea' – *hsieh-i* (*xieyi*), as it is called in Chinese, in which exact reproduction of objects, the effort, that is, to achieve formal verisimilitude, takes second place to an entirely personal way of graphic expression – the artist's 'handwriting'. The dynamic, rough brush-work and the deliberately unpolished use of the ink combine to produce an effect which was very popular in unconventional Zen painting: as the brush 'flies over' the painting surface the hairs of the brush are spread so that the white of the paper is actually visible through the stroke, giving the effect known in Chinese as '*fei-pai*' (*feibai*; Japanese: *hihaku*) – 'the over-flown white' (not 'flying white', as usually incorrectly translated). It fixes a fleeting moment of consummation. When a brush-stroke was to have this striated, almost clumsy effect, painters and calligraphers alike preferred to use an old frayed-out 'dry brush' (Chinese: *k'o-pi*/*kebi*; Japanese: *kappitsu*).

Pride of place in the wide spectrum of artistic means and ends is taken by the line. Classical art in East Asia, both religious and secular, is essentially built up on a cool, distanced and supra-personal linear language. Here the line has no special value in itself: it is evenly thin, precise and functional, and, whatever its rhythmic-musical qualities and its ornamental effect, its main purpose is always to separate spaces and to act as a contour in defining spaces thus delimited as objects. In its purest form this is achieved by the so-called 'drawing on white' (Chinese: *pai-miao*/*baimiao*; Japanese: *hakubyō*) which discards colour altogether. This remained a department of figure-painting. Its most important representative was the painter-poet, antiquarian and court official Li Kung-lin (Li Gonglin, *c.*

1049-1106), and it was very rarely used in the treatment of Zen Buddhist themes. The potential sublimity of expression which Zen art could also achieve via the pure line-drawing may be gauged from the Sixteen Lohan handscrolls attributed to Fanlung (Fanlong) in the Freer Gallery of Art, a Yüan (Yuan) painting showing the 'Four Sleepers' in the Tōkyō National Museum, or the almost ascetically austere and nearly dematerialised representations of the Bodhisattva 'Kuanyin in a White Robe' by the *ch'an* painter-monk Chüeh-chi Yung-chung (Jueji Yongzhong), who was a pupil of the abbot Chung-feng Mingpen (Zhongfeng Mingben, 1263-1323) and lived in the Huanchu-an (Huanzhuan) just outside Soochow (Suzhou). One of his Kuanyin drawings is now in the Cleveland Museum of Art.

The antithesis of the strict, uniformly fine and dematerialised lines of the *pai-miao* (*baimiao*) is provided by the lively and expressively modulated lines of the ink-painting. This takes a first and unchallenged place in Zen Buddhist painting, especially where the depiction of figures is concerned. Its vitality comcs from a flexible ebb and flow which not only confers a certain two-dimensionality upon the work, but also gives the objects depicted corporeal substance and plastic volume thanks to its subtle properties of shading and modelling. Varying thickness of line coupled with immanent gradation in tone ensures smooth flowing transition between line and plane surface, between brightness and darkness, between object and empty ground, between body and space: a reciprocal dialectic through which is achieved the openness which is congruent with the essential aims of Zen, and which eschews unilateral commitment and finality. The flowing ink-line, obedient to laws which, in the final analysis, have nothing to do with the object portrayed, does not conceal its generation; rather, it lets the viewer follow the process of its becoming, and thus take part in an act of creation which is at once timeless and fleeting.

The painter Liang K'ai (Liang Kai), who was active in the Imperial Academy in the first half of the thirteenth century, was in close contact with the *ch'an* clergy of Hangchow (Hangzhou) and treated a number of typically Zen Buddhist themes in the course of his stylistically very wide-ranging output. *Inter alia*, his name is inseparably associated with a reductionist linear language, known in Chinese as *chien-pi* (*jianbi*), in Japanese as

gempitsu-tai. Seeking as it does the most extreme abbreviation and concentration of the image as conceived, this spontaneous use of 'abbreviated brush' is very close in its intensity and purity to the essence of meditative Buddhism. A poem contained in the anthology of the *ch'an* master Pei-chien Chü-chien (Beijian Jujian, 1164-1246) who seems to have been a close friend of the eccentric court painter, begins with a sentence which sums up the *chien-pi* (*jian-bi*) technique:

> Liang K'ai [Liang Kai] is sparing with his ink, sparing as though it were gold; but when he is drunk, [the treasured drops of ink] could suddenly become a downpour. Sometimes singing, sometimes silent, this heavenly music comes and goes by its own will. While the ordinary painters could do nothing but [lay down their brushes and] become completely lost.

The 37th abbot of the Ching-tz'u-ssu (Jingzisi) presented this poem to 'the Imperial Attendant Liang of the Court Service', as we learn from the title.

Along with the extreme abbreviation of this ink technique, from the thirteenth century on, Zen Buddhist figure-painting made use of a related stylistic idiom, whose effect depends on the intimate relationship between the form depicted in delicate pale-grey ink lines, sparingly accentuated and pointed where necessary in deep black, and the empty ground. The Confucian scholar Lou Yo (died 1213) caught its ephemeral character well when he called it *wang-liang-hua* (*wanglianghua*; Japanese: *mōryōga*), which means something like 'apparition painting' or 'ghost painting'.[59] Lou Yo, who was on friendly terms with several well-known *ch'an* masters, had an opportunity to observe this, at the time, novel style in the work of the painter-monk Chih-yung (Zhiyong). This Chih-yung (Zhiyong) is supposed to have lived during the second half of the twelfth century in the Ling-yin-ssu (Lingyinsi), one of the biggest *ch'an* monasteries in Hangchow (Hangzhou), and to have painted his pictures with an ink-solution so thin and watery that the object depicted could hardly be recognised: in 'ghostly fashion' it surfaced, as it were, only to disappear again in the circumambient emptiness. Figures executed in such a pale ink tone that they appear almost formless and unreal represent the pictorial

embodiment of a concept of 'being and non-being', images of the paradoxical Zen philosophy regarding reality and illusion. It would be difficult to find a better description of the ambivalent 'hovering' quality of *wang-liang-hua* than that given by Dietrich Seckel:

> But it is precisely in the visualisation, the making-conscious of the ontologically determined boundaries of the phenomenal, and in the suggestion that they can be crossed, that the quintessential achievement of this art — and hence of the viewer inspired and moved by it — lies. The 'sketchiness' of a Zen picture is therefore something quite different from what we in the West understand by 'sketch'. It is an abbreviated statement which concentrates on the essential inner nature of things, something we can only guess at, and which at the same time offers an apparent paradox: the self-set aim to cross a self-set boundary. But religious insight will see that there is no real paradox here; and in the same way the realm of depicted objects fades gradually into the realm of the empty ground, from which they seem now to emerge and into which they now seem to fade back, dream-like and shadowy: a ground which seems to shine through their very transparency. Here we are taken close to a limit where the limitless looms before us, and where contradiction is transcended.[60]

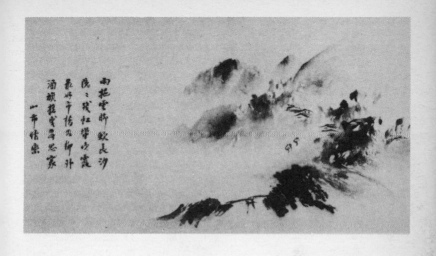

'Mountain Market, Clear with Rising Mist' from a series of 'Eight Views of Hsiao and Hsiang', by Yü-chien (second half of the thirteenth century). Idemitsu Museum of Arts, Tōkyō

Notes

1 Originally published in German as *Zen in der Kunst des Bogenschiessens*, Konstanz, 1948.
2 *The Method of Zen*, London, 1960, p. 57. Originally published in German as *Der Zen-Weg*, Weilheim/Obb., 1958.
3 Daisetz T. Suzuki in his introduction to Eugen Herrigel's book *Zen in the Art of Archery*, p. 10.
4 Daisetz T. Suzuki in his introduction to the original German edition of Eugen Herrigel's book *Zen in der Kunst des Bogenschiessens* only, p. 8.
5 Only in the German edition of Eugen Herrigel: *Der Zen-Weg*, p. 9.
6 Huang-po, *Der Geist des Zen*. Der klassische Text eines der grössten Zen-Meister aus dem China des 9. Jh., hrsg. von John Blofeld, Bern, München, Wien, 1983, p. 83.
7 Cf. Wilhelm Gundert, *Bi-yän-lu*. Meister Yüan-wu's Niederschrift von der Smaragdenen Felswand, verfasst auf dem Djia-schan bei Li in Hunan zwischen 1111 und 1115, im Druck erschienen in Sitschuan um 1300, München, ch. 1-33, 1960, chs. 34-50, 1967, chs. 51-68, 1973.
8 Cf. Heinrich Dumoulin, 'Das Wu-mên-kuan oder "Der Pass ohne Tor" ', *Monumenta Serica*, vol. VIII, 1943, pp. 41-102, and Dumoulin, *Wu-mên-kuan: Der Pass ohne Tor*, Monumenta Nipponica Monographs, no. 13, Tōkyō, 1953.
9 For an excellent survey of the history of Zen Buddhism in India, China, and Japan see Heinrich Dumoulin, *Geschichte des Zen-Buddhismus*, vol. I, *Indien und China*, Bern, 1985, and vol. II, *Japan*, Bern, 1986.
 For the complex organisation of the *gozan* system see the thorough study of Martin Collcutt, *Five Mountains. The Rinzai Zen Monastic Institution in Medieval Japan*, Cambridge, Mass., and London, 1981.
10 *The Method of Zen*, p. 52.
11 Daisetz T. Suzuki, *Essays in Zen Buddhism* (First Series), London, 1949, p. 24.
12 *Zen and Japanese Culture* (Bollingen Series LXIV), Princeton, 1959, pp. 31f.

13 *Ibid.*, pp. 44f.
14 Cf. Lao-tse, *Tao-Tê-King*. Übersetzung, Einleitung und Anmerkungen von Günther Debon, Reclam Universal-Bibliothek no. 6798/98a, Stuttgart, 1961, p. 76.
15 See John M. Rosenfield, 'The Unity of the Three Creeds: A Theme in Japanese Ink Painting of the Fifteenth Century', in *Japan in the Muromachi Age*, ed. John W. Hall and Toyoda Takeshi, Berkeley, Los Angeles, London, 1977, p. 223.
16 *Ibid.*, p. 219.
17 Daisetz T. Suzuki, *Sengai. The Zen Master*, London, 1971, no. 46, p. 103.
18 The original Japanese edition was published in Kyōto, 1958. *Zen and the Fine Arts*, translated by Gishin Tokiwa, Tōkyō/Palo Alto, 1971, pp. 28 ff.
19 Cf. in this connection Wilhelm Gundert's admirable translation under the title *Bi-yän-lu* (see note 7).
20 Translation by Ann Yonemura in *Japanese Ink Paintings*, ed. Yoshiaki Shimizu and Carolyn Wheelwright, Princeton, 1976, no. 9, p. 88.
21 Cf. Wilhelm Gundert, *Bi-yän-lu*, vol. 1, München, 1960, p. 264.
22 *Zen und die Künste*. Tuschmalerei und Pinselschrift aus Japan, ed. Museum für Ostasiatische Kunst der Stadt Köln, Köln, 1979, no. 2.1, pp. 38f.
23 Dietrich Seckel, *Jenseits des Bildes*. Anikonische Symbolik in der buddhistischen Kunst. Abhandlungen der Heidelberger Akademie der Wissenschaften, Philosophisch-historische Klasse. Heidelberg, 1976, p. 61.
24 *Shōbōgenzō* (The Eye and Treasury of the True Law), translated by Kōsen Nishiyama and John Stevens, vol. II, Tōkyō, 1977, pp. 146 ff.
25 Translation by Fumiko E. Cranston in *Song of the Brush. Japanese Paintings from the Sansō Collection*, ed. John M. Rosenfield, Seattle, 1979, no. 22.
26 Jan Fontein and Money L. Hickman, *Zen Painting et Calligraphy*, Museum of Fine Arts, Boston, 1970, no. 42, p. 99.
27 *Ibid.*, p. 99. The 'Diamond Throne' refers to the Vajrāsana or Bodhimanda, the seat where the Buddha attained Enlightenment; and the 'one body' to the universal Buddha-nature.
28 Dietrich Seckel, *Buddhistische Kunst Ostasiens*, Stuttgart, 1957, p. 236.
29 See Helmut Brinker, *Shussan Shaka–Darstellungen in der Malerei Ostasiens* (Schweizer Asiatische Studien, Monographie 3), Bern/Frankfurt am Main/New York, 1983.
30 *Ibid.*, pp. 27f. and p. 118.

31 'Shâkyamunis Rückkehr aus den Bergen', *Asiatische Studien*, XVIII/XIX, 1965, p. 37.

32 Translation by Wai-kam Ho in: *Eight Dynasties of Chinese Painting: The Collections of the Nelson Gallery-Atkins Museum, Kansas City, and The Cleveland Museum of Art*, Cleveland, 1980, no. 65, p. 83.

33 Thomas Lawton, *Chinese Figure Painting*, Freer Gallery of Art, Fiftieth Anniversary Exhibition, Washington, D.C., 1973, no. 20, p. 99.

34 *Cold Mountain. 100 Poems by the T'ang poet Han-shan*, Translated and with an Introduction by Burton Watson, New York and London, 1962, p. 118.

35 *Ibid.*, p. 115.

36 Daisetz T. Suzuki, *Essays in Zen Buddhism* (First Series), London, 1949, pp. 220 f., and Daisetz T. Suzuki, *Manual of Zen Buddhism*, Kyōto, 1935, pp. 95 f.

37 After the German translation of Wilhelm Gundert in *Lyrik des Ostens*, München, 1952, p. 425.

38 Jan Fontein and Money L. Hickman, *Zen Painting et Calligraphy*, Museum of Fine Arts, Boston, 1970, no. 29, p. 73.

39 *Asiatische Studien*, XVIII/XIX, 1965, p. 64.

40 For questions relating to Zen Buddhist portraiture see Helmut Brinker, *Die zen-buddhistische Bildnismalerei in China and Japan* (Münchener Ostasiatische Studien, Bd. 10), Wiesbaden, 1973.

41 The English translations of the prose paragraphs are taken from Jan Fontein and Money L. Hickman, *Zen Painting et Calligraphy*, Museum of Fine Arts, Boston, 1970, pp. 116 f.; the translations of the short poems are based with a few alterations on D.T. Suzuki, *Essays in Zen Buddhism* (First Series), London, 1949, pp. 371 ff.

42 Rose Hempel, *Zenga. Malerei des Zen-Buddhismus*, München, 1960, fig. 22, p. 62.

43 Heinrich Dumoulin, *Zen. Geschichte und Gestalt*, Bern, 1959, p. 163, and Heinrich Dumoulin, *Geschichte des Zen-Buddhismus*, Bd. II, *Japan*, Bern, 1986, p. 55.

44 Daisetz T. Suzuki, *Sengai. The Zen Master*, London, 1971, no. 40, pp. 94 f.

45 Kurt Brasch, *Zenga. Zen-Malerei*, Tōkyō 1961, fig. 54, p. 168; and Rose Hempel, *Zenga, Malerei des Zen-Buddhismus*, München, 1960, fig. 27, p. 62.

46 Oscar Benl, 'Die Lehre des Küchenmeisters. Das Tenzo-kyōkun von Dōgen', *Oriens Extremus*, 22/1, Juni 1975, pp. 78 f.

47 The Edo artist Itō Jakuchū (1716-1800), layman and son of a Kyōto greengrocer, expresses in a painting his devotion for vegetables by euphemistically likening a reclining radish surrounded

by a group of vegetables to the Buddha's *parinirvāṇa*. This so-called *Yasai-nehan*, 'Vegetable Nirvāṇa', is in the Kyōto National Museum; cf. Jorinde Ebert, 'Das Gemüse-Nehan von Itō Jakuchū', in *XIX. Deutscher Orientalistentag*, Freiburg i.Br., 1975, Vorträge (ZDMG Suppl. III, 2), Wiesbaden, 1977, Bd. 2, pp. 1584-8, and Yoshiaki Shimizu, 'Zen Art?', in *Zen in China, Japan, East Asian Art*, ed. H. Brinker, R.P. Kramers, C. Ouwehand (Schweizer Asiatische Studien, Studienhefte, Bd. 8), Bern/Frankfurt am Main/New York, 1985, pp. 97 f.

48 Jan Fontein and Money L. Hickman, *Zen Painting et Calligraphy*, Museum of Fine Arts, Boston, 1970, No. 52, p. 125.

49 Richard Edwards, 'Ue Gukei – Fourteenth-Century Ink-Painter', *Ars Orientalis*, VII (1968), p. 172.

50 See *Japanese Ink Paintings*, ed. Yoshiaki Shimizu and Carolyn Wheelwright, Princeton, 1976, no. 30, p. 224.

51 *Ibid.*, p. 234.

52 *Ibid.*, p. 218.

53 For a discussion of the Hsiao-and-Hsiang theme in western languages and further bibliographical references see Richard Stanley-Baker, 'Mid-Muromachi Paintings of the Eight Views of Hsiao and Hsiang' (PhD diss., Princeton University, 1979); Richard Stanley-Baker, 'Gakuō's Eight Views of Hsiao and Hsiang', *Oriental Art* 20 (1974), pp. 283-303; Alfreda Murck, 'Eight Views of the Hsiao and Hsiang Rivers by Wang Hung', in *Images of the Mind*, The Art Museum, Princeton University, 1984, pp. 213-35, and No. 4, pp. 226-77.

54 *Tu Fu's Gedichte*, trans. Erwin von Zach, Harvard-Yenching Institute Studies, VIII, vol. 1, Cambridge, Mass., 1952, II -57, pp. 73 ff.

55 Wolfgang Bauer, *China und die Hoffnung auf Glück. Paradiese, Utopien, Idealvorstellungen*, München, 1971, p. 246.

56 Eugen Herrigel, *The Method of Zen*, London, 1960, p. 54.

57 Dōgen Zenji's *Shōbōgenzō* (The Eye and Treasury of the True Law), vol. II, trans. Kōsen Nishiyama and John Stevens, Tōkyō, 1977, p. 150.

58 A good selection of poems by Zen literati has been translated by David Pollack: *Zen Poems of the Five Mountains*, American Academy of Religion: Studies in Religion, 37, New York and Decatur, GA, 1985.

59 A thorough investigation of this mode of painting was made by Shūjirō Shimada: 'Mōryōga' ['Apparition Painting'], *Bijutsu kenkyū*, Nos 84 (1938) and 86 (1939).

60 *Buddhistische Kunst Ostasiens*, Stuttgart, 1957, pp. 248 and 249.

ARKANA - NEW-AGE BOOKS FOR MIND, BODY AND SPIRIT

With over 150 titles currently in print, Arkana is the leading name in quality new-age books for mind, body and spirit. Arkana encompasses the spirituality of both East and West, ancient and new, in fiction and non-fiction. A vast range of interests is covered, including Psychology and Transformation, Health, Science and Mysticism, Women's Spirituality and Astrology.

If you would like a catalogue of Arkana books, please write to:

Arkana Marketing Department
Penguin Books Ltd
27 Wright's Lane
London W8 5TZ

ARKANA – NEW-AGE BOOKS FOR MIND, BODY AND SPIRIT

A selection of titles already published or in preparation

The TM Technique Peter Russell

Through a process precisely opposite to that by which the body accumulates stress and tension, transcendental meditation works to produce a state of profound rest, with positive benefits for health, clarity of mind, creativity and personal stability. Peter Russell's book has become the key work for everyone requiring a complete mastery of TM.

The Development of the Personality: Seminars in Psychological Astrology Volume I Liz Greene and Howard Sasportas

Taking as a starting point their groundbreaking work on the cross-fertilization between astrology and psychology, Liz Greene and Howard Sasportas show how depth psychology works with the natal chart to illuminate the experiences and problems all of us encounter throughout the development of our individual identity, from childhood onwards.

Homage to the Sun: The Wisdom of the Magus of Strovolos Kyriacos C. Markides

Homage to the Sun continues the adventure into the mysterious and extraordinary world of the spiritual teacher and healer Daskalos, the 'Magus of Strovolos'. The logical foundations of Daskalos' world of other dimensions are revealed to us – invisible masters, past-life memories and guardian angels, all explained by the Magus with great lucidity and scientific precision.

The Year I: Global Process Work Arnold Mindell

As we approach the end of the 20th century, we are on the verge of planetary extinction. Solving the planet's problems is literally a matter of life and death. Arnold Mindell shows how his famous and groundbreaking process-orientated psychology can be extended so that our own sense of global awareness can be developed and we – the whole community of earth's inhabitants – can comprehend the problems and work together towards solving them.

ARKANA – NEW-AGE BOOKS FOR MIND, BODY AND SPIRIT

A selection of titles already published or in preparation

Neal's Yard Natural Remedies Susan Curtis, Romy Fraser and Irene Kohler

Natural remedies for common ailments from the pioneering Neal's Yard Apothecary Shop. An invaluable resource for everyone wishing to take responsibility for their own health, enabling you to make your own choice from homeopathy, aromatherapy and herbalism.

The Arkana Dictionary of New Perspectives Stuart Holroyd

Clear, comprehensive and compact, this iconoclastic reference guide brings together the orthodox and the highly unorthodox, doing full justice to *every* facet of contemporary thought – psychology and parapsychology, culture and counter-culture, science and so-called pseudo-science.

The Absent Father: Crisis and Creativity Alix Pirani

Freud used Oedipus to explain human nature; but Alix Pirani believes that the myth of Danae and Perseus has most to teach an age which offers 'new responsibilities for women and challenging questions for men' – a myth which can help us face the darker side of our personalities and break the patterns inherited from our parents.

Woman Awake: A Celebration of Women's Wisdom Christina Feldman

In this inspiring book, Christina Feldman suggests that it *is* possible to break out of those negative patterns instilled into us by our social conditioning as women: confirmity, passivity and surrender of self. Through a growing awareness of the dignity of all life and its connection with us, we can regain our sense of power and worth.

Water and Sexuality Michel Odent

Taking as his starting point his world-famous work on underwater childbirth at Pithiviers, Michel Odent considers the meaning and importance of water as a symbol: in the past – expressed through myths and legends – and today, from an advertisers' tool to a metaphor for aspects of the psyche. Dr Odent also boldly suggests that the human species may have had an aquatic past.

ARKANA – NEW-AGE BOOKS FOR MIND, BODY AND SPIRIT

A selection of titles already published or in preparation

The I Ching and You Diana ffarington Hook

A clear, accessible, step-by-step guide to the *I Ching* – the classic book of Chinese wisdom. Ideal for the reader seeking a quick guide to its fundamental principles, and the often highly subtle shades of meaning of its eight trigrams and sixty-four hexagrams.

A History of Yoga Vivian Worthington

The first of its kind, *A History of Yoga* chronicles the uplifting teachings of this ancient art in its many guises: at its most simple a beneficial exercise; at its purest an all-embracing quest for the union of body and mind.

Tao Te Ching The Richard Wilhelm Edition

Encompassing philosophical speculation and mystical reflection, the *Tao Te Ching* has been translated more often than any other book except the Bible, and more analysed than any other Chinese classic. Richard Wilhelm's acclaimed 1910 translation is here made available in English.

The Book of the Dead E. A. Wallis Budge

Intended to give the deceased immortality, the Ancient Egyptian *Book of the Dead* was a vital piece of 'luggage' on the soul's journey to the other world, providing for every need: victory over enemies, the procurement of friendship and – ultimately – entry into the kingdom of Osiris.

Yoga: Immortality and Freedom Mircea Eliade

Eliade's excellent volume explores the tradition of yoga with exceptional directness and detail.

'One of the most important and exhaustive single-volume studies of the major ascetic techniques of India and their history yet to appear in English' – *San Francisco Chronicle*

ARKANA – NEW-AGE BOOKS FOR MIND, BODY AND SPIRIT

A selection of titles already published or in preparation

Being Intimate: A Guide to Successful Relationships
John and Kris Amodeo

This invaluable guide aims to enrich one of the most important – yet often problematic – aspects of our lives: intimate relationships and friendships.

'A clear and practical guide to the realization and communication of authentic feelings, and thus an excellent pathway towards lasting intimacy and love' – George Leonard

The Brain Book Peter Russell

The essential handbook for brain users.

'A fascinating book – for everyone who is able to appreciate the human brain, which, as Russell says, is the most complex and most powerful information processor known to man. It is especially relevant for those who are called upon to read a great deal when time is limited, or who attend lectures or seminars and need to take notes' – *Nursing Times*

The Act of Creation Arthur Koestler

This second book in Koestler's classic trio of works on the human mind (which opened with *The Sleepwalkers* and concludes with *The Ghost in the Machine*) advances the theory that all creative activities – the conscious and unconscious processes underlying artistic originality, scientific discovery and comic inspiration – share a basic pattern, which Koestler expounds and explores with all his usual clarity and brilliance.

A Psychology With a Soul: Psychosynthesis in Evolutionary Context Jean Hardy

Psychosynthesis was developed between 1910 and the 1950s by Roberto Assagioli – an Italian psychiatrist who, like Jung, diverged from Freud in search of a more spiritually based understanding of human nature. Jean Hardy's account of this comprehensive approach to self-realization will be of great value to everyone concerned with personal integration and spiritual growth.

ARKANA – NEW-AGE BOOKS FOR MIND, BODY AND SPIRIT

A selection of titles already published or in preparation

Encyclopedia of the Unexplained
Edited by Richard Cavendish Consultant: J. B. Rhine

'Will probably be the definitive work of its kind for a long time to come' – *Prediction*

The ultimate guide to the unknown, the esoteric and the unproven: richly illustrated, with almost 450 clear and lively entries from Alchemy, the Black Box and Crowley to faculty X, Yoga and the Zodiac.

Buddhist Civilization in Tibet Tulku Thondup Rinpoche

Unique among works in English, *Buddhist Civilization in Tibet* provides an astonishing wealth of information on the various strands of Tibetan religion and literature in a single compact volume, focusing predominantly on the four major schools of Buddhism: Nyingma, Kagyud, Sakya and Gelug.

The Living Earth Manual of Feng-Shui Stephen Skinner

The ancient Chinese art of Feng-Shui – tracking the hidden energy flow which runs through the earth in order to derive maximum benefit from being in the right place at the right time – can be applied equally to the siting and layout of cities, houses, tombs and even flats and bedsits; and can be practised as successfully in the West as in the East with the aid of this accessible manual.

In Search of the Miraculous: Fragments of an Unknown Teaching P. D. Ouspensky

Ouspensky's renowned, vivid and characteristically honest account of his work with Gurdjieff from 1915–18.

'Undoubtedly a *tour de force*. To put entirely new and very complex cosmology and psychology into fewer than 400 pages, and to do this with a simplicity and vividness that makes the book accessible to any educated reader, is in itself something of an achievement' – *The Times Literary Supplement*

ARKANA – NEW-AGE BOOKS FOR MIND, BODY AND SPIRIT

A selection of titles already published or in preparation

Judo – The Gentle Way Alan Fromm and Nicolas Soames

Like many of the martial arts, Judo primarily originated not as a method of self-defence but as a system for self-development. This book reclaims the basic principles underlying the technique, re-emphasizing Judo as art rather than sport.

Women of Wisdom Tsultrim Allione

By gathering together the rich and vivid biographies of six Tibetan female mystics, and describing her own experiences of life as a Tibetan Buddhist nun and subsequently as a wife and mother, Tsultrim Allione tells the inspirational stories of women who have overcome every difficulty to attain enlightenment and liberation.

Natural Healers' Acupressure Handbook
Volume II: Advanced G-Jo Michael Blate

Volume I of this bestselling handbook taught the basic G-Jo – or acupressure – techniques, used to bring immediate relief to hundreds of symptoms. In Volume II Michael Blate teaches us to find and heal our own 'root organs' – the malfunctioning organs that are the true roots of disease and suffering – in order to restore balance and, with it, health and emotional contentment.

Shape Shifters: Shaman Women in Contemporary Society
Michele Jamal

Shape Shifters profiles 14 shaman women of today – women who, like the shamans of old, have passed through an initiatory crisis and emerged as spiritual leaders empowered to heal the pain of others.

'The shamanic women articulate what is intuitively felt by many "ordinary" women. I think this book has the potential to truly "change a life"' – Dr Jean Shinoda Bolen, author of *Goddesses in Everywoman*.

ARKANA – NEW-AGE BOOKS FOR MIND, BODY AND SPIRIT

A selection of titles already published or in preparation

On Having No Head: Zen and the Re-Discovery of the Obvious
D. E. Harding

'Reason and imagination and all mental chatter died down . . . I forgot my name, my humanness, my thingness, all that could be called me or mine. Past and future dropped away . . .'

Thus Douglas Harding describes his first experience of headlessness, or no self. This classic work truly conveys the experience that mystics of all ages have tried to put into words.

Self-Healing: My Life and Vision Meir Schneider

Born blind, pronounced incurable – yet at 17 Meir Schneider discovered self-healing techniques which within four years led him to gain a remarkable degree of vision. In the process he discovered an entirely new self-healing system, and an inspirational faith and enthusiasm that helped others heal themselves. While individual response to self-healing is unique, the healing power is inherent in all of us.

'This remarkable story is tonic for everyone who believes in the creative power of the human will' – Marilyn Ferguson.

The Way of the Craftsman: A Search for the Spiritual Essence of Craft Freemasonry W. Kirk MacNulty

This revolutionary book uncovers the Kabbalistic roots of Freemasonry, showing how Kabbalistic symbolism informs all of its central rituals. W. Kirk MacNulty, a Freemason for twenty-five years, reveals how the symbolic structure of the Craft is designed to lead the individual step by step to psychological self-knowledge, while at the same time recognising mankind's fundamental dependence on God.

Dictionary of Astrology Fred Gettings

Easily accessible yet sufficiently detailed to serve the needs of the practical astrologer, this fascinating reference book offers reliable definitions and clarifications of over 3000 astrological terms, from the post-medieval era to today's most recent developments.

ARKANA – NEW-AGE BOOKS FOR MIND, BODY AND SPIRIT

A selection of titles already published or in preparation

The Networking Book: People Connecting with People
Jessica Lipnack and Jeffrey Stamps

Networking – forming human connections to link ideas and resources – is the natural form of organization for an era based on information technology. Principally concerned with those networks whose goal is a peaceful yet dynamic future for the world, *The Networking Book* – written by two world-famous experts – profiles hundreds of such organizations worldwide, operating at every level from global telecommunications to word of mouth.

Chinese Massage Therapy: A Handbook of Therapeutic Massage Compiled at the Anhui Medical School Hospital, China
Translated by Hor Ming Lee and Gregory Whincup

There is a growing movement among medical practitioners in China today to mine the treasures of traditional Chinese medicine – acupuncture, herbal medicine and massage therapy. Directly translated from a manual in use in Chinese hospitals, *Chinese Massage Therapy* offers a fresh understanding of this time-tested medical alternative.

Dialogues with Scientists and Sages: The Search for Unity
Renée Weber

In their own words, contemporary scientists and mystics – from the Dalai Lama to Stephen Hawking – share with us their richly diverse views on space, time, matter, energy, life, consciousness, creation and our place in the scheme of things. Through the immediacy of verbatim dialogue, we encounter scientists who endorse mysticism, and those who oppose it; mystics who dismiss science, and those who embrace it.

Zen and the Art of Calligraphy
Omōri Sōgen and Terayama Katsujo

Exploring every element of the relationship between Zen thought and the artistic expression of calligraphy, two long-time practitioners of Zen, calligraphy and swordsmanship show how Zen training provides a proper balance of body and mind, enabling the calligrapher to write more profoundly, freed from distraction or hesitation.